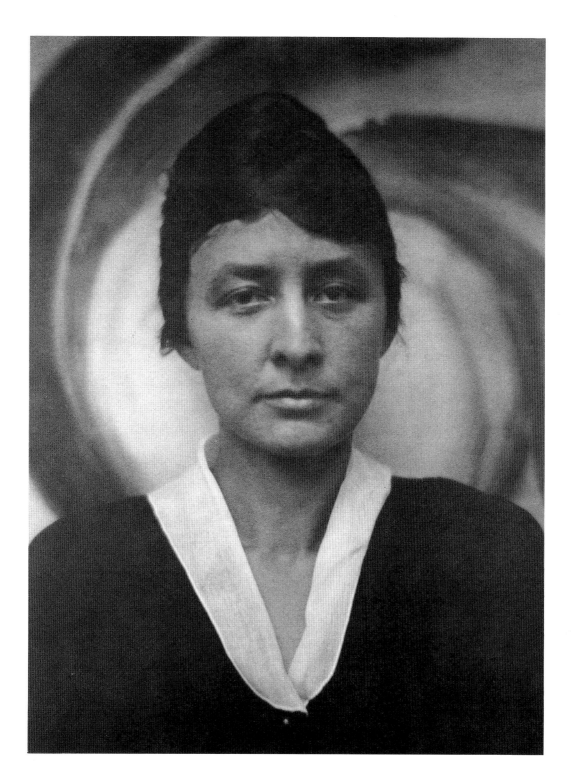

The Georgia

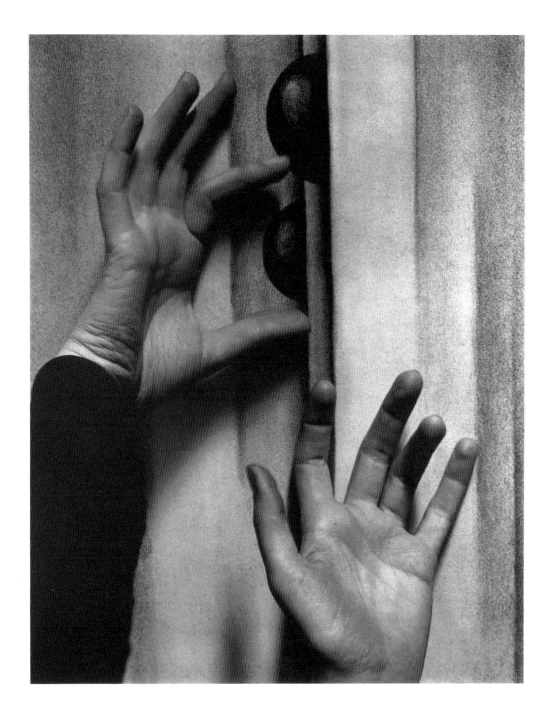

O'Keeffe Museum

General Editor: Peter H. Hassrick, Director

Introduction by Mark Stevens

Essays by Lisa Mintz Messinger, Barbara Novak,
and Barbara Rose

Harry N. Abrams, Inc., Publishers,
in association with
The Georgia O'Keeffe Museum

THE GEORGIA O'KEEFFE MUSEUM

Project Director: Margaret L. Kaplan
Editor: Margaret Donovan
Designer: Dirk Luykx

front cover: Belladonna—Hāna (Two Jimson Weeds). 1939.
Extended loan to The Georgia O'Keeffe Museum, Santa Fe, New Mexico. Private collection

back cover: Abstraction. 1945, 1979–80.
The Georgia O'Keeffe Museum, Santa Fe, New Mexico

page 1: Alfred Stieglitz. *Georgia O'Keeffe: A Portrait—at '291,' June 4, 1917*. 1917. Platinum print, 9½ x 7⅞".
National Gallery of Art, Washington, D.C., Alfred Stieglitz Collection

frontispiece: Alfred Stieglitz. *Georgia O'Keeffe: A Portrait—Hands*. c. 1919. Silver gelatin developed-out print (1924–40), 9½ x 7⅞".
National Gallery of Art, Washington D.C., Alfred Stieglitz Collection

Library of Congress Cataloging-in-Publication Data
The Georgia O'Keeffe Museum / general editor, Peter H. Hassrick;
introduction by Mark Stevens; essays by Lisa Mintz Messinger,
Barbara Novak, and Barbara Rose.
p. cm.
Includes bibliographical references and index.
ISBN 0–8109–3685–2 (clothbound) / 0–8109–2794–2 (paperback)
1. O'Keeffe, Georgia, 1887–1986—Catalogs. 2. Georgia O'Keeffe
Museum—Catalogs. 3. Art—New Mexico—Santa Fe—Catalogs.
I. Hassrick, Peter H. II. Messinger, Lisa Mintz. III. Novak,
Barbara. IV. Rose, Barbara. V. Georgia O'Keeffe Museum.
N6537.O39A4 1997
759.13—dc21 97–7954

Published in 1997 by Harry N. Abrams, Incorporated, New York
All rights reserved. No part of the contents of this book may be reproduced without the written permission of the publisher
Printed and bound in Japan

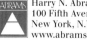 Harry N. Abrams, Inc.
100 Fifth Avenue
New York, N.Y. 10011
www.abramsbooks.com

Contents

Foreword 7

ANNE W. MARION

Preface 9

Acknowledgments 11

PETER H. HASSRICK

Introduction: Georgia O'Keeffe and the American Dream 12

MARK STEVENS

Georgia O'Keeffe: Painting Her Life 33

LISA MINTZ MESSINGER

Georgia O'Keeffe and American Intellectual and Visual Traditions 73

BARBARA NOVAK

O'Keeffe's Originality 99

BARBARA ROSE

Chronology 137

CHARLES C. ELDREDGE

Selected Bibliography 142

Index 143

Photograph Credits 144

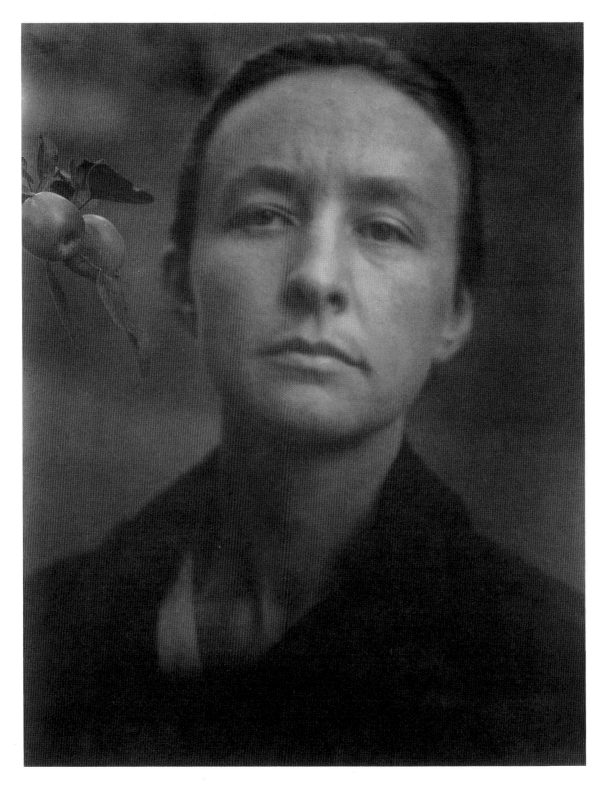

Alfred Stieglitz. *Georgia O'Keeffe: A Portrait—Head.* 1920–22. Silver gelatin developed-out print (1920–24), 9⅝ x 7⅝″. National Gallery of Art, Washington D.C., Alfred Stieglitz Collection

Foreword

THE OPENING of The Georgia O'Keeffe Museum is a very happy moment for my husband, John, and me. From the very first announcement of its inception, in the *Santa Fe New Mexican* on November 18, 1995, the Museum has been widely acclaimed as a "dream come true." When a good dream becomes a reality, it is always a felicitous experience, and when a dream represents the aspirations of an entire community, as this one does, the reaction is widespread public celebration. The response to the idea of a museum devoted to the art and life of O'Keeffe, one of America's preeminent artists, has been truly remarkable, both locally and nationally.

When the Board of Directors was established in late 1995, it articulated a simple yet lofty mission for the new institution: "to maintain property, including a museum building and collections, for the operation of a museum devoted primarily to the exhibition of the works of Georgia O'Keeffe. The corporation shall promote and encourage public awareness of, interest in and appreciation of its collections and shall engage in educational programs as are consistent with the operation of a museum." Buildings in downtown Santa Fe were soon acquired to accommodate these goals, and major donations.of O'Keeffe's art began to flow into the nascent institution. We were most fortunate in being able to attract as our first director Peter H. Hassrick, who joins us after a distinguished career at the Buffalo Bill Historical Center in Cody.

Although totally private, The Georgia O'Keeffe Museum is proud to have developed a close, collegial association with the Museum of New Mexico. Our cooperative programs and revenue sharing have become models for other public-private ventures to emulate. I would especially like to thank Thomas Livesay, Director of the Museum of New Mexico, and Stuart Ashman, Director of the Museum of Fine Arts, for their encouragement and support throughout the development process. The Georgia O'Keeffe Foundation has been both supportive and generous in helping us to acquire an important group of extremely fine works that would not otherwise have been available. Juan Hamilton's advice and counsel have been invaluable.

Governor and Mrs. Gary Johnson, Mayor Debbie Jaramillo, and the City Council of Santa Fe have done much at various times to make our tasks easier and our burden lighter.

I would also like to single out our architect, Richard Gluckman (ably assisted by Greg Allegretti), as well as our builder, John Wolf, for their extraordinary efforts in the design and construction of the Museum, which was completed in record time.

There is one other individual who deserves special notice, my old friend Stanley Marcus, who first spoke with me two years ago about "an O'Keeffe project" that eventually developed into the Museum.

Situated in close proximity to the Museum of Fine Arts in the center of downtown Santa Fe, The Georgia O'Keeffe Museum will complement and enhance the artistic heritage for which New Mexico's capital is so well known. We believe that we are off to a good start in the establishment of our institution, but it is our intention that this will be a living museum. We will constantly be seeking to improve and upgrade our collections as well as our ability to show and interpret them. We hope that visitors to the Museum and readers of the catalogue will share the enthusiasm we feel at this, our inaugural exhibition.

Anne W. Marion
President of the Board

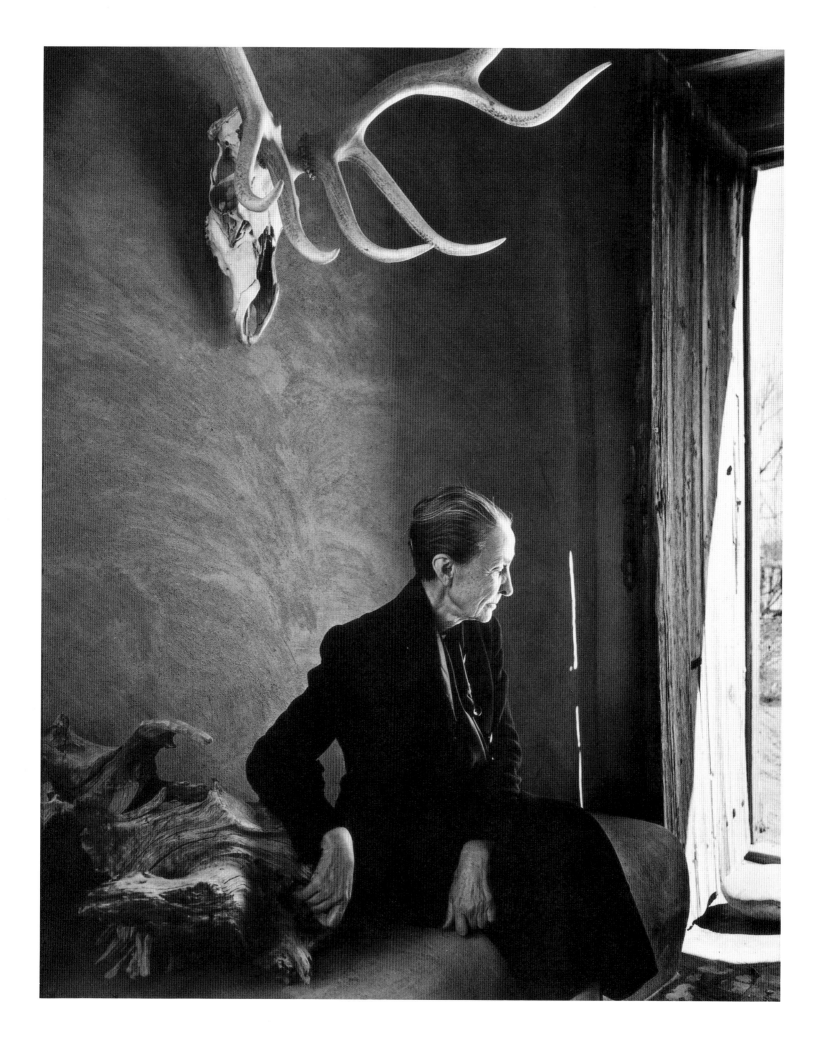

Preface

THE GEORGIA O'KEEFFE MUSEUM—its collections, programs, and physical plant—is a gift from the private sector to the nation as a whole and, in particular, to the people of Santa Fe. As a unit, the Museum represents one of the most generous contributions presented to the city in this century. The founders, Anne and John Marion and The Burnett Foundation, are determined that the results of their considerable largesse will endure and will, in fact, become another jewel in the crown of Santa Fe's wonderful family of museums.

Over the years, many efforts have been made to accommodate the compelling public fascination with O'Keeffe by providing a museum devoted to her. At the end of her life the National Park Service made proposals to her for a museum at Abiquiu, and the Santa Fe Opera discussed a similar proposal for Santa Fe. The Museum of New Mexico later considered the idea of adding a special O'Keeffe wing to its Museum of Fine Arts. While none of these endeavors came to fruition, they attest to the decided attractiveness of the notion.

Yousuf Karsh.
Georgia O'Keeffe with Skull. 1956

That O'Keeffe was a teacher as well as an artist for many years and that she was responsible over several decades for installing the exhibitions in Alfred Stieglitz's galleries (including those of her own work) suggest a natural compatibility between her talents and interests and the standard imperatives of a museum. She was also integrally involved with the selection and installation of her many retrospective museum exhibitions and, far more than many other artists, was directly concerned with the conservation and preservation of her own works. Thus, in matters of didactics, aesthetics, and stewardship, O'Keeffe held firm convictions about the public perception and appreciation of art. And she was eager that her images would have continuity over many generations. At the Whitney Museum's 1970 retrospective exhibition, for example, one of the things that pleased her most was the fact that young people responded so favorably to her art. In several ways, then, O'Keeffe herself had forged a union, an inherent compatibility, with the museum as a public forum for art.

But beyond these issues, the question remains: why this current effort? What makes Georgia O'Keeffe so important? There are more than four hundred single-artist museums in the world today, many of them in the United States. However, this will be the first museum in America to be devoted exclusively to a woman artist of national stature. This presupposes, of course, that Georgia O'Keeffe is extraordinarily special. But why? Is it because of the commanding breadth of her popularity? Is it because she has become, often through misguided reasoning, somewhat mythic in the public mind? Or is it because of the importance of her work in the American art canon?

Certainly, it is the Museum's mission to explore with some seriousness the latter question—that of the contribution O'Keeffe made to American art. It cannot be denied, however, that the public fascination with O'Keeffe also stems from a popularized vision of the woman herself: her mystery, her personal strength and independence, her charisma—in fact, her whole story. It is a story that has been recounted over the last decade in a number of major biographies. It is also a story that might have frustrated O'Keeffe herself. Her famous comment, "I should have kept a diary because they are going to get my life all wrong," suggests the difficulty of trying to summarize O'Keeffe's personal world for a public audience.

Fortunately, the general public also shares a firm belief that O'Keeffe was important because of her commitment to do good work. People are fascinated with her art—its fundamental beauty, its expression of an inner vision, its transcendence, its empathic portrayal of nature, its remarkable craftsmanship, its "American-ness," its independence from other art trends, its womanliness, its whimsy, and its controversial character. She has become something of a national symbol for an honest and pure art. Her presence as a model for other artists, both in her professional dedication and in the consuming emotional and aesthetic impact of her paintings, is widely acknowledged.

What we at the O'Keeffe Museum think the artist would be most proud of is the recognition she has received over the years for her personal, unique, and often landmark contributions to American art. Various eminent figures in the art world have commented on such contributions, and their insights serve as guideposts to the O'Keeffe Museum's acquisitions philosophy as well as to the organizational principles behind the presentation of its permanent collection.

For example, the art critic John Russell proclaimed in 1988 that O'Keeffe had given "a new dimension to American modernism" in her early abstractions.[1] Previously, the venerable museum patriarch Lloyd Goodrich had written that her special contribution to American art was her demonstrated breadth of expression, which ranged from abstraction to precise realism. He also lauded O'Keeffe for the individuality of her style, which steadfastly separated itself from international trends like Cubism, for her capacity to express her emotions so effectively, for her ability to concentrate on "pure form" and to engage her audience in it, and for her lifelong interest in the essential being of the ordinary things around her, which she, in extraordinary fashion, could bring to life for a wide and enthusiastic public audience.[2]

Museum curators over the past decades have made similar observations. In 1987 Jack Cowart, then at the National Gallery of Art, posited that O'Keeffe, better than any other American artist, could "suspend the mundane laws of reality and reason" in the service of her personal vision. What resulted was a refreshing originality of thought and art. In addition, Cowart praised O'Keeffe for her ability to combine "rich color with energetic line," thus producing works that were both bold and well crafted.[3] The matter of craftsmanship also impressed Mark Simpson, curator in the early 1990s of the Fine Arts Museums of San Francisco, who declared O'Keeffe's stature in American art unique because of her "exquisite craftsmanship," her "ordered sense of design," and her ability to expose "pure color."[4] Simpson quoted Murdock Pemberton of the *New Yorker*, who wrote of O'Keeffe's paintings with both acuity and prescience when he claimed, in 1926, "They mean nothing, except beauty." They are "a magnificent leveling of nature," reducing it to something purely joyous.[5] It is in response to that joy and to those remarkable contributions that The Georgia O'Keeffe Museum dedicates its focus and its future.

Peter H. Hassrick
Director

1. John Russell, "Georgia O'Keeffe at Met," *New York Times*, November 18, 1988.
2. Lloyd Goodrich and Doris Bry, *Georgia O'Keeffe* (New York: Whitney Museum of American Art [Praeger], 1970), pp. 7–26.
3. Jack Cowart, "Georgia O'Keeffe: Art and Artist," in Jack Cowart, Juan Hamilton, and Sarah Greenough, *Georgia O'Keeffe: Art and Letters* (Washington, D.C.: National Gallery of Art, 1987), pp. 2–5.
4. Mark Simpson, "Georgia O'Keeffe's *Petunias*," *Triptych*, April/May 1991: 20–21.
5. Murdock Pemberton, "The Art Galleries: Eight out of Every Ten Are Born Blind and Never Find Out—Here Come the Fire Engines," *New Yorker*, February 20, 1926, p. 40.

Acknowledgments

THE INAUGURAL CATALOGUE for The Georgia O'Keeffe Museum was conceived in the early summer of 1996. We knew from the outset that this would be a daunting task, as we hoped not only to present the initial collections of our nascent institution but also to work with eminent American art scholars to make a serious contribution to the understanding of O'Keeffe and her world. We are understandably proud of the final result and grateful to a number of people for accommodating our needs and helping us to fulfill our rather ambitious goal of having the catalogue ready for the Museum's opening in the summer of 1997.

There are many people to thank for this wonderful catalogue. First and foremost, The Georgia O'Keeffe Museum would like to extend its thanks and appreciation to Anne and John Marion, who, through The Burnett Foundation, underwrote the catalogue financially. It was the Marions also who encouraged our association with Harry N. Abrams, Inc. Paul Gottlieb and Margaret Kaplan, with whom I have worked on a number of projects over the years, evinced extraordinary enthusiasm for the project and accommodated an unusually brief schedule with ease and good humor. Margaret Rennolds Chace, Dirk Luykx, Margaret Donovan, and Amy Vinchesi were also of great help at Abrams.

I would also like to extend my sincere thanks for the special assistance in this project provided by Juan Hamilton, Barbara Buhler Lynes, Nat Owings, Gene Thaw, and the staff of The Georgia O'Keeffe Foundation, especially Elizabeth Glassman and Judy Lopez. In addition, the project could not have been completed without the able and gracious assistance of Ted Pillsbury at the Kimbell Art Museum and his staff, especially Anne Adams, Claire M. Barry, and Michael Bodycomb.

My profound gratitude goes also to the authors of this volume. It is thanks to Charles Eldredge, Lisa Messinger, Barbara Novak, Barbara Rose, and Mark Stevens that O'Keeffe's art is presented here with such fresh insight and acuity.

We owe thanks to the many lenders of the illustrations presented here, which help to enhance our appreciation of O'Keeffe and her life. These include the Amon Carter Museum, the Ansel Adams Publishing Rights Trust, the Art Institute of Chicago, the Betsy Evans Gallery, Dan Budnik, the Carl van Vechten Gallery of Fine Arts at Fisk University, the Center for Creative Photography at the University of Arizona, the Cleveland Museum of Art, The Georgia O'Keeffe Foundation, the Greenburg Van Doren Gallery, the family of Yousuf Karsh, Catherine Krueger, the Metropolitan Museum of Art, the Museum of Fine Arts (Springfield, Massachusetts), the Museum of Modern Art, the Museum of New Mexico, the National Gallery of Art, the Norton Museum of Art, the R. W. Norton Gallery, Andrew Smith, Time Life Syndication, Tony Vaccaro, Malcolm Varon, Todd Webb, and Woodfin Camp and Associates.

And, finally, I extend my personal and professional acknowledgment to two staff members, Theresa Harnisch and Amanda Jones, who have worked with me on the myriad details of seeing this project to fruition.

Peter H. Hassrick
Director

Introduction:
Georgia O'Keeffe and the American Dream

MARK STEVENS

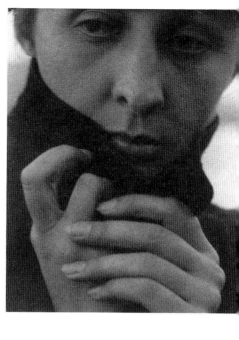

Alfred Stieglitz. *Georgia O'Keeffe: A Portrait— Hands and Face.* 1918. Platinum print, 4⅝ x 3¾". National Gallery of Art, Washington, D.C., Alfred Stieglitz Collection

G EORGIA O'KEEFFE is now an iconic figure, a woman who represents an essential version of the American dream. Very few artists play such a part; in the twentieth century, only Jackson Pollock and Andy Warhol make a comparable claim upon the American imagination. Artists of this kind attain their position not because they are necessarily the best painters, but because they have a deep emblematic power, or presence, that possesses the mind with the force of myth.

The mystique around an iconic figure can be distracting. Camp followers create an air of inflation; the art is treated as incidental or used to fight fashionable cultural battles; the facts bend to serve myth. O'Keeffe is certainly subject to such distortions. And the grandiloquent works of her later years—in which her spiritual aspirations sometimes appear forced—are too often used to represent her vision. But this should not be allowed to obscure either her achievement or her larger significance. For American culture, O'Keeffe has a beckoning kind of beauty, at once mysterious and clear-eyed. She seems to stand—sharply defined—at an open door.

O'Keeffe's iconic power begins, but does not end, with her life as an American woman. She symbolizes the entrancing air of possibility that characterizes the history of women during the twentieth century. Not confined by the conventional pattern of mother and housewife, O'Keeffe brings vividly to life not one but several newly perceived female roles. Her first definitive performance comes as the muse of Alfred Stieglitz, when she inspires him to make hundreds of photographs of her. A pretty young woman serving as a muse to an older male artist is, of course, common enough: it might even seem an old-fashioned role for a serious modern woman. But O'Keeffe is no ordinary muse. She subtly changes the terms of the classic connection, as can be seen in Stieglitz's view of their relationship, which is embodied in the pictures of her that he collected into a multi-image "portrait." While certainly an object of erotic desire—wonderfully so in certain images—O'Keeffe is also much else besides. There is nothing of the master and his mistress in the Stieglitz portrait, no sense of the coquette or shopgirl, no hint of the melancholy sweetness that suffuses French painting.

Instead, O'Keeffe appears as an independent woman of many moods and guises—an intelligent woman, sexy and wry, with a force of character equal to that of Stieglitz himself. That a woman should be portrayed as having many serious aspects is, in itself, a radical revision of the idea of the muse. O'Keeffe is modern, flickering, ever-changing; she cannot finally be possessed by the artist. The photographs may belong to Stieglitz's oeuvre, but they are in a deeper sense a collaboration. Highly conscious of the camera—only Pablo Picasso dominated the lens as she did—O'Keeffe knew what she was projecting when Stieglitz depicted her. Their collaboration is a repeated struggle toward an image that suits both artist and subject, dreamer and muse, man and woman. The result is that rarity in portraiture: a mature view of a relationship between the sexes, in which a woman appears fully seen and wholly rendered.

12

In addition to redefining the role of muse, O'Keeffe also plays the more obviously radical part of the woman who breaches a masculine preserve—in her case, that of art. Today, when there are many women artists, it can be hard to remember how few there were earlier in the century. What is astonishing is how naturally O'Keeffe assumes her place in Stieglitz's gallery, along with Marsden Hartley, Arthur Dove, John Marin, and the rest. She generally fits in without great bitterness or struggle. This has something to do with being married to the boss, but it is not the whole explanation. There is an *of course* about O'Keeffe taking her place, an easy assumption of authority, that is even more impressive in its way than an aggressive confrontation would have been.

In the circle around Stieglitz, O'Keeffe often behaved almost like one of the boys: the tomboy American modernist. Yet her painting remained, strikingly, that of a woman. "Finally a woman on paper," Stieglitz famously said when he first saw her drawings. The way she remained a woman, however, is important. What we call masculine and feminine in art does not always depend on the gender of the artist; a male artist, for example, may use more feminine forms than does a female artist. And the artist's gender is often of small consequence in the viewer's response to art. Yet Stieglitz was right to stress the point, despite his condescension, for O'Keeffe brought a new note to the "feminine" that has little to do, for instance, with the allegedly sexual forms that have aroused so much discussion in the flower paintings. O'Keeffe put enormous, radical pressure on traditionally feminine conventions—on flowers, on flowing shapes, on soft coloring—without abandoning those conventions. Never demure, she gave the feminine a powerful scale. As a result, her work, delicate without being dainty, seemed that of a strong woman. That, too, increases her iconic power in our culture.

O'Keeffe's final definitive performance as a woman is that of a solitary, a woman alone, in an era that did not easily grant women that autonomy. During the 1930s she began spending increasing amounts of time by herself in New Mexico. In her behavior as a solitary, no less than as a muse or radical, there was nothing overtly confrontational or political. She did not formally or ostentatiously abandon or "leave" Alfred Stieglitz. Instead, she seemed to choose the solitary life—apart from husband and marriage—as if this were entirely natural, customary, and right for a woman to do. In choosing to be alone, she implicitly defined herself not through her relationship to a man or family, but through her relationship to her art, her sensibility, and her subject. New Mexico—what she called "her country"—was finally more necessary than Stieglitz.

After Stieglitz's death in 1946, O'Keeffe made of the solitary life a cultivated practice. She did not become an asocial hermit who avoids human contact; she had plenty of friends and lived well. By solitary she meant, instead, one who gives priority to the moments alone—and is the master of one's own life. The house in Abiquiu that she bought in 1945 was originally the hacienda of an important Spanish soldier, a place behind walls that was a world unto itself, with animals, gardens, and orchards. O'Keeffe bought it in ruins and, in renovating it, turned it into a modern version of a world unto itself, for she wanted very much to raise her own food there. A solitary should be self-sufficient in body no less than in spirit.

Solitary, radical, muse—to each perspective O'Keeffe gave a definitive personal form during an era when women in Western culture were just beginning to recast the possibilities of their sex. She did so almost seamlessly, without ripped emotional edges or hostility toward men, so that she became a fluent and ideal embodiment of the various options opening to women. What made O'Keeffe's life as a woman importantly *American*, however, was the way in which she drew on certain quintessential American themes, so that she did not in the end appear defined by her sex. She transcended her gender because she embodied, as men could, some universal aspirations of her culture. Never less than a woman, she was also never only a woman.

In O'Keeffe's life, there are two great pilgrimages, which happen to be the essential, yet contrary, destinations of the questing American spirit—New York and the West. O'Keeffe has become so identified with New Mexico that, nowadays, she is sometimes overlooked as a sophisticated New Yorker. That is a serious mistake if one is to fathom her complex iconic significance. As a young woman, O'Keeffe made the trip to Manhattan that countless other ambitious American writers and artists have felt obliged to make, whether or not they stayed in the city. To an artist of O'Keeffe's generation, New York was the capital of American arts and letters, the center of modernity, the place that, early in the century, knew the most about the great achievements of European modernism. Only in New York could you seriously test your mettle.

O'Keeffe not only came to New York from the Midwest and Texas (there could be no better name for a hometown, in a classic American life, than "Sun Prairie"); she showed her work at the most important modernist gallery of the time and married the informal leader of New York modernism. She knew most of the main artists of the period; she befriended the important New York critic Henry McBride. She certainly became knowledgeable about the radical modernist ideas in Europe, for no one in Stieglitz's circle could avoid it. O'Keeffe would very early have thought about Kandinsky's mystical yearnings and spirit-charged color. She would have known about abstracted form, severe simplifications, and a life lived beyond the circle of middle-class convention.

Yet O'Keeffe retained, as well, a genius for innocence and a flair for the American gee-whiz. If European ideas inform O'Keeffe's art, her pictures of New York reflect more than a merely savvy European style. Her version of the city—particularly in *Radiator Building—Night, New York* (1927; Collection Fisk University, Nashville), *The Shelton with Sunspots* (1926; The Art Institute of Chicago), and *New York, Night* (1929; Sheldon Memorial Art Gallery, University of Nebraska, Lincoln)—is that of a plainspoken visionary, a Whitman-esque beacon for all who wish to transcend conventional limits. She is drawn to the city in the evening, when its windows become necklaces of light. She also likes the hazy and un-focused in New York—steam, sunspots, and so on—because that softens the strict lines of the city, creating a space available for dreaming.

Together with Willem de Kooning's *Excavation* (1950; The Art Institute of Chicago), O'Keeffe's visionary pictures of New York stand as the preeminent paintings of the city. But she portrayed another New York, too, a darker and less inspiring place. Some pastels, such as *East River, New York, No. 2* (1927; private collection), present horizontal views. Here, we sense an artist trapped behind glass, painting a view rather than being in the view. The melancholy browns and greys are a kind of visual whisper. It is hard not to feel the claus-trophobia of a young woman who dreams of the country among all the argument and sophisticated point making of the Stieglitz circle.

In one remarkable painting—*Street, New York I* (1926; plate 34)—O'Keeffe actually brings together the contrasting sensations of rapture, claustrophobia, and liberation. New York appears awesome, a vast vertical dream. At the same time, the city is a puzzle or maze that traps the eye with its asymmetric skyline; the buildings almost close down the sky. Yet, even in this forbidding New York, the sky finally seems to escape from the upward thrust of man-made structures. The artificial light of the city appears as a small, low creation—sym-bolized by the tiny streetlamp on the bottom of the picture—when compared to the rising light of the eternal sky.

In American culture, New York is the magnet that also repels. The city symbolizes a form of European-tinged sophistication that a powerful element in the American imagina-tion finally cannot abide. O'Keeffe's withdrawal from New York rhymes with the greatest of all American stories—the "goodbye to all that" of the pioneers who set their faces West, abandoning conventional civilization. Although O'Keeffe was not a literal pioneer, she re-creates the American dream of the West, especially the dream of a majestic and mystical

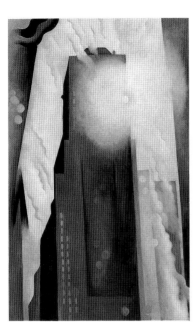

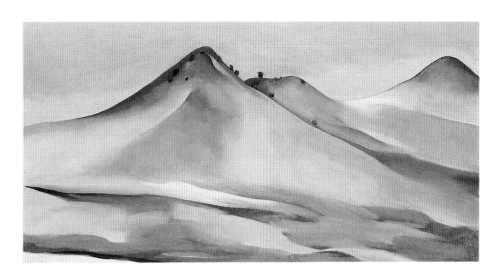

landscape that sends the spirit soaring. At the same time, she embodies a certain down-to-earth quality that is equally part of the West. Indeed, the West of myth combines exactly these two qualities: a skyward-looking idealism and an earthy practicality. In many photographs taken of O'Keeffe in New Mexico, she resembles the pioneer woman of tradition. The bones in her face are strong and angular. There is no city softness in her spine or expression. Something frank in her manner evokes the heartland. Her humor, which left its mark on her face, is of the wry and teasing variety favored by Westerners who like to take the highfalutin down a notch or disparage anyone who gets "too big for his britches." This earthy aspect provides a powerful foil to the more spiritual yearnings of her sensibility. She appears in interviews and photographs as idealistic but also practical, metaphysical but plainspoken, a person equally absorbed in the otherworldly epiphany and the visceral detail.

More important, her paintings display the same knotty strength, in which seeming opposites become inseparable. Everyone knows that O'Keeffe was interested in the American sublime, but not enough is made of the paradoxical means by which she creates her version of the sublime, for it is these that give her art its power. What makes O'Keeffe's depiction of American space transcendent? To begin with, she brings to her painting a surprising simplicity. In spiritually ambitious art, there is always a danger of becoming overblown and exhibiting an unseemly pride, especially when traditional religious iconography is not present to temper the individual personality of the artist. Nothing, in short, serves spiritual aspiration better than an air of humility.

O'Keeffe attains this, particularly in her earlier work, in ways that may seem straightforward but are actually quite subtle. Her most obvious method is the radical simplification of form: the depiction of the "black door" in her house in Abiquiu, for example, becomes increasingly honed down and abstracted as she paints it over time. This drive toward the essential is mirrored, in turn, by her choice of subject and locale, for the New Mexican landscape is itself pared down, its forms isolated in vast space. Mystics and hermits are traditionally attracted to the desert for its aura of simplicity, revelation, and death. The overgrown distractions of the world have no place there; the desert reflects the mystic's aspiration to empty himself of the selfish thickets of desire and to "die" to the ordinary life so that the soul may live. Not surprisingly, mystics and hermits also traditionally cherish bones. When O'Keeffe paints bones set in the desert, she portrays life doubly stripped.

O'Keeffe's images look homemade, almost primitive, as if made by a pioneer with a knack for getting a big job done without a lot of fuss. This was her natural style as an artist, yet her trips to New Mexico must have reinforced her faith in a seemingly naive or simple "hand." The old adobe buildings and colonial furniture, crosses, and paintings display what Willa Cather, in *Death Comes for the Archbishop*, called "that irregular and intimate quality

of things made entirely by the human hand." O'Keeffe's pictures abound in this quality—which, incidentally, is one of the essential strategies of the spirit in art that aspires to the transcendent. Like Russian icons—or most Mondrians—O'Keeffe's paintings are usually small and depend on that homemade look for the touch of transcendence. They seem to invite being grasped in the hands. In this way, they are spiritually "felt."

Despite her many small paintings, with their intimacies of touch, O'Keeffe's feeling for scale remains grand. In most of her pictures, such as *New Mexican Landscape* (1930; Museum of Fine Arts, Springfield, Massachusetts), she has no interest in the middle distance, which represents the ordinary measure of human life. Only the far or the close, the distant mountain or the enveloping flower, holds her eye. And not, of course, a flower at conventional scale. When Paul Strand made an extraordinary close-up photograph of a flower, he maintained a certain classical reserve, emphasizing the formal beauty of the image. O'Keeffe instead intensifies the flower as she enlarges it, so that it becomes not simply an object of contemplation but an internal landscape—a vision of an alternative world.

O'Keeffe's flower pictures have often been called erotic, which is not exactly wrong, but the emphasis is misplaced. It would be surprising if an artist with her passion for the transcendent did not make use of erotically charged imagery. Reducing her flowers to symbols of female sexuality is, however, a trivializing mistake, for the sexual particulars matter less in art with this aspiration than the vivid and more universal sensation of a joyful release into another world beyond the usual distinctions. (Constantin Brancusi, another rhapsodic visionary, sometimes employs highly masculine forms. Yet his art does not then command our attention as a symbol of masculine sexuality.) O'Keeffe's interest in the scale of transcendence led her to violate certain boundaries. Not only did she make the large small and the small large, but she took serious chances with color, sometimes upsetting conventions of visual harmony in order to startle the eye into new kinds of seeing. She liked to stress visual edges that have metaphysical implications: between night and day, earth and sky, life and death. She was not afraid of the large, symbolic reverberation; her bones often seem strangely alive, the flowers of the desert. Here, too, there is something natively American about O'Keeffe, for she does not fear the accusation of vulgarity and she, like her country, is not polite about scale.

Did O'Keeffe cultivate her own iconic power? She was too intelligent—too aware of the camera—not to help shape what the world made of her. In the portrait of O'Keeffe as an iconic American figure, there is certainly this one last minor but important inflection—show business. Nothing significant in American culture, once recognized, seems to escape the pressures of performance, and the line between conviction and humbug often becomes difficult to define. The celebrated instance of this is the later Ernest Hemingway. O'Keeffe never became a meretricious figure, but she did become a saint of sorts—the matron saint of New Mexico, whose houses now serve as secular shrines. She could perform "sincerity," which does not mean that she was just acting. Sometimes O'Keeffe becomes in the mind's eye a sophisticated naif—a profoundly American paradox.

Just as Stieglitz depicted a many-sided woman in his portrait of her, so O'Keeffe embodies much that is best in classical American culture. She remains a powerful emblematic figure, however, not because she brings together so many contrary elements, but because she reflects the American world writ large, one of the last to do so convincingly. A master of the ecstatic eye, she keeps alive, far into the twentieth century, the transcendental tradition in American life. She remains open, expansive; she seems to glimpse something vital just beyond the hills. If "the American dream" means anything important, it is this air of quest or possibility that O'Keeffe brought into both her life and her art.

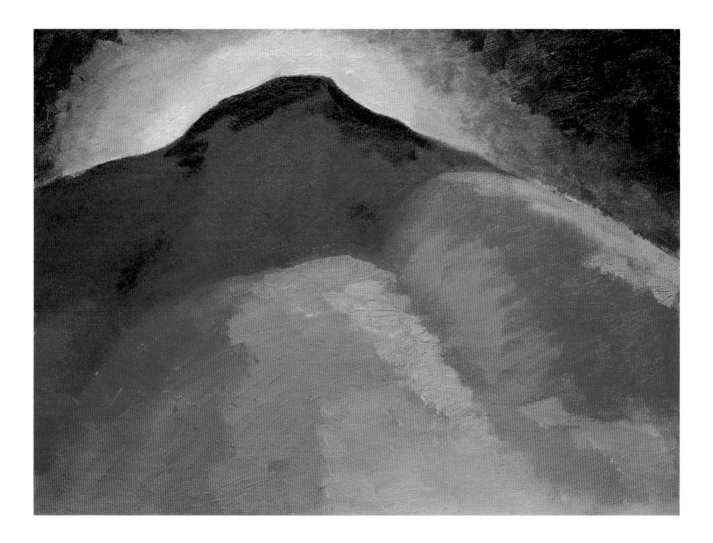

1. *Special XXII*. 1916. Oil on board, 13 x 17⅛″.
Gift of The Burnett Foundation and The Georgia O'Keeffe Foundation

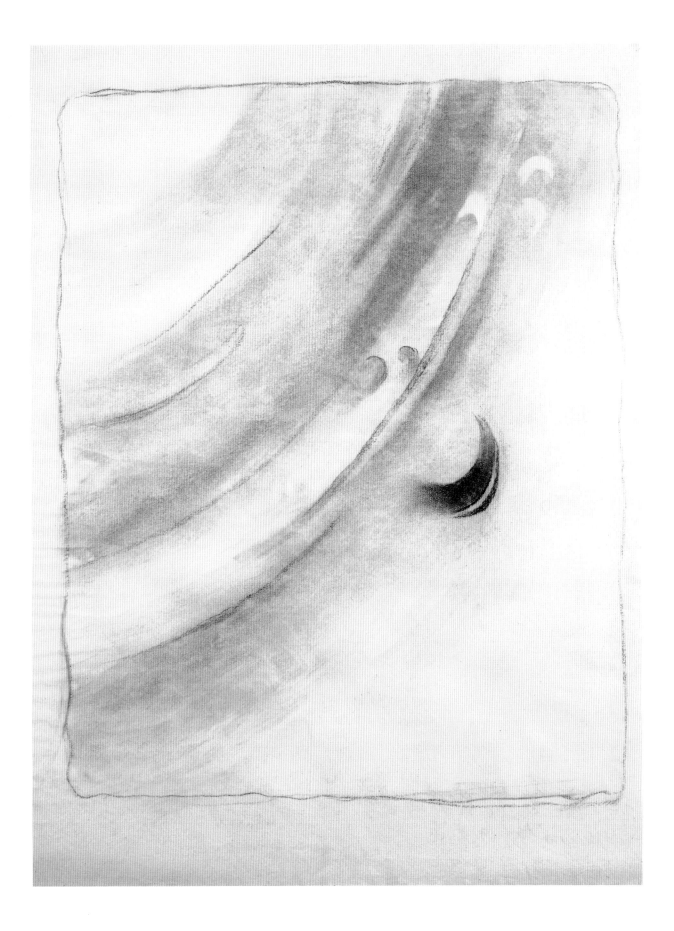

2. *Abstraction with Curve and Circle.* 1916. Charcoal on paper, 24 x 18½".
Gift of The Burnett Foundation and The Georgia O'Keeffe Foundation

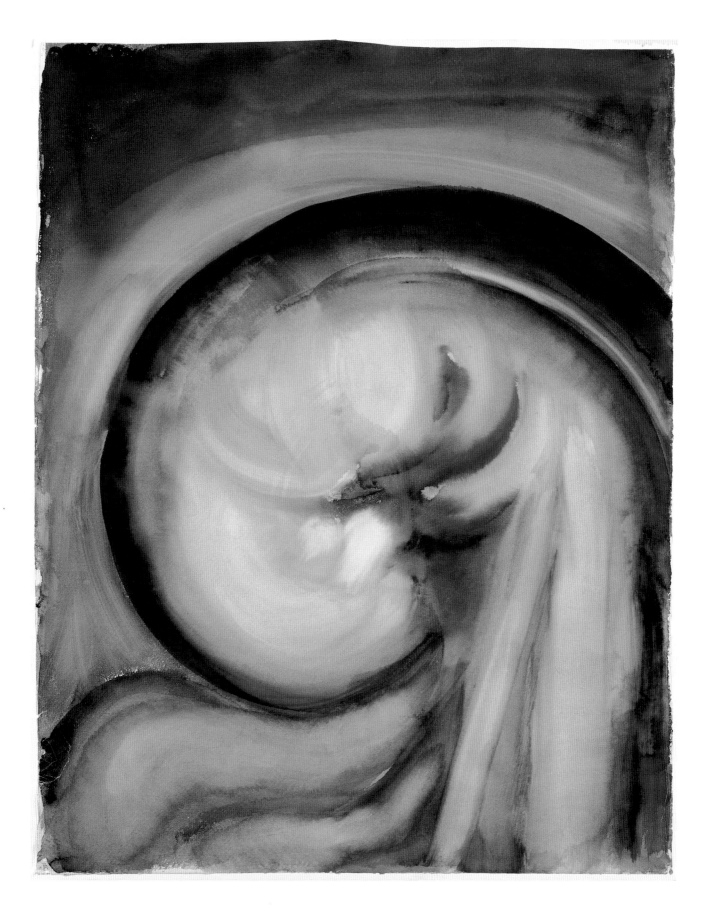

3. *Blue II.* c. 1917. Watercolor on paper, 28⅛ x 22¼".
Gift of The Burnett Foundation

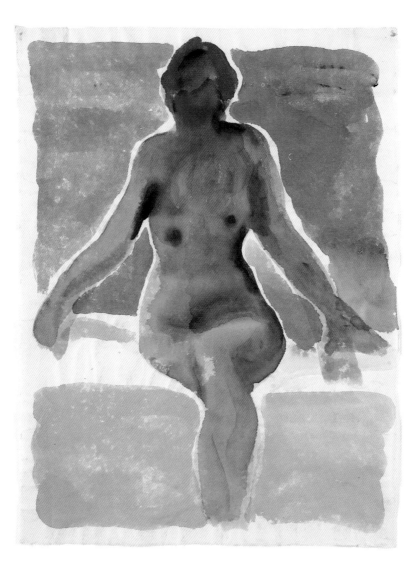

4. *Nude Series VII.* 1917. Watercolor on paper, 17¾ x 13½".
Gift of The Burnett Foundation and The Georgia O'Keeffe Foundation

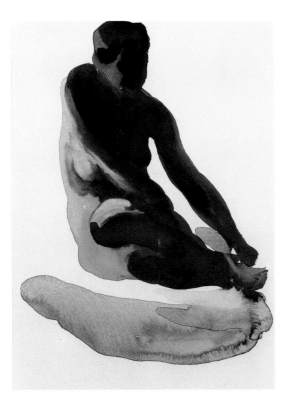

5. *Nude Series (Seated Red).* c. 1917. Watercolor on paper,
12 x 9". Gift of The Burnett Foundation and The Georgia
O'Keeffe Foundation

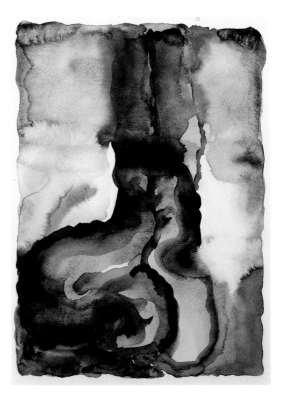

6. *Portrait W III.* 1917. Watercolor on paper, 12 x 8⅞".
Gift of The Burnett Foundation and The Georgia O'Keeffe
Foundation

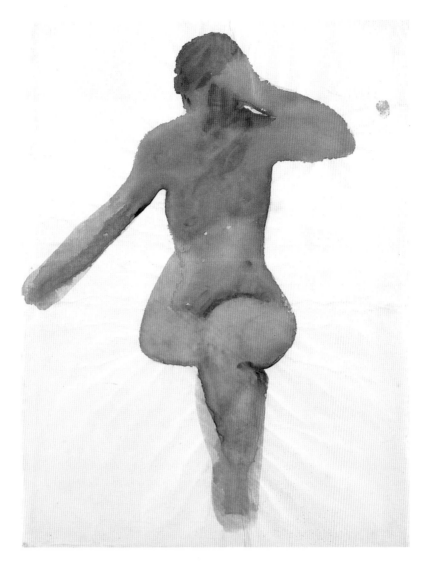

7. *Nude Series VIII*. 1917. Watercolor on paper, 18 x 13½″.
Gift of The Burnett Foundation and The Georgia O'Keeffe Foundation

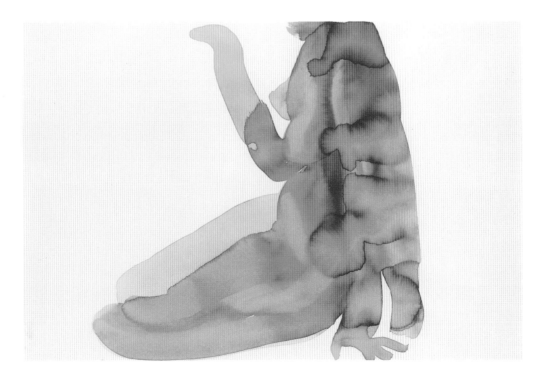

8. *Nude Series XII*. 1917. Watercolor on paper, 12 x 17⅞″.
Gift of The Burnett Foundation and The Georgia O'Keeffe Foundation

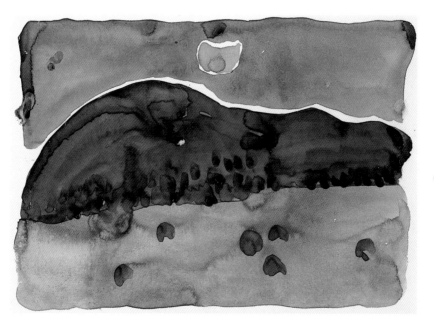

9. *Evening*. 1916. Watercolor
on paper, 8⅞ x 12″.
Gift of The Burnett Foundation and
The Georgia O'Keeffe Foundation

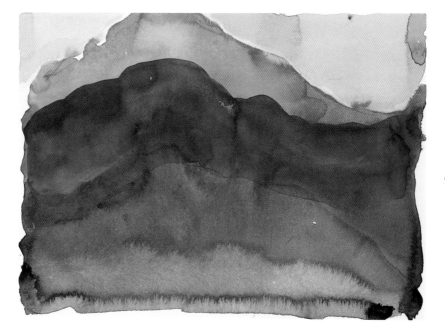

10. *Pink and Blue Mountain*. 1917.
Watercolor on paper, 8⅞ x 12″.
Gift of The Burnett Foundation and
The Georgia O'Keeffe Foundation

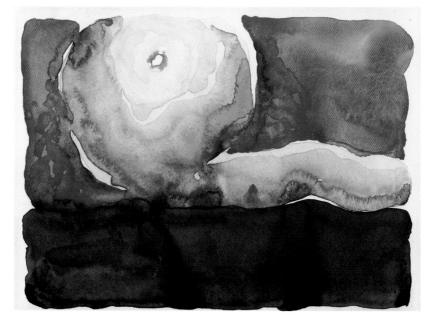

11. *Evening Star VII*. 1917.
Watercolor on paper, 8⅞ x 11⅜″.
Gift of The Burnett Foundation

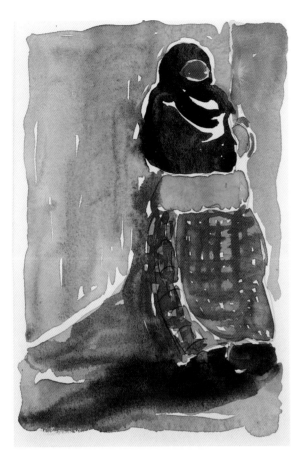

12. *Woman with Apron.* 1918. Watercolor on paper, 8⅞ x 6″.
Gift of The Burnett Foundation

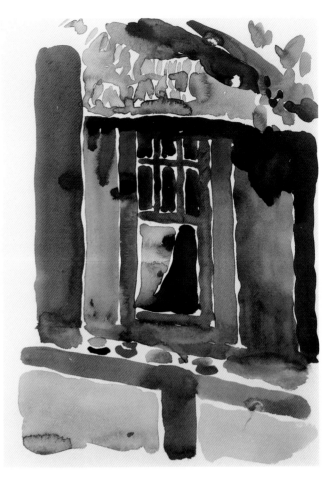

13. *Window, Red and Blue Sill.* 1918. Watercolor on paper, 12 x 9″.
Gift of The Burnett Foundation

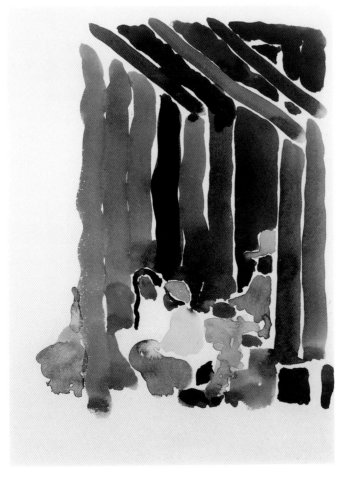

14. *Figures Under Rooftop.* 1918. Watercolor on paper, 12 x 9″.
Gift of Mr. and Mrs. Gerald Peters

15. *Three Women.* 1918. Watercolor on paper, 8⅞ x 6″.
Gift of Mr. and Mrs. Gerald Peters

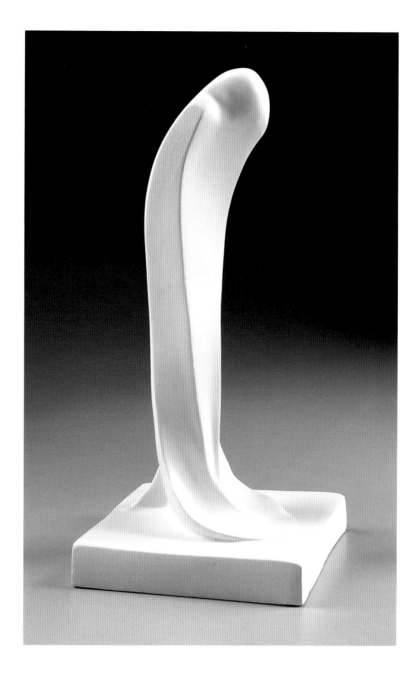

16. *Abstraction*. c. 1916, 1979–80. White lacquered bronze, 10⅛ x 5 x 4¾".
Gift of The Burnett Foundation

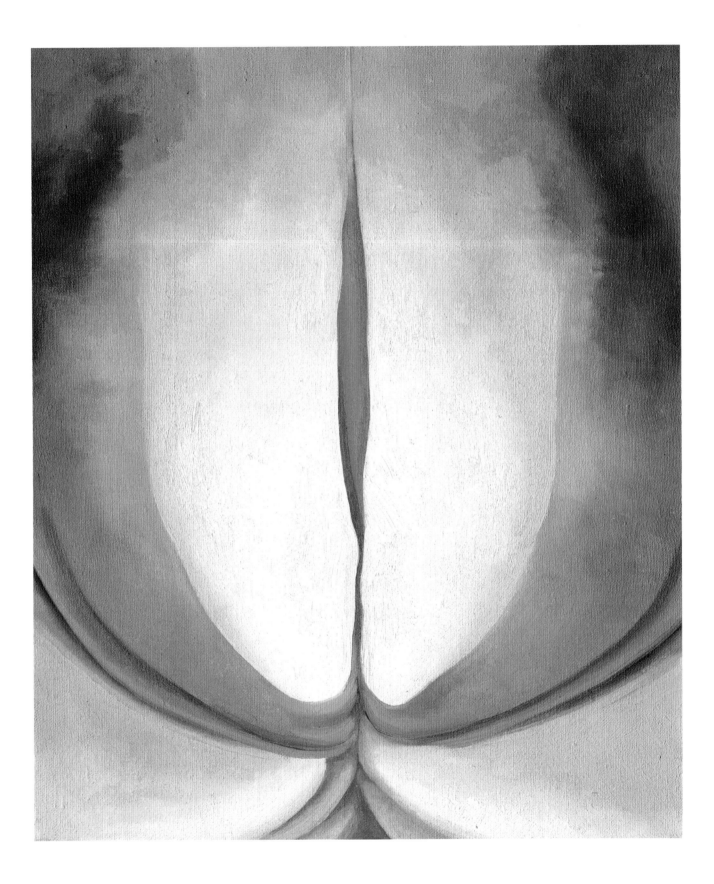

17. *Blue Line*. c. 1919. Oil on canvas, 20⅛ x 17⅛".
Gift of The Burnett Foundation and The Georgia O'Keeffe Foundation

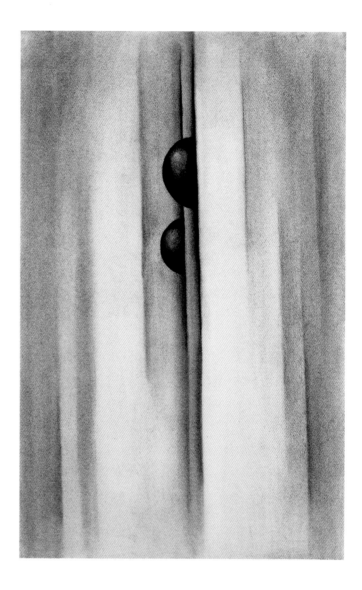

18. *Green Lines and Pink.* c. 1919. Oil on canvas, 18 x 10″.
Gift of The Burnett Foundation and The Georgia O'Keeffe
Foundation

19. *Special XVII.* 1919. Charcoal on paper, 19¾ x 12¾″.
Gift of The Burnett Foundation and The Georgia O'Keeffe Foundation

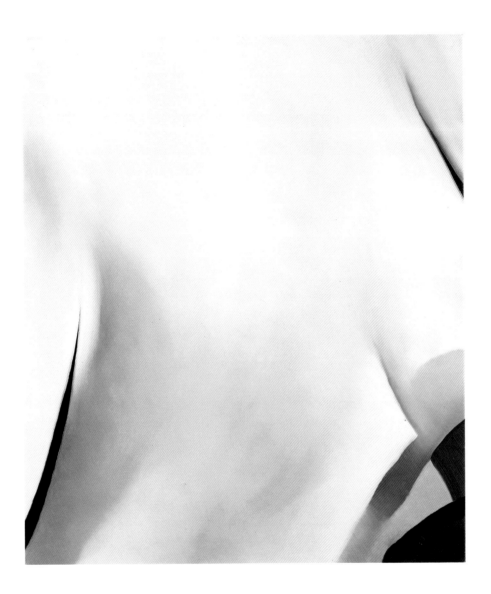

20. *Series I, 12*. 1920. Oil on canvas, 20⅛ x 17¼".
Gift of The Burnett Foundation and The Georgia O'Keeffe Foundation

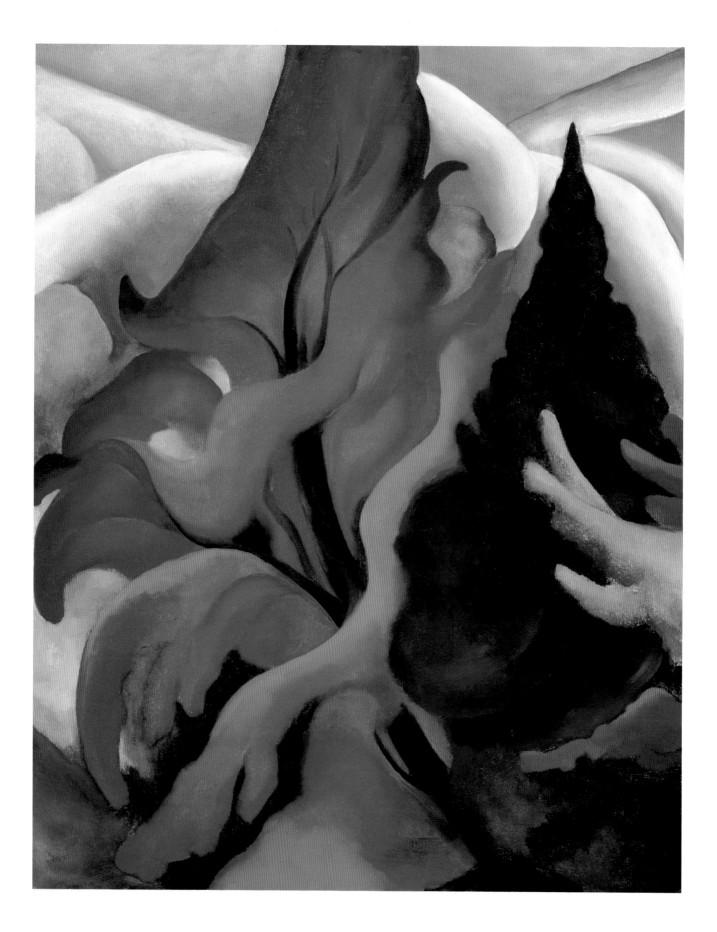

21. *Maple and Cedar, Lake George.* 1920. Oil on canvas, 25¼ x 20¼".
Gift of The Burnett Foundation

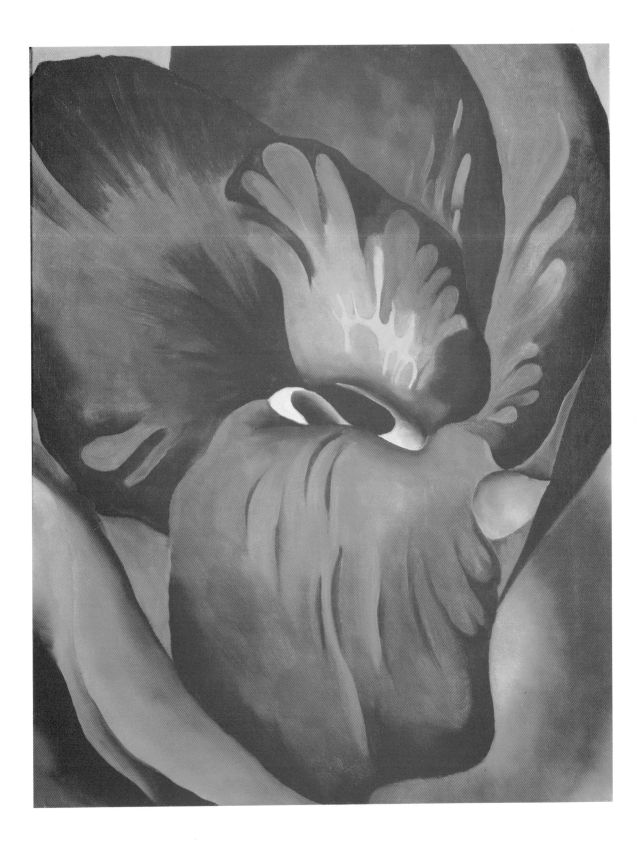

22. *Canna, Red and Orange.* c. 1922. Oil on canvas, 20 x 16".
Gift of The Burnett Foundation

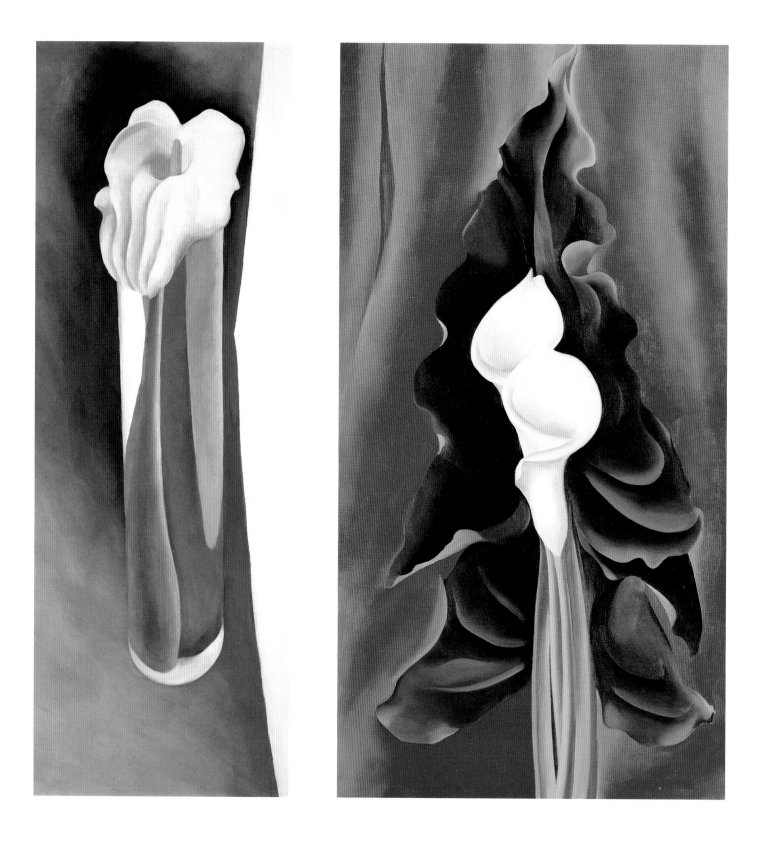

23. *Calla Lily in Tall Glass II.* 1923. Oil on canvas,
32⅛ x 12″. Gift of The Burnett Foundation

24. *White Calla Lily with Red Background.* 1928. Oil on canvas, 32⅛ x 17⅛″.
Gift of Anne Windfohr Marion

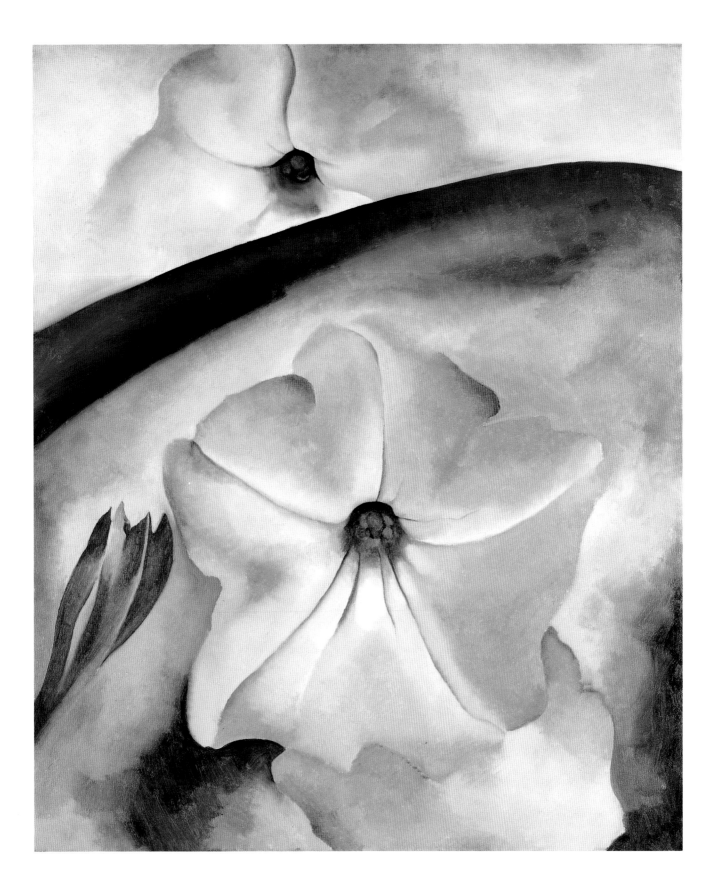

25. *Petunia II*. 1924. Oil on canvas, 36 x 30″.
Gift of The Burnett Foundation and Mr. and Mrs. Gerald Peters

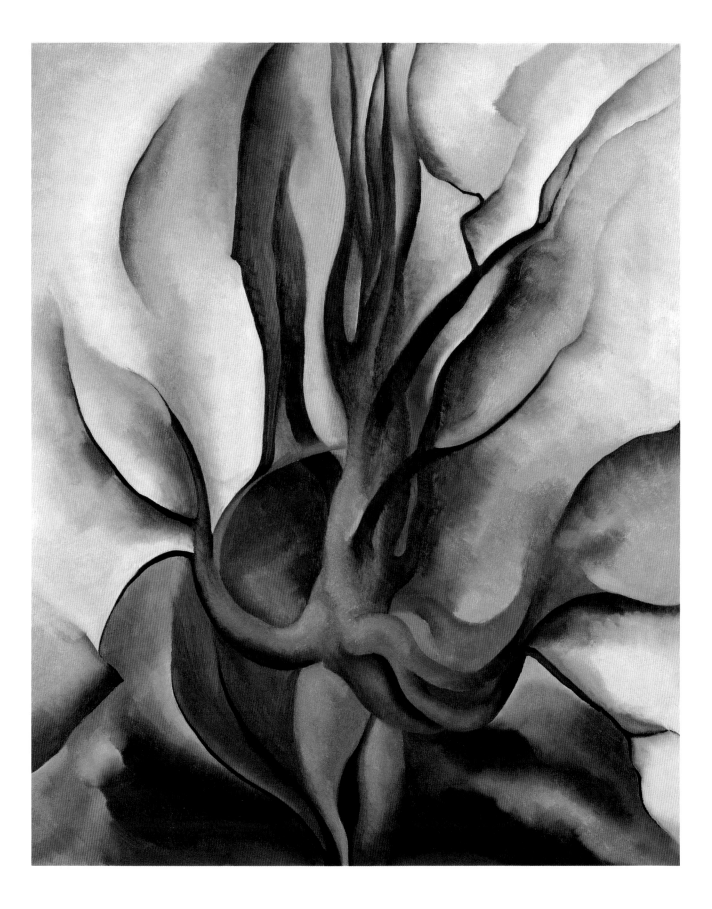

26. Autumn Trees, The Maple. 1924. Oil on canvas, 36 x 30″.
Gift of The Burnett Foundation and Mr. and Mrs. Gerald Peters

Georgia O'Keeffe: Painting Her Life

LISA MINTZ MESSINGER

I find that I have painted my life—things happening in my life—without knowing.—Georgia O'Keeffe[1]

FOR SEVEN DECADES Georgia O'Keeffe (1887–1986) was a major figure in American art who, remarkably, maintained her independence from shifting artistic trends and remained true to her own unique artistic vision. That vision—based on finding the essential, abstract forms in the subjects she painted—evolved during the first twenty years of her career and continued to inform her later work. O'Keeffe generally explored the pictorial possibilities of each subject in a series, usually three or four pictures but sometimes as many as a dozen works. Through repeated reworkings of familiar themes that extended over several years and even decades, she produced an enormous body of work that is intensely focused and unusually coherent.

The subjects that O'Keeffe painted were taken from life and related either generally or specifically to places where she lived. Through her art she explored the minute nuances of a setting's or an object's physical appearance and thereby came to know it even better. Often her pictures convey a highly subjective impression of an image, although it is depicted in a straightforward and realistic manner. Such subjective interpretations were frequently colored by important events in the artist's personal and professional life. In this essay the parallels between O'Keeffe's extraordinary life and art are discussed in terms of the newly formed collection of The Georgia O'Keeffe Museum, which chronicles her work from the earliest charcoal drawings of the mid-1910s to the monumental rock paintings of the 1970s.

O'Keeffe's early biography is typical for a young woman with artistic talent growing up in the United States in the first decades of the twentieth century. Born the second of seven children, O'Keeffe spent her first fourteen years on the family farm near Sun Prairie, Wisconsin; she later attended high schools in Madison, Wisconsin, and Chatham, Virginia. Although she received some art lessons during those years, her first formal training began in 1905 at the School of the Art Institute of Chicago and continued from fall 1907 through spring 1908 at the Art Students League in New York. Both schools offered a classical European curriculum in which students drew from plaster casts and live models and painted still-life arrangements. Over the next several years O'Keeffe also enrolled in art classes at the University of Virginia in Charlottesville (summer 1912) and at Columbia University's Teachers College in New York (fall 1914–spring 1915 and spring 1916), where the more

adventurous teaching methods and design theories of Arthur Wesley Dow and his disciple Alon Bement awakened in her a new creativity.

Rather than expecting to have a career as an artist, O'Keeffe trained to be an art teacher and taught in various elementary schools, high schools, and colleges in Virginia, Texas, and South Carolina from 1911 to 1918. During one such position, at Columbia College in South Carolina (from fall 1915 through spring 1916), O'Keeffe produced a series of radically abstracted charcoal drawings that effectively began her professional career when they came to the attention of prominent photographer, editor, and New York gallery owner Alfred Stieglitz, in January 1916. Later that year Stieglitz showed them at his gallery 291, where the work of many avant-garde European and American artists of the day, including photographers, was featured.

In such charcoals as *Abstraction with Curve and Circle* (1916; plate 2), O'Keeffe abandoned traditional tenets about composition and subject matter in order to create instead evocative images devoid of identifiable content. Rather than representing human figures or still lifes, she orchestrated lines, shapes, and tonal values into harmonious compositions, as she had been taught by Dow and Bement. All distractions of color were deliberately eliminated, at least for the moment.

By June 1916 O'Keeffe had reintroduced color into her work, explaining later that "I found that I could say things with color and shapes that I couldn't say in any other way— things that I had no words for."[2] Over the next two years, numerous small watercolor landscapes, such as *Evening* (1916; plate 9) and *Pink and Blue Mountain* (1917; plate 10), were produced on 9-by-12-inch sheets of paper. These luminous compositions masterfully exploited the clarity and fluidity of the watercolor medium, while taking full advantage of the visual effects derived from leaving strategic areas of white paper unpainted.

Between September 1916 and February 1918 O'Keeffe's landscapes were inspired by the open plains around Canyon, Texas, where she had gone to teach. She described the terrain as being wide like the ocean, without paved roads, fences, or trees. Among her most glorious watercolors from this period are those in the Evening Star series, from 1917. *Evening Star VII* (plate 11) typifies O'Keeffe's use in the series of loose, wide brushwork and saturated colors to convey the magnificence of a scene. Here, a wide band of dark blue ground anchors the red explosion happening in the sky and flowing out along the horizon line. The source of this immense energy seems to emanate from the pale yellow evening star in the upper left corner of the composition.

Besides painting landscapes, O'Keeffe also rendered the human figure in some sixteen watercolors, dating from late 1917, that divide into two distinct series. The first, painted on small sheets of paper, are dark and mysterious and suggest only in the most abstract terms the amorphous shape of a woman seen in profile; *Portrait W III* (plate 6) is one such example. Despite O'Keeffe's titling of the series, these pictures are more concerned with evoking the physical presence of a figure than with depicting any sort of likeness.

The second group of figures consists of about a dozen watercolors, including *Nude Series VII, VIII, XII* (plates 4, 7, and 8) and *Nude Series (Seated Red)* (plate 5). Focusing more specifically on the anatomical structure and pose of a seated woman, these works are generally larger in size and more brightly colored than the "portraits." O'Keeffe's technique is considerably more controlled here and allows her to bleed colors, blur edges, and create sharp contours at will, without benefit of pencil underdrawings. This second set of 1917 figures marks the most extensive exploration of the nude in her work.

O'Keeffe's first solo exhibition was held at the 291 gallery from April to May 1917. With further encouragement from Stieglitz, and the promise of his financial support, O'Keeffe arrived in New York in June 1918 to pursue a career as an artist. Thereafter, until his death in 1946, Stieglitz vigorously promoted her work; he featured it in twenty-two one-person shows and innumerable group installations. Shortly after she relocated to New York, O'Keeffe and Stieglitz began to live together, and in 1924 they were married. She was also the subject of his most celebrated photographic portrait cycle, made over the course of twenty years (1917–37). In more than three hundred black-and-white photographs, Stieglitz captured the ups and downs of this long, complex association that bridged the personal and professional lives of both. Almost single-handedly, Stieglitz's photographs defined O'Keeffe's persona and the public's perception of her art for generations to come.

O'Keeffe's early years in New York, from 1918 through the 1920s, proved crucial to her maturation as an artist. As a new member of the Stieglitz circle, O'Keeffe associated with some of America's most notable early modernists—painters such as Arthur Dove, John Marin, Marsden Hartley, and Charles Demuth; the photographer Paul Strand, among many others; art critics and writers. Their discussions about art, and the examples their work presented, both validated and influenced what O'Keeffe did in her own work. And within a relatively short time, her ideas and imagery became a source of influence for these artists as well.

O'Keeffe's art changed dramatically when she came to New York. Rather than continuing to make small, lyrical watercolors on paper, she now worked almost exclusively with oil paint on generally larger canvases. Her first major pictures of 1919 were highly abstracted images, painted in soft shades of pink and blue, that were inspired by listening to music. Others from about the same time, such as *Blue Line* (plate 17), utilized stronger color schemes but shared similar imagery and compositional arrangements. In each, a semicircular arc that fills almost the entire canvas can be viewed either as a solid form, composed of several layers and crevices, or as an opening through which light rays emanate.

While the specific references for these paintings are not known, the imagery strongly suggests organic life forms such as flowers or the human anatomy or, perhaps, geological formations. Stieglitz's provocative pairing, in a 1919 photograph, of one of these works, *Music, Pink and Blue I* (Collection Mr. and Mrs. Barney A. Ebsworth), with an early O'Keeffe sculpture (plate 16) clearly suggested an erotic, sexual reading for these images. While O'Keeffe always discouraged such interpretations, they persisted throughout her life because her paintings—with their velvety texture, sumptuous color, and organic forms— exuded both an intimacy and an exquisite sensibility. That O'Keeffe's work could evoke diverse associations is entirely in keeping with her attempt to pare down images to their essential, universal forms. Often, as she reworked compositions within a series or moved from one series to another, she unconsciously applied the same forms and arrangements to unrelated subjects. Her 1923 series of large, complex abstractions titled *Grey Line*, for example, returned to the imagery of her 1919 abstractions. They also foreshadowed her representational depictions of opened and closed clamshells in 1926 and the jack-in-the-pulpit flower paintings of 1930. Elsewhere in her oeuvre, it is not unusual to find O'Keeffe's seascapes looking like her floral compositions, or her studies of seashells resembling mountain ranges.

Throughout the 1920s O'Keeffe produced an enormous number of landscapes and botanical studies that were generated by her annual trips to the Stieglitz family country estate in Lake George, New York. Stieglitz and O'Keeffe spent several months there, from

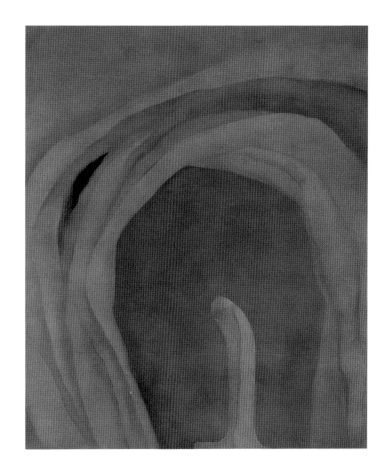

spring to fall, working in their respective studios. O'Keeffe's exhilaration in being with Stieglitz and her discovery of new subjects to paint at Lake George were reflected in her paintings from the early to mid-1920s. She wrote of her enthusiasm to author Sherwood Anderson in 1923: "There is something so perfect about the mountains and the lake and the trees—Sometimes I want to tear it all to pieces—it seems so perfect—but it is really lovely— And when the household is in good running order—and I feel free to work it is very nice."[3]

O'Keeffe employed both realistic and abstract idioms to explore various facets of the Lake George landscape; she produced panoramic paintings of the mountains and lake as well as close-up studies of individual objects on the property. Trees—maples, cedars, pines, poplars, chestnuts, and birches—were particularly favorite subjects, exuberantly painted either singly or in groups as records of the changing seasons. The Museum's *Autumn Trees, The Maple* (1924; plate 26) is a fine Lake George canvas in which amorphous veils of vibrant autumnal color fill the background around a central grey tree. At other times, O'Keeffe focused on the leaves themselves or on the apples picked on the property. Several tiny, jewel-like still-life arrangements, such as *Apple Family II* (c. 1920; plate 27), were created during the 1920s. Later, when the artist worked in New Mexico, she periodically returned to the theme of trees and continued to do so through the 1950s. One of the first paintings she made there, *The Lawrence Tree* (1929; Wadsworth Atheneum, Hartford, Connecticut), depicted a specific tree that held a personal meaning for her, as did several later works, including *Gerald's Tree I* (1937; plate 48) and *Stump in Red Hills* (1940; plate 52). At other times she painted entire groves of trees, such as the ones she saw from her Abiquiu house, as in *Cottonwood Trees in Spring* (1943; plate 58).

Among the richest and most powerful images to emerge in O'Keeffe's early work as a result of these stays at Lake George were her studies of flowers and plants. At first, she portrayed these specimens in simple still-life arrangements, such as *Calla Lily in Tall Glass II* (1923; plate 23). By the summer of 1924, however, she had begun to depict her botanical subjects from closer range and in much greater detail. Focusing attention on much smaller sections of the plant and enlarging them to fill the entire composition, she brought the image right up to the front of the picture plane. Although the results often appeared abstract, they were in fact close transcriptions of nature. Precedents for such magnified images can be found in Paul Strand's and Edward Steichen's photographs of botanical subjects, which O'Keeffe would have known through Stieglitz. But unlike Strand and Steichen, who did not alter their images, O'Keeffe applied judicious editing to eliminate extraneous details or to adjust the composition.

Corn II (1924; plate 32), the second of three variations produced that summer, depicts the leaves of a corn plant in O'Keeffe's Lake George garden: "The growing corn was one of my special interests—the light-colored veins of the dark green leaves reaching out in opposite directions. And every morning a little drop of dew would have run down the veins into the center of this plant like a little lake—all fine and fresh."[4] The images she described and painted in this series could only be seen when the plant was looked down on from directly above. By tipping the picture plane upright so that the leaves appear head-on, O'Keeffe allowed the viewer to share her unusual perspective. *Corn II*, unlike the more static first painting in the series, is an arrangement of curves and scallops along a diagonal axis that writhes with movement, conveying the plant's vitality and growth. The painting's rich, unusual green-and-magenta color scheme is also found in other Lake George pictures, among them *Canna Leaves* (1925; plate 33), which relates closely to the series of corn images.

In 1924 O'Keeffe increased the magnification in her close-up flower paintings, unveiling even larger pictures in which the flower head alone filled an entire 36-by-30-inch canvas. She reasoned that although "everyone has many associations with a flower. . . . Still—in a way—nobody sees a flower—really—it is so small—we haven't time. . . . So I said to myself—I'll paint what I see—what the flower is to me but I'll paint it big and they will be surprised into taking time to look at it."[5] The Museum's beautiful flower painting *Abstraction, White Rose II* (1927; plate 35) exemplifies the expressive potential of O'Keeffe's technique: she draws the viewer into the swirling petals, which are softly tinted and exceedingly sensual. It is one of several compositions produced in 1927 that present a rose, either singly or in combination with other flowers.

Architectural subjects appeared infrequently within O'Keeffe's nature-oriented oeuvre, yet they were often significant indicators of her reactions to specific places encountered through residence or travel. Among the few such scenes painted at Lake George is the small, narrow canvas *Little House with Flagpole* (1925; plate 31), one of at least five versions of this subject (the others date from 1922, 1923, and 1959). Its whimsical merger of reality and fantasy conveys as much about the setting as it does about O'Keeffe's liberated state of mind. Nestled beneath gently rolling blue mountains is the small square wooden house that Stieglitz used as a darkroom, and sometimes photographed, when he was at Lake George. O'Keeffe's painting reduces it to its fewest essential shapes and architectural features—a triangular roof, a rectangular black door, an arrow from the rooftop weathervane, and two narrow electrical wires. In contrast to these fairly representational details, the exaggerated proportions of the soaring flagpole and the enormous blue ball of light add a magical touch

to this ordinary scene. Such indications of humor and contentment were short-lived in O'Keeffe's Lake George pictures, as marital conflicts with Stieglitz arose in the late 1920s.

In a much larger series of architectural pictures depicting New York City (1925–29), a similar change in mood can be discerned by the end of the decade. Although O'Keeffe had lived in New York since 1918, she was inspired to paint city scenes only after she and Stieglitz moved in November 1925 to a new apartment on the thirtieth floor of the Shelton Hotel in midtown Manhattan. At first, O'Keeffe's panoramic views over the East River and paintings of individual skyscrapers conveyed the energy and excitement of city life. Over the next four years, however, as her relationship with Stieglitz became troubled and the strains of living and working in a big city took their toll on her physical and emotional health, O'Keeffe came to feel oppressed by the city views that had once excited her, as she also grew impatient with the sameness of the Lake George landscape. In *Street, New York I* (1926; plate 34), the beginnings of these feelings may be found. Rather than a celebration of lights and movement, or of feats of architectural engineering, O'Keeffe now presented a grim, desolate scene. Two immense walls, without light, windows, or signs of life, crowd out what little grey sky is left. The city has become uninhabitable, a ghost town mirroring the artist's own feelings.

By 1929 O'Keeffe had begun to look elsewhere for artistic inspiration and emotional solace. Between a few short retreats to Maine and Canada, she made her first extended trip to New Mexico, from April to August 1929. The effects of this visit on her life and her work were immediate and long-lasting. That first summer she wrote from the Taos home of her host, Mabel Dodge Luhan, a New York socialite, "You know I never feel at home in the East like I do out here—and finally feeling in the right place again—I feel like myself—and I like it."[6] Over the next twenty years, she traveled almost every year to New Mexico, working for up to six months there in relative solitude, then returning to New York each winter ready to exhibit her paintings. This pattern continued until 1949, three years after Stieglitz's death, when she moved permanently to New Mexico. Between 1929 and 1986, the year O'Keeffe died, at age ninety-eight, she worked in various locales in New Mexico—Taos, Alcalde, Ghost Ranch, and Abiquiu, the last two the sites of the houses she owned.

Among the canvases completed during her first New Mexico visit were a pair titled *Black Hollyhock with Blue Larkspur*, one of which is in the O'Keeffe Museum (1929; plate 28), the other in the Metropolitan Museum of Art, New York. These paintings capture the delicate textures and dramatic coloring of the flowers that lined the path outside the Luhan guest house. While they follow the basic formula set by her magnified Lake George flower paintings, they are unusual in that they explore the same composition from two different orientations: one painting is vertical, the other horizontal. In both, O'Keeffe skillfully balances contrasts of light and dark, small and large, delicate and dense shapes.

Floral subjects were reprised sporadically in O'Keeffe's work through the late 1950s. Included in the Museum's collection are two different interpretations inspired by her travels in the 1930s to New Mexico and Hawaii. The first painting, *Jimson Weed* (1932; plate 46), is a highly stylized, carefully detailed frontal view of a beautiful but poisonous flower (*Datura stramonium*) that proliferated in the Southwest. Years later, she vividly described the strange exoticism of this night-blooming flower: "It is a beautiful white trumpet flower with strong veins that hold the flower open and grow longer than the round part of the flower—twisting as they grow off beyond it. . . . Now when I think of the delicate fragrance of the flowers, I almost feel the coolness and sweetness of the evening."[7] Three years later,

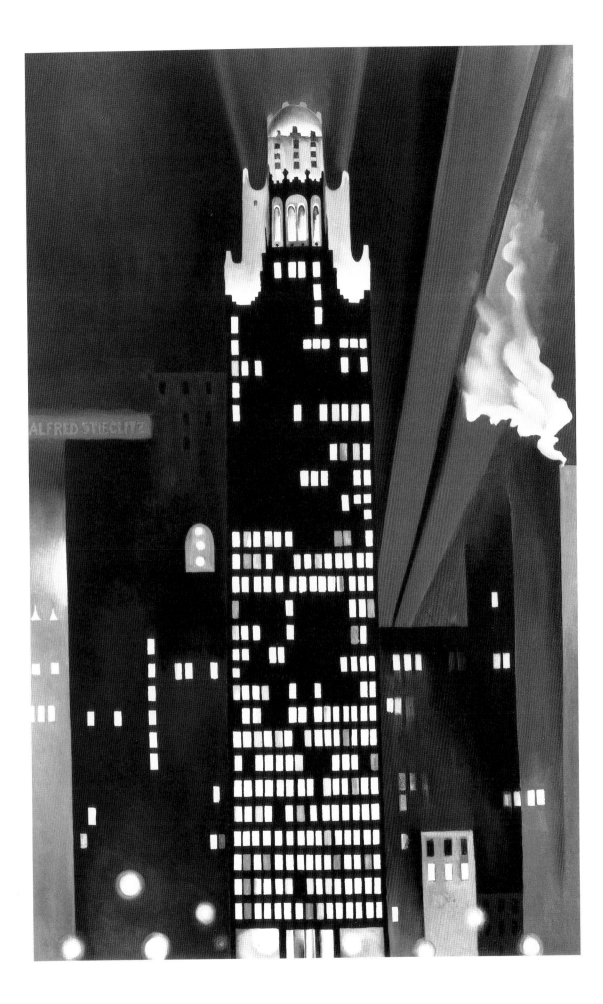

39

in a large commissioned mural for the Elizabeth Arden spa in Phoenix, Arizona, O'Keeffe painted a mirror image of this exact composition in the lower right portion of a panel that included several other views of the jimsonweed, one of which illustrated its long trumpet. In 1939 O'Keeffe again returned to this striking image (minus the leaves) in a design for an etched glass plate commissioned by Steuben Glass.

Also in 1939 O'Keeffe spent two months (from early February to mid-April) working in Hawaii on a commission from the Dole Pineapple Company that was intended to produce several images that could be used to advertise its products. Instead, O'Keeffe painted nineteen landscape and floral subjects, and only one small pineapple bud. The large and expansive *Belladonna—Hāna* (plate 51), which resulted from the artist's two-week stay on Maui, follows the basic imagery and compositions of the earlier jimsonweed pictures. But here, O'Keeffe expresses the tropical sensuality of these lush white blossoms (*Datura candida*, known as angel's trumpets) with abstract shapes and lines and with softly focused veils of pale color.

While such flower paintings were exceedingly accomplished, they added nothing new to O'Keeffe's repertoire. More important to the development of her art were the indigenous subjects she found in New Mexico that occupied her work for the next fifty years. Two of the first such images she adopted were the rugged, mountainous terrain and the sun-bleached animal bones. These powerful motifs readily adapted to both representational and abstract interpretations, and their sculptural qualities prodded O'Keeffe to attempt more three-dimensional depictions in her canvases.

The region's majestic terrain, with its unusual geological formations, vivid colors, clarity of light, and exotic vegetation, provided ample visual resources for her to explore. In *Out Back of Marie's II* (1930; plate 43), O'Keeffe compressed and flattened the vast space into a succession of horizontal bands that recede, only by virtue of their color differences, from light to dark. *Out Back of Marie's IV* (1931; plate 29) is another work that emphasizes the sculptural qualities of the brightly colored landscape around Alcalde.

As O'Keeffe became increasingly familiar with the New Mexico terrain, she often painted particular sections of the landscape in close-up, as she had done with her flower subjects. Two pictures in the Museum's collection, *Red Hills with White Flower* (1937; plate 65), a sumptuous pastel, and *Red and Yellow Cliffs* (1940; plate 67), an oil painting, bring the viewer dramatically close to the mountain walls. Only the inclusion of the narrowest bit of ground and sky suggests the mountain's place within a larger environment. In the pastel, the unexpected addition of an enormous jimsonweed blossom in the immediate foreground further calls into question our perception of relative size and scale.

Red and Yellow Cliffs is a faithful rendering of the colorful striated cliffs and reddish hills that loom up about seven hundred feet behind O'Keeffe's Ghost Ranch home. It is one of several studies she made of this view, which she humorously referred to as her "backyard." In a 1942 letter O'Keeffe described the site: "I wish you could see what I see out the window—the earth pink and yellow cliffs to the north—the full pale moon about to go down in an early morning lavender sky behind a very long beautiful tree covered mesa to the west—pink and purple hills in front and the scrubby fine dull green cedars—and a feeling of much space—It is a very beautiful world."[8]

Another favorite spot for O'Keeffe to paint was a setting she nicknamed "The Black Place," first seen on her motor trip through Navajo country in 1937. Located about one hundred fifty miles northwest of Ghost Ranch, it is a stretch of grey hills that the artist said

Georgia O'Keeffe. *Black Place II.* Oil on canvas, 23⅞ x 30″. The Metropolitan Museum of Art, New York, Alfred Stieglitz Collection, 1949 (59.204.1)

looked like "a mile of elephants." In a large series of paintings spanning the 1940s O'Keeffe interpreted this scene both panoramically and in close-up views that repeatedly featured the juncture of two particular hills. Her most intensive work on this subject was done between 1944 and 1945, when about seven canvases were completed, but she continued to reprise this motif as late as 1949 in large, and considerably more abstract, pictures. In one of these, *Black Place, Grey and Pink* (1949; plate 70), painted the year she moved permanently to New Mexico, the tension and darkness that had characterized the earlier versions have dissipated into an ethereal vision.

Among the most potent New Mexico images to emerge in O'Keeffe's work of the 1930s were those involving animal bones. After she shipped a barrel of bones to New York in 1930, O'Keeffe began to paint their sun-bleached surfaces, jagged edges, and irregular openings in numerous guises. Stieglitz also photographed O'Keeffe with these bones, as if they said something significant about the artist. Some of the first paintings were detailed renderings of isolated animal skulls, usually floating in a darkened space and sometimes adorned with the fabric flowers she had collected in New Mexico. The Museum's small, eerie painting *Horse's Skull with White Rose* (plate 44) and its companion piece, *Horse's Skull on Blue* (Collection Arizona State University, Tempe), both from 1931, are two of the earliest studies and were probably painted at Lake George. The same year, O'Keeffe produced her monumental skull paintings *Cow's Skull: Red, White and Blue* (The Metropolitan Museum of Art, New York) and *Cow's Skull with Calico Roses* (The Art Institute of Chicago), in which similar motifs are enlarged and elaborated. For O'Keeffe the bones symbolized the eternal beauty of the desert: "To me they are as beautiful as anything I know. To me they are

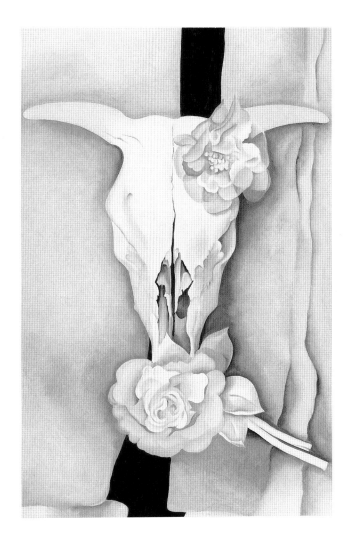

Georgia O'Keeffe. *Cow's Skull with Calico Roses.* 1932. Oil on canvas, 35⅞ x 24". The Art Institute of Chicago, Gift of Georgia O'Keeffe, 1947.712

strangely more living than the animals walking around. . . . The bones seem to cut sharply to the center of something that is keenly alive on the desert even tho' it is vast and empty and untouchable—and knows no kindness with all its beauty."[9]

Four years after the first skull pictures, O'Keeffe was combining skeletal and landscape imagery, with occasional floral additions, in the same composition and suggesting the relationship between the three disparate elements either through color, shape, or texture. The results were often provocative and unsettling, as in *Mule's Skull with Pink Poinsettias* (1936; plate 50). The odd discrepancies in the size and scale of the pictorial elements, and the symbolic meaning implied by their juxtaposition, led some to call O'Keeffe's work surreal. A decade later, her seven-foot-wide painting, *Spring* (1948; plate 66), represents a consolidation and summation of these ideas, rather than a search for new ones.

The bone motif was further developed in the large Pelvis series, containing about a dozen paintings produced between 1943 and 1945. In these works, and in a related abstract sculpture of 1945 (plate 86), O'Keeffe explored contrasts between convex and concave surfaces and between solid and open spaces. While the first works in the Pelvis cycle depicted the entire bone standing upright within a landscape setting, subsequent paintings, such as *Pelvis IV* (1944; plate 60), focused exclusively on the ovoid openings within the bones, through which only the sky, and sometimes the moon, could be seen. In a similar composition of the following year, *Pelvis Series, Red with Yellow* (plate 68), O'Keeffe deviated from the naturalistic coloring of the earlier works to produce a far more abstract statement in bold, vibrant colors. In December 1945 she wrote in a letter about "the blue and the red of the bone series": "It is a kind of thing that I do that makes me feel I am going off into space—in a way

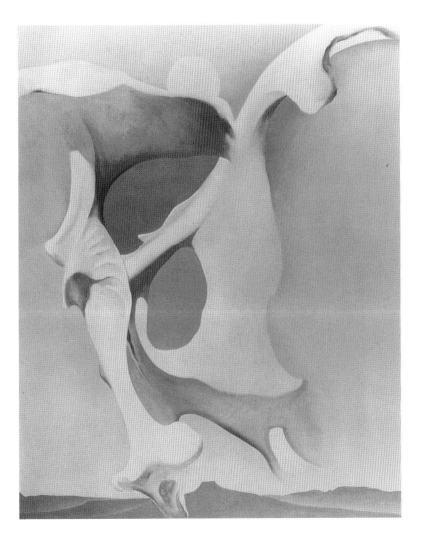

Georgia O'Keeffe.
Pelvis with Moon.
1943. Oil on canvas,
30 x 24″. Norton
Museum of Art, West
Palm Beach, Florida

that I like—and that frightens me a little because it is so unlike what anyone else is doing."[10]

In the same letter she noted, "I have sent my check to buy the Abiquiu house."[11] The house, on three acres of land, required three years of renovations before O'Keeffe could use it as her winter residence (the house at Ghost Ranch was kept as her summer home). Years later she recalled her attraction to the house: "When I first saw the Abiquiu house it was a ruin with an adobe wall around the garden broken in a couple of places by falling trees. . . . I found a patio with a very pretty well house and bucket to draw up water. It was a good-sized patio with a long wall with a door on one side. That wall with a door in it was something I had to have."[12] Doors had already been featured in other O'Keeffe works, such as *Little House with Flagpole* (1925; plate 31) and the Canadian White Barn series of 1932, but they had always been part of a larger architectural or landscape scene. Now, they became the central motif of her compositions and were featured in more than thirty patio pictures between 1946 and 1960, including a group of small black-and-white photographs she took about 1955.

Four pictures in the O'Keeffe Museum, dating from 1946 to 1956, document the artist's profound fascination with the Abiquiu patio doors, which were painted either green or black. They illustrate some of the inventive variations she was able to derive from this simple motif. The earliest example, a small sketchbook page from 1946, is an engaging study of lights and darks, executed in soft graphite pencil (plate 61). Revealing her initial observations of the site, the sketch relates closely to a small, sun-drenched oil painting titled *In the Patio I* of the same year (San Diego Museum of Art). In both, the open door invites a shallow recession into the space through a series of rectangular portals. Thereafter, O'Keeffe painted the closed, exterior view of the patio doors.

43

In the Patio VIII (1950; plate 73), the most representational of the four patio paintings in the Museum, places the small green door in the context of its surroundings. Among the descriptive elements included are two that relate this work to other O'Keeffe paintings from the 1950s and 1960s. The first element, a large, triangular diagonal shadow, finds parallels with the Black Bird series of the same year, in which two black diagonals form the V shape of a bird in flight. In other patio paintings, such as *Patio Door with Green Leaf* (1956; plate 76), the patio wall itself, not just the shadow, is on a diagonal. Of greater consequence to O'Keeffe's thematic development is the second element: the painting's cloud-filled blue sky, which evolved in the 1960s into a separate series of large paintings, titled *Sky Above Clouds*.

A very different interpretation of the patio subject is presented in *My Last Door* (1954; plate 74)—misleadingly titled since several more patio paintings followed over the next six years. Painted on a mural-size canvas, this image is one of several that are highly reductive and two-dimensional—totally abstract and formal arrangements of geometric shapes and colors. Here, the rectangular black door floats in the center of a long white field, framed top and bottom by two thin grey bands denoting the sky above the wall and the patio walk below. The simplicity of the image and the large size of the canvas produce a tranquil, meditative effect that echoes the mood of the artist as she faced life in New Mexico after Stieglitz's death.

With her release from the obligations that had continued to bring her back East, O'Keeffe traveled more widely around the world in the 1950s and 1960s. Flying in airplanes inspired two of her last major subjects—aerial views of rivers seen from a great height and expansive sky paintings viewed from just above the clouds. During the years when she made *Drawing V* (1959; plate 80)—a study for the painting *Blue, Black, and Grey* (1960; Collection Mr. and Mrs. Gilbert H. Kinney)—*Tan, Orange, Yellow, Lavender* (c. 1959; plate 81), and *Pink and Green* (1960; plate 82), O'Keeffe traveled extensively to the Far East, Southeast Asia, India, the Middle East, and Europe. The abstract pictures these trips inspired harked back to her earliest charcoal drawings and watercolors of 1915–16, as well as to her 1941 description of looking out of an airplane window: "It is breathtaking as one rises up over the world one has been living in . . . and looks down at it stretching away and away. The Rio Grande—the mountains—then the pattern of rivers—ridges—washes— roads—fields—water holes—wet and dry—Then little lakes—a brown pattern—then after a while as we go over the Amarillo country, a fascinating restrained pattern of different greens and cooler browns."[13] In all, she made about a dozen aerial river paintings between 1959 and 1960 that also recall her colorful, painterly depictions of trees with their meandering branches.

The most dramatic paintings of O'Keeffe's later years were the seven Sky Above Clouds pictures she produced between 1962 and 1965, which thrust the viewer into the upper reaches of the atmosphere. Each canvas was divided into two registers, with clouds below and atmosphere above. While the first work, from 1962, was extremely minimal, the others, such as *Sky Above Clouds I* (plate 84) from a year later, were enlivened by a rich pattern of puffy white clouds in the lower register that leads the eye back into space. O'Keeffe wrote about this change in composition: "One day when I was flying back to New Mexico, the sky below was a most beautiful solid white. It looked so secure that I thought I could walk right out on it to the horizon if the door opened. The sky beyond was a light clear blue. It was so wonderful that I couldn't wait to be home to paint it. . . . The next time I flew, the sky below was completely full of little oval white clouds, all more or less alike. The many clouds were more of a problem."[14] In *Sky Above Clouds I*, we see O'Keeffe's tentative

44

attempts to re-create her impression of these "many clouds." Roughly brushed, with areas of canvas left unpainted around the clouds, the picture is more of a working sketch than a finished painting. By 1965, however, she had successfully expanded this motif on a monumental canvas measuring twenty-four feet in length. It was an enormous challenge for any artist but a special feat for one nearing eighty years of age.

Among the last subjects O'Keeffe undertook before poor eyesight curtailed her working entirely were the Black Rock pictures of the early 1970s. In color and shape these paintings relate to her smaller alligator-pear (avocado) pictures from the early 1920s. They also anticipate the clay pots that she and her new assistant, Juan Hamilton, made about 1973. *Black Rock with Red* (1971; plate 85), like the others in this series, is a simple still-life arrangement featuring a single, smooth, pear-shaped stone sitting majestically on top of a cut tree stump. The rocks in these works had been collected during several rafting trips down the Colorado River, the first of which was taken when the artist was in her early seventies. O'Keeffe later noted that "the black rocks from the road to the Glen Canyon dam seem to have become a symbol to me—of the wideness and wonder of the sky and the world. They have lain there for a long time with the sun and the wind and the blowing sand making them into something that is precious to the eye and hand."[15] It was the same symbolic meaning that forty years earlier had drawn her to the bleached-white animal bones of the New Mexico desert.

That O'Keeffe's last paintings should recall works from decades before is not surprising. There had always been an amazing continuity in her art, as visual ideas and images were constantly worked and reworked in a cyclical pattern of self-evaluation that led to new discovery. Through this process O'Keeffe came to understand and appreciate the world around her and find fulfillment in a life that had almost totally revolved around her art. Painting, she once said, "is like a thread that runs through . . . all the other things that make one's life."[16]

1. Georgia O'Keeffe, *Georgia O'Keeffe* (New York: Viking Press, 1976), opp. pl. 52.
2. Ibid., opp. pl. 13.
3. O'Keeffe to Sherwood Anderson, c. September 1923, reprinted in Jack Cowart, Juan Hamilton, and Sarah Greenough, *Georgia O'Keeffe: Art and Letters* (Washington, D.C.: National Gallery of Art, 1987), p. 173 (no. 29).
4. O'Keeffe, *O'Keeffe* (1976), opp. pl. 34.
5. Ibid., opp. pl. 23.
6. O'Keeffe to Henry McBride, summer 1929, reprinted in Cowart, Hamilton, and Greenough, *Art and Letters*, p. 189 (no. 44).
7. O'Keeffe, *O'Keeffe* (1976), opp. pl. 84.
8. O'Keeffe to Arthur Dove, September 1942, reprinted in Cowart, Hamilton, and Greenough, *Art and Letters*, p. 233 (no. 83).

9. Georgia O'Keeffe, "About Myself," in *Georgia O'Keeffe: Exhibition of Oils and Pastels* (New York: An American Place, 1939), n.p.
10. O'Keeffe to Caroline Fesler, December 24, 1945, reprinted in Cowart, Hamilton, and Greenough, *Art and Letters*, pp. 242–43 (no. 92).
11. Ibid., p. 243.
12. O'Keeffe, *O'Keeffe* (1976), opp. pl. 82.
13. O'Keeffe to Maria Chabot, letter written in midair, November 1941, reprinted in Cowart, Hamilton, and Greenough, *Art and Letters*, p. 231 (no. 81).
14. O'Keeffe, *O'Keeffe* (1976), opp. pl. 106.
15. Ibid., opp. pl. 107.
16. Quoted in Lee Nordness, *Art USA Now* (Lucerne, 1962), reprinted in Laurie Lisle, *Portrait of an Artist: A Biography of Georgia O'Keeffe* (New York: Seaview Books, 1980), p. 404.

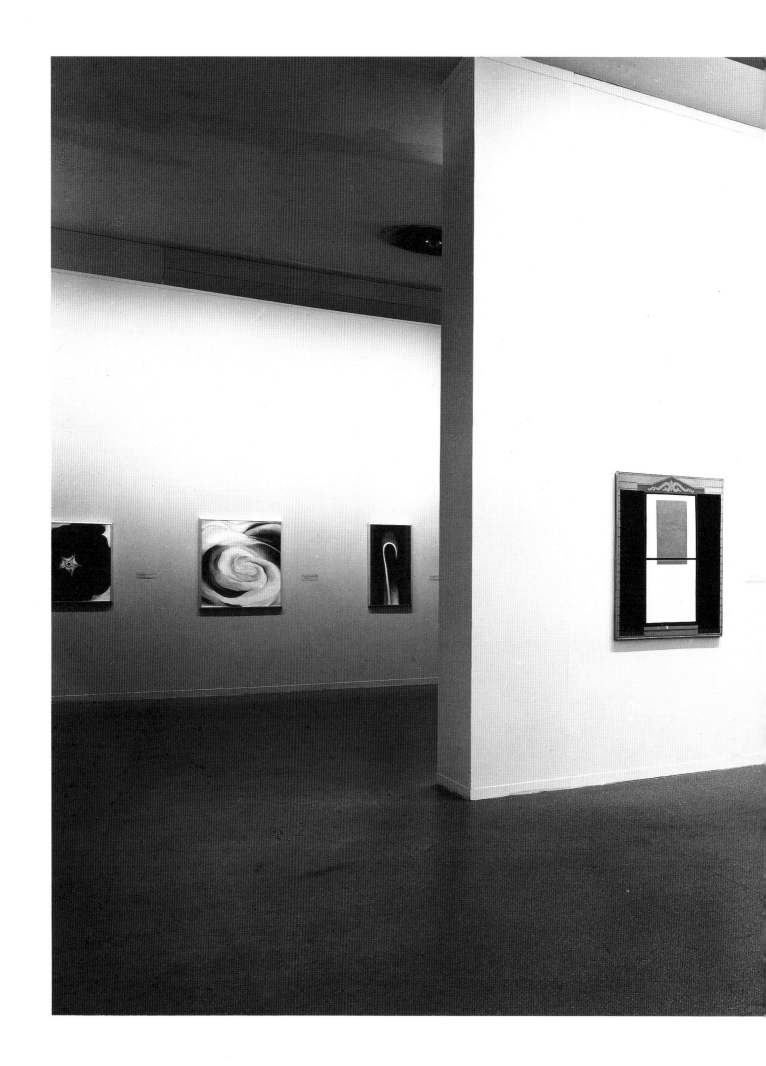

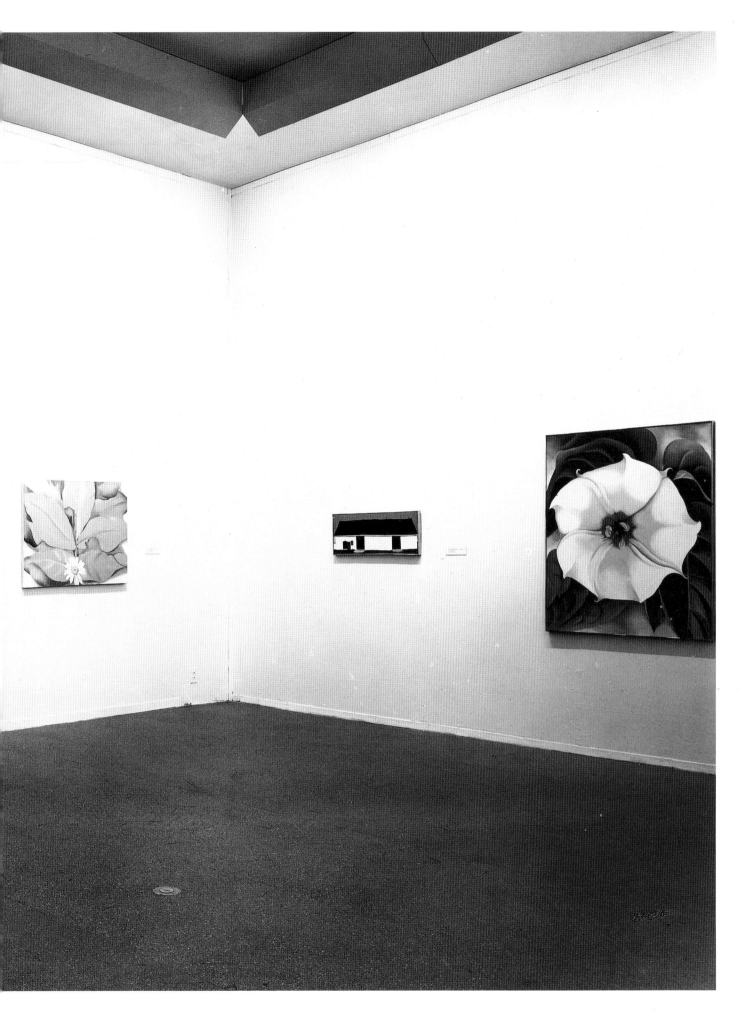

Installation View of the Exhibition "Georgia O'Keeffe." The Museum of Modern Art, New York, May 14, 1946, through August 25, 1946

right:
Ansel Adams.
*Georgia O'Keeffe,
Sketching.* 1937.
The Ansel Adams
Publishing Rights
Trust, Carmel,
California

below:
*Georgia O'Keeffe
Touching up a
Painting in the 1966
Retrospective
Exhibition.* 1966.
Courtesy Amon
Carter Museum
Archives, Fort
Worth, Texas

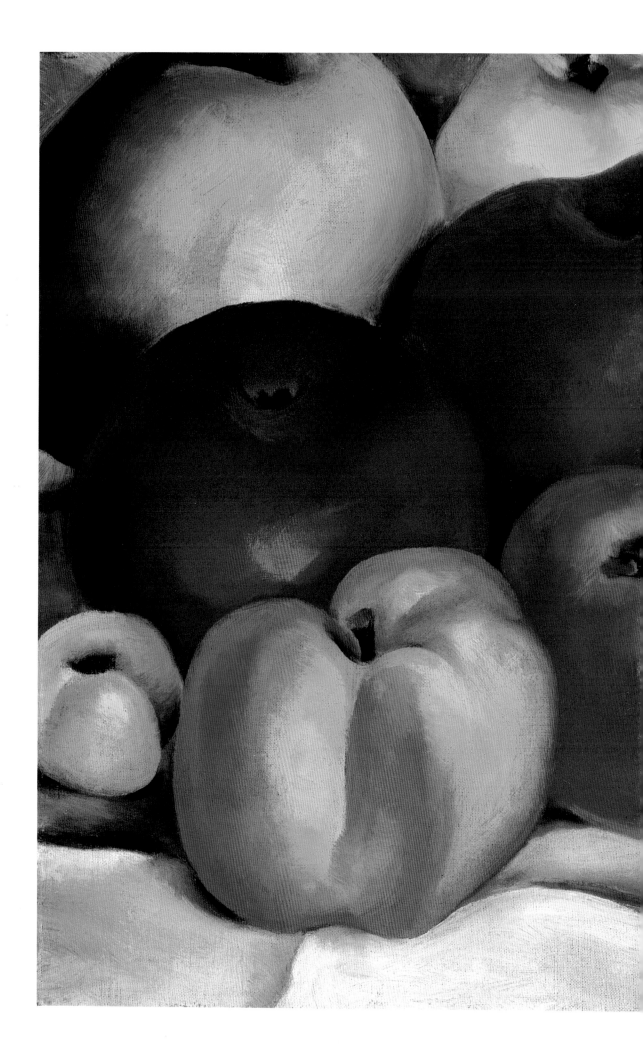

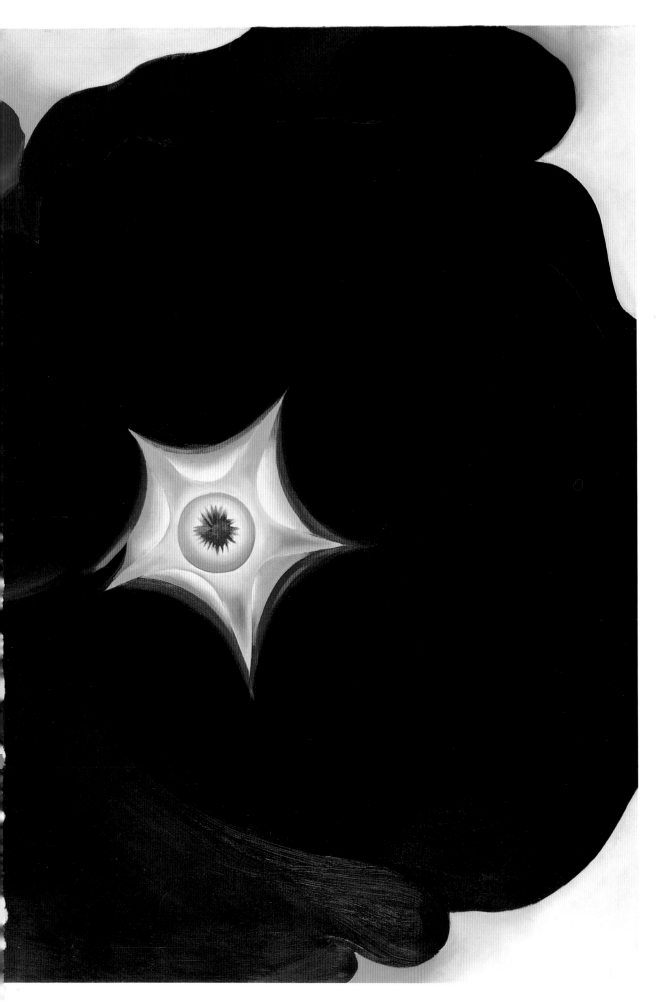

28. *Black Hollyhock with Blue Larkspur.* 1929. Oil on canvas, 29¾ x 40″.
Extended loan, private collection

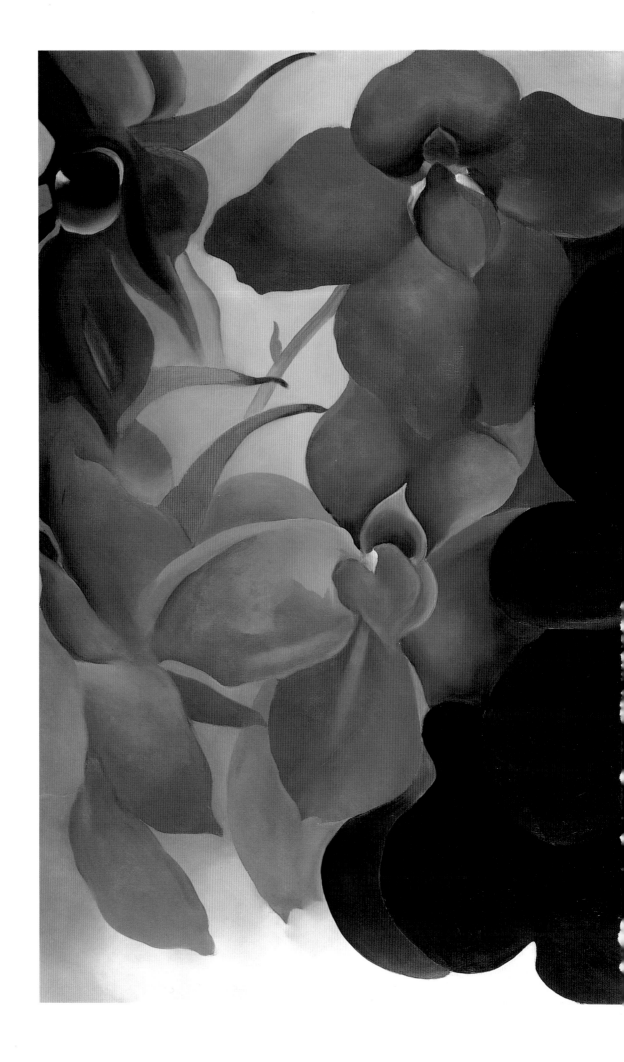

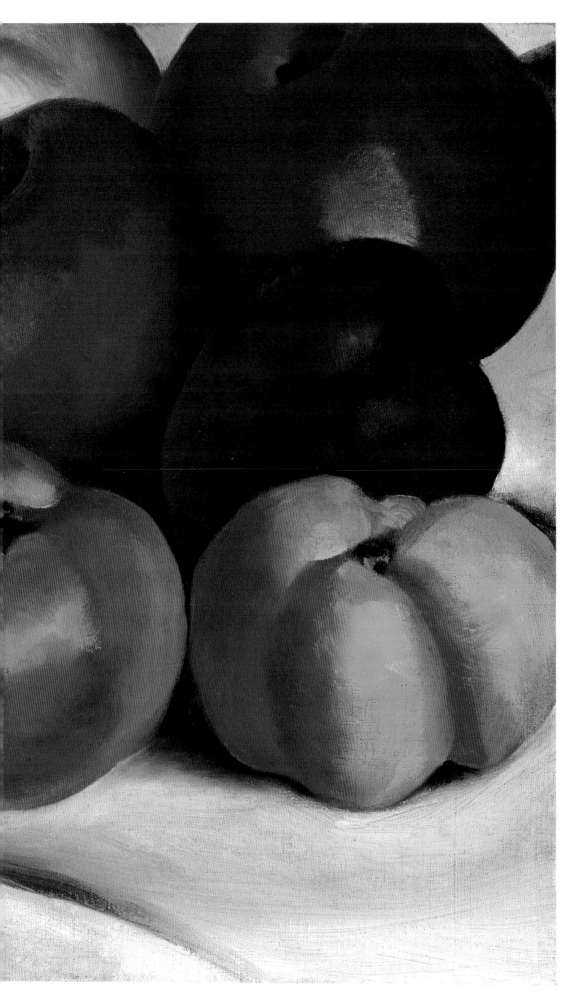

27. *Apple Family II.* c. 1920. Oil on canvas, 8 x 10⅛".
Gift of The Burnett Foundation and The Georgia O'Keeffe Foundation

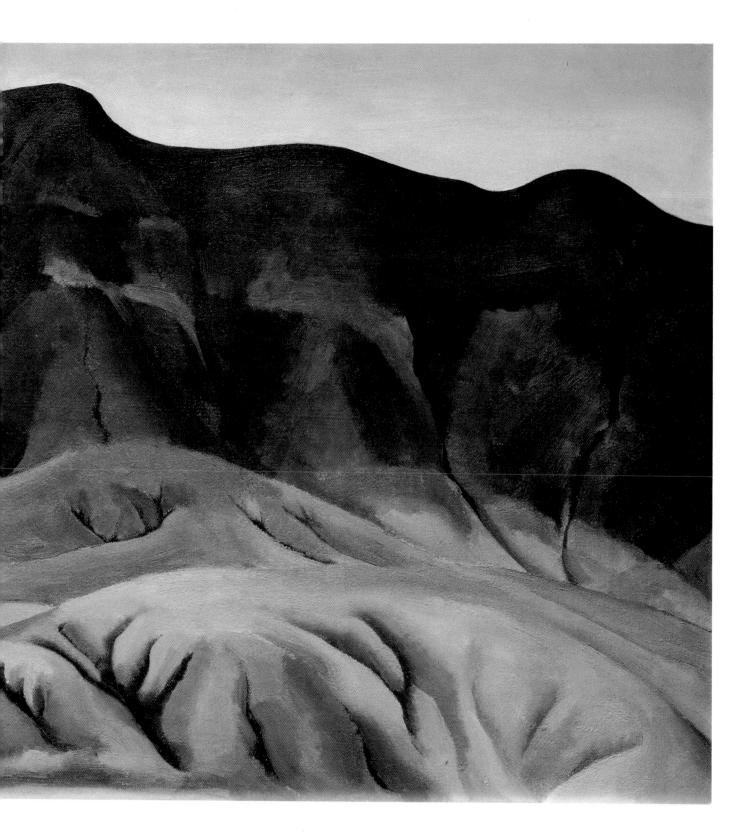

30. *Purple Hills II, Ghost Ranch, New Mexico.* 1934. Oil on canvas, 16¼ x 30¼″.
Gift of The Burnett Foundation

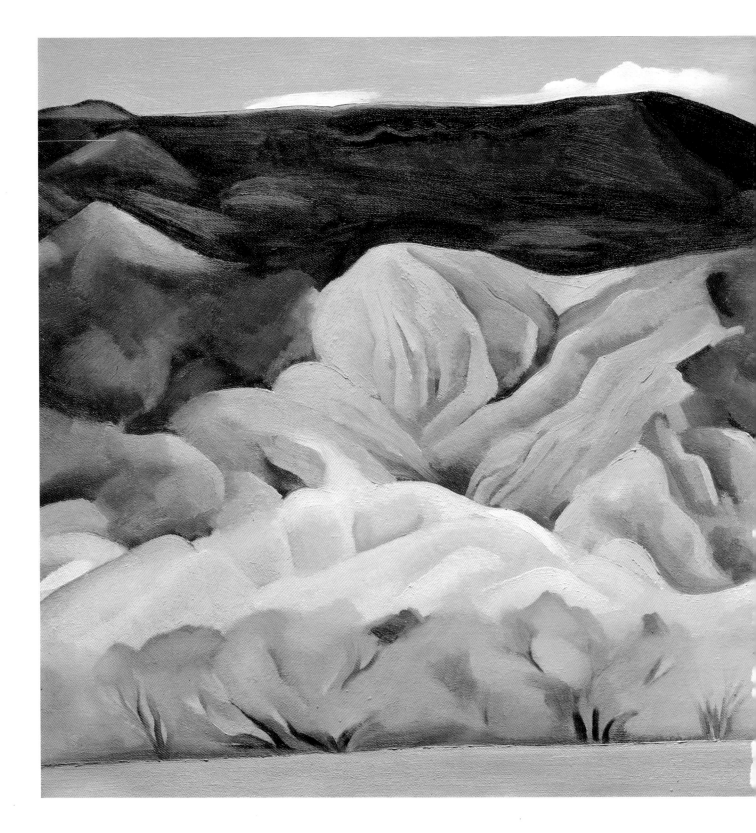

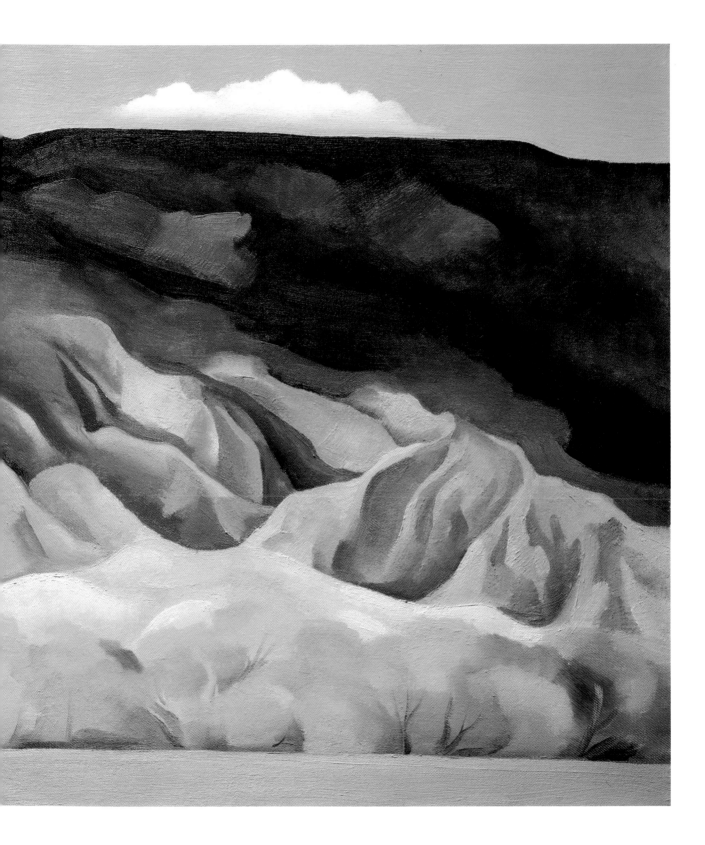

29. *Out Back of Marie's II*. 1931. Oil on canvas, 16 x 30″.
Gift of The Burnett Foundation

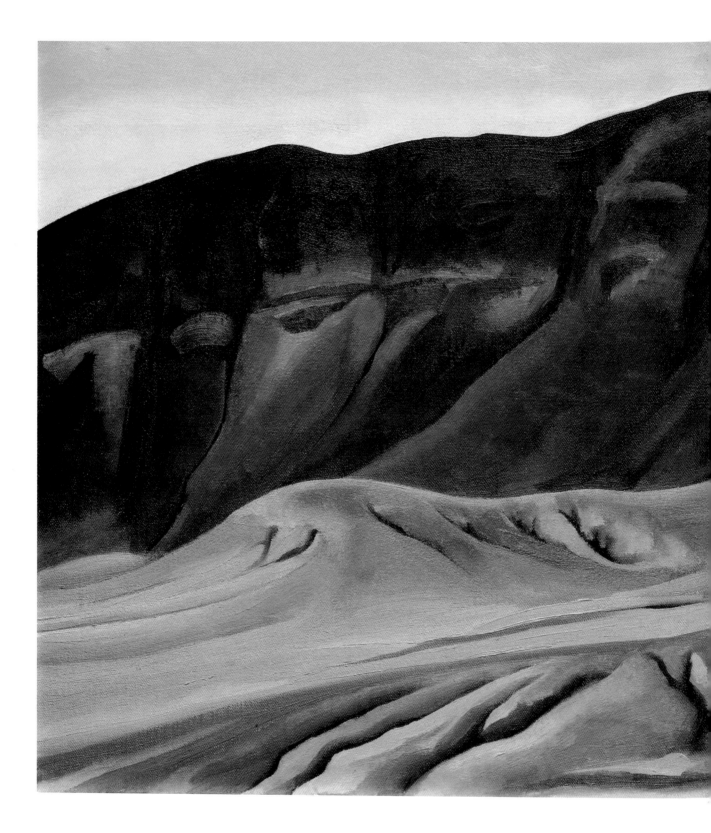

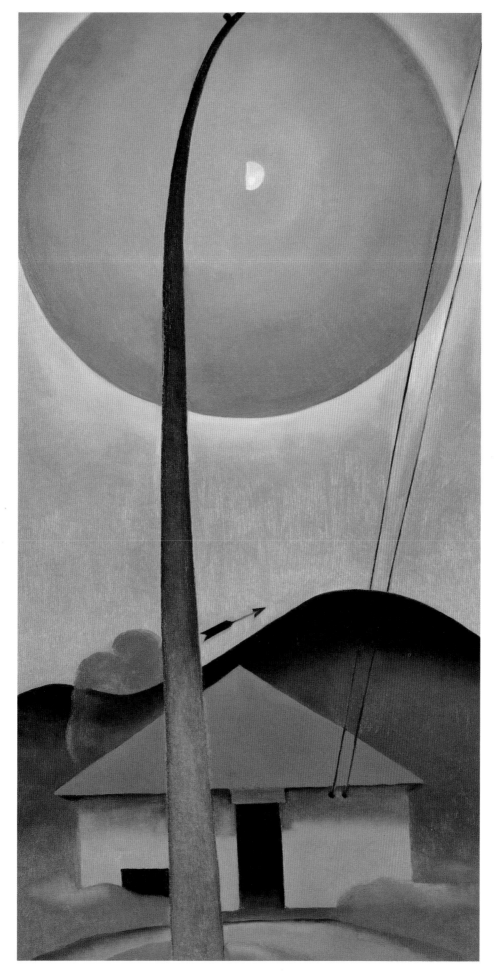

31. *Little House with Flagpole*. 1925. Oil on canvas, 35 x 17⅛″.
Gift of The Burnett Foundation and anonymous donor

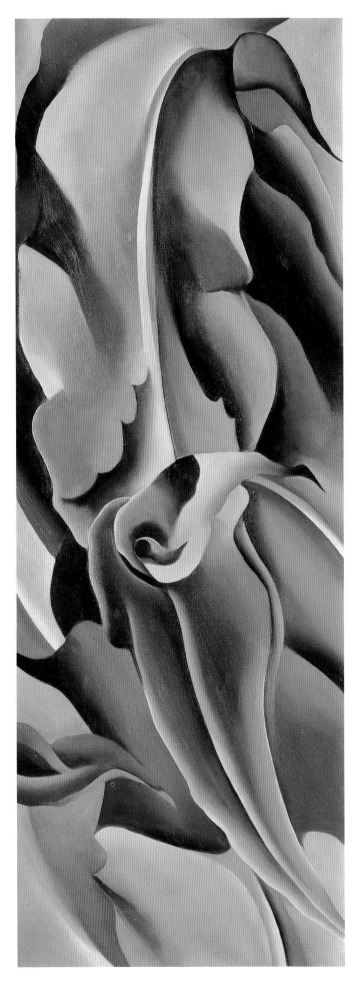

32. *Corn II*. 1924. Oil on canvas, 27¼ x 10″.
Gift of The Burnett Foundation and The Georgia O'Keeffe Foundation

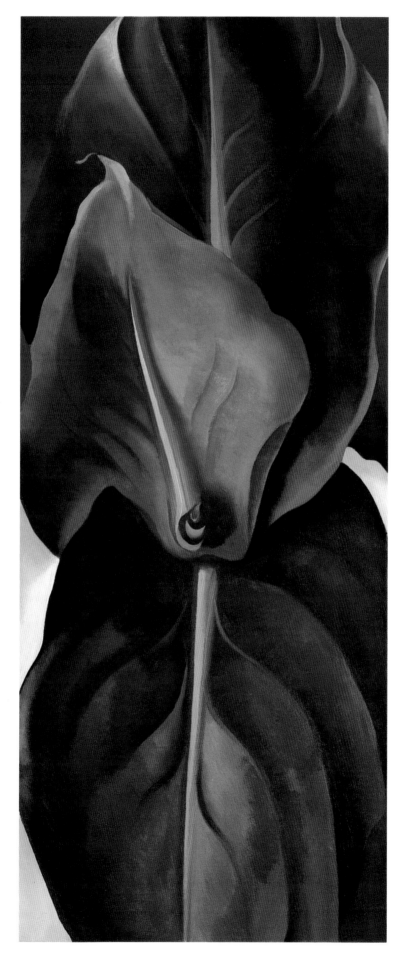

33. *Canna Leaves.* 1925. Oil on canvas, 26 x 11″.
Gift of The Burnett Foundation

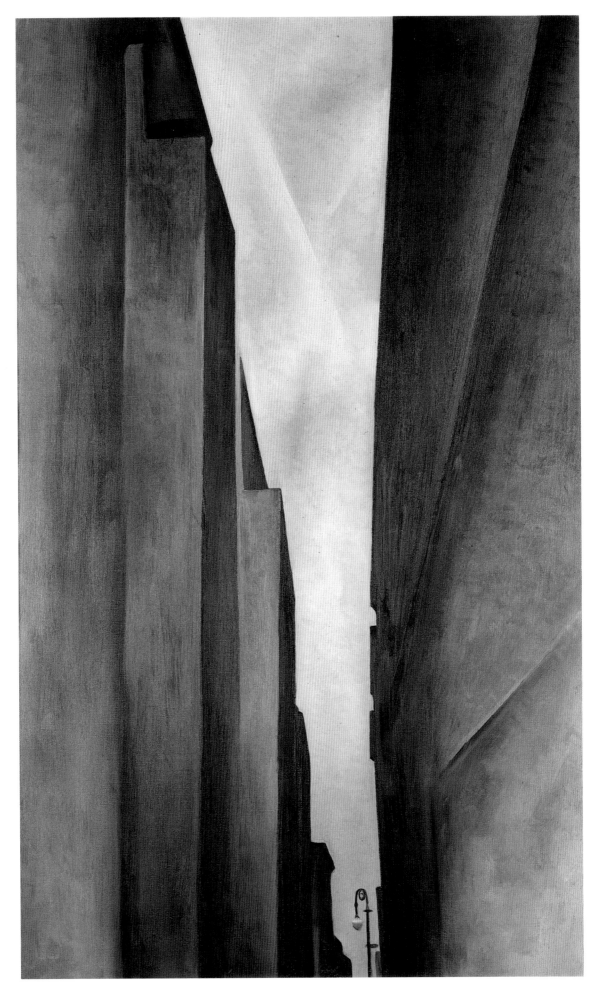

34. *Street, New York I.* 1926. Oil on canvas, 48⅛ x 29⅞".
Gift of The Burnett Foundation

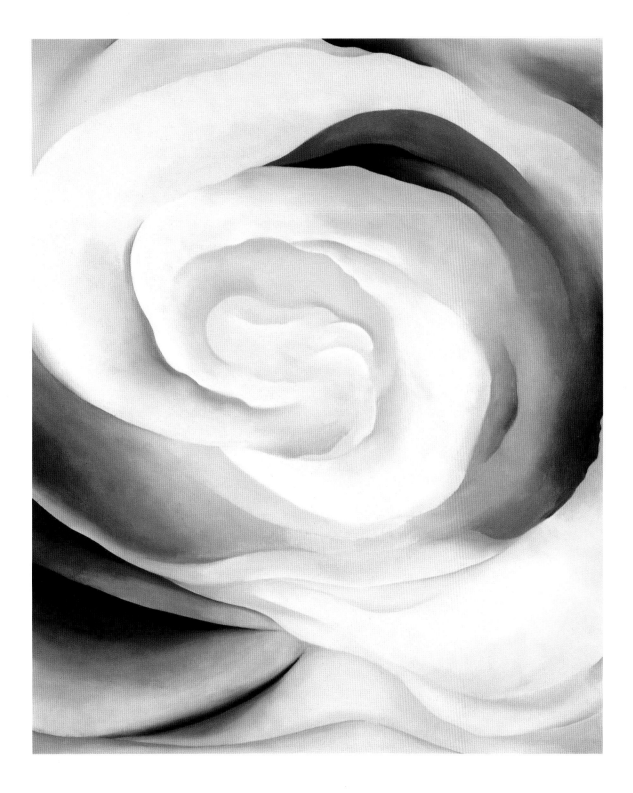

35. *Abstraction, White Rose II.* 1927. Oil on canvas, 36¼ x 30″.
Gift of The Burnett Foundation and The Georgia O'Keeffe Foundation

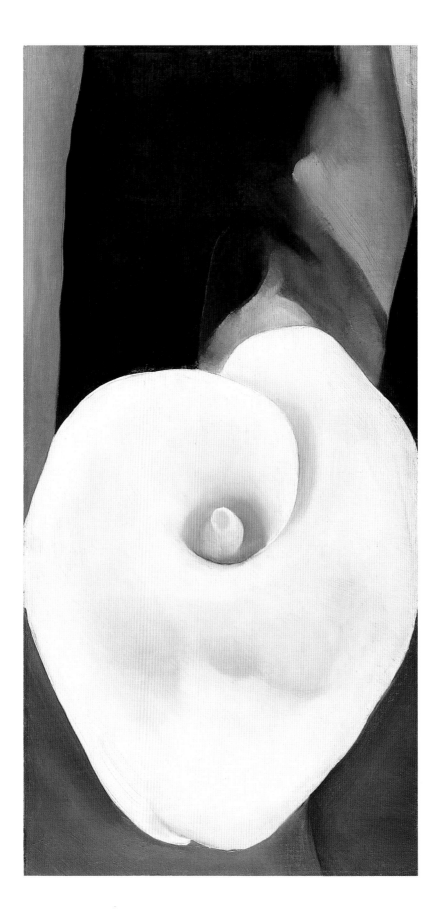

36. *Calla Lily, White with Black.* 1927. Oil on canvas board, 12 x 6".
Gift of Eugene and Clare Thaw

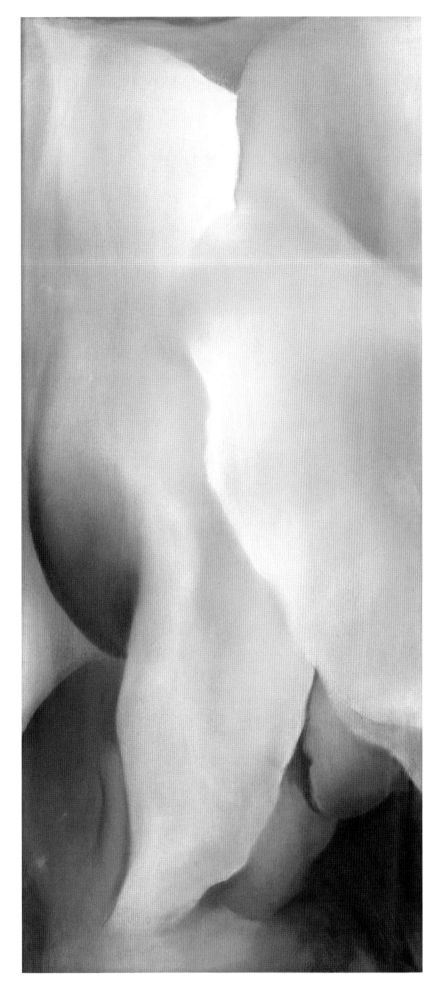

37. *Dark Iris III.* 1927. Pastel on paper-covered board, 20 x 9″.
Gift of The Burnett Foundation and The Georgia O'Keeffe Foundation

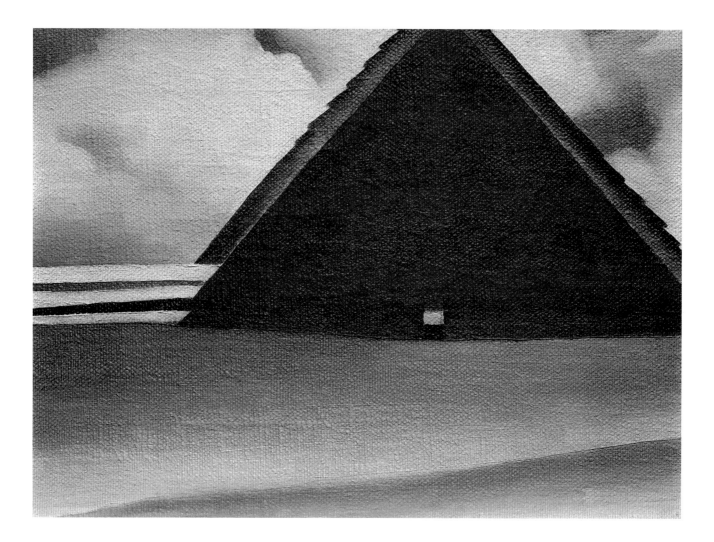

38. *Wisconsin Barn.* 1928. Oil on canvas-covered board, 9 x 12".
Gift of The Burnett Foundation

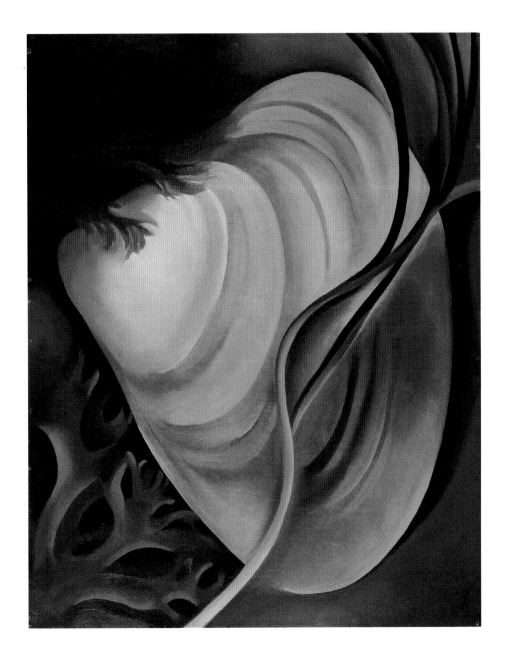

39. *Shell II*. 1928. Oil on board, 9¼ x 7¼".
Gift of The Burnett Foundation

40. *Cross.* 1929. Pencil on paper, 10 x 6⅜″.
Gift of The Burnett Foundation

41. *Ranchos Church.* 1929. Pencil on paper, 6⅜ x 10″.
Gift of The Burnett Foundation

42. Bell, Cross, Ranchos Church, New Mexico. 1930. Oil on canvas, 30 x 16″.
Gift of The Burnett Foundation

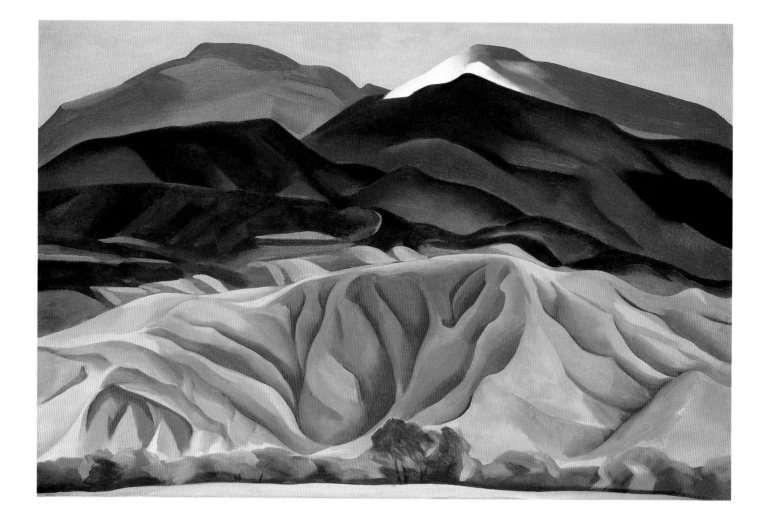

43. *Out Back of Marie's II.* 1930. Oil on canvas, 24¼ x 36¼".
Gift of The Burnett Foundation

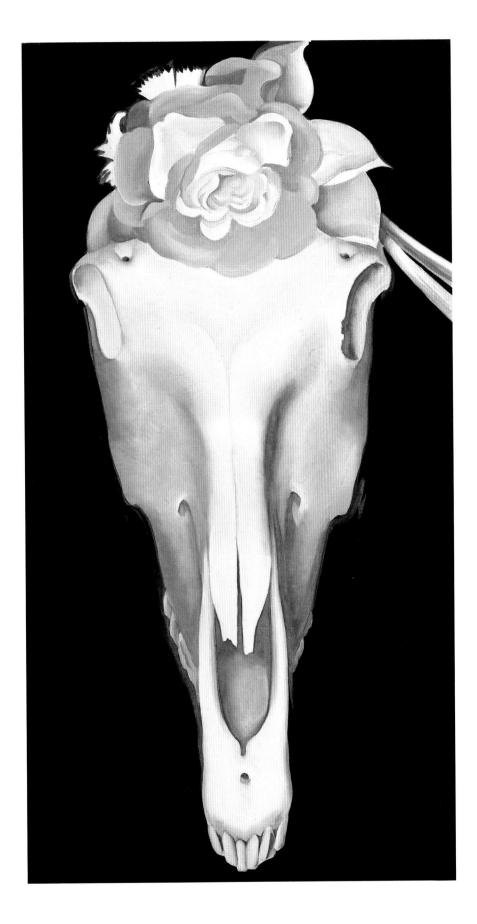

44. *Horse's Skull with White Rose.* 1931. Oil on canvas, 30 x 16⅛".
Extended loan, private collection

45. *Blue-Headed Indian Doll.* 1935. Watercolor on paper, 21 x 12⅛".
Gift of The Burnett Foundation

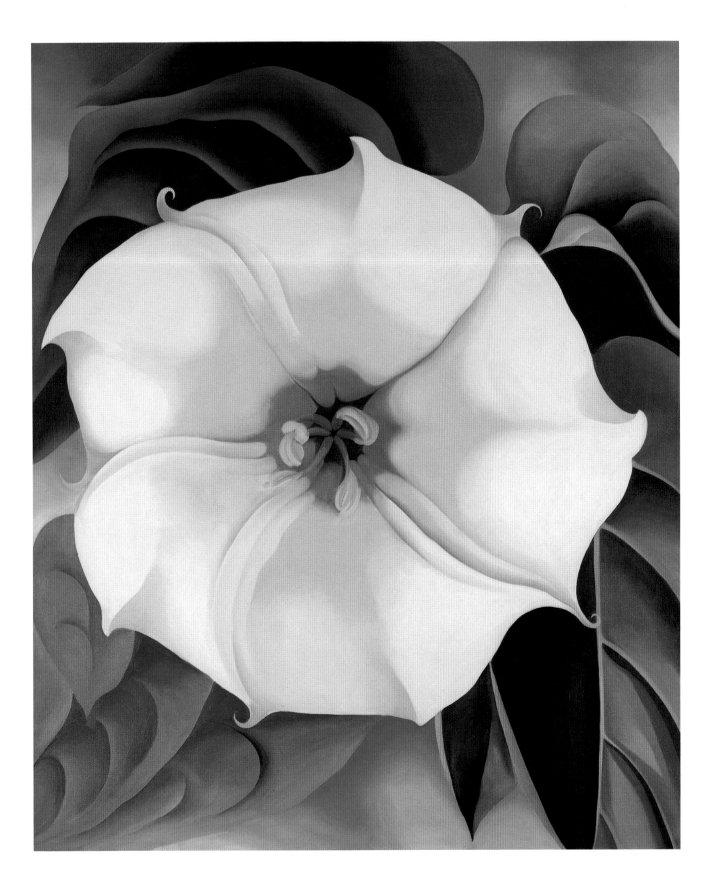

46. *Jimson Weed.* 1932. Oil on canvas, 48 x 40".
Gift of The Burnett Foundation

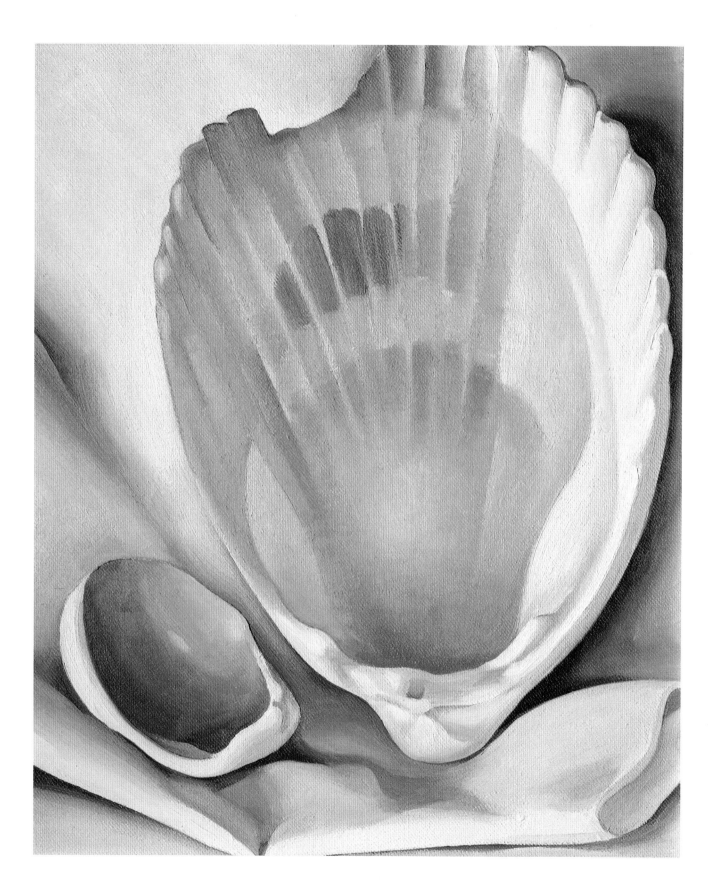

47. *Broken Shell, Pink.* 1937. Oil on canvas, 12 x 10″.
Gift of The Burnett Foundation and The Georgia O'Keeffe Foundation

Georgia O'Keeffe and American Intellectual and Visual Traditions

BARBARA NOVAK

WHEN ALFRED STIEGLITZ mounted an exhibition of Georgia O'Keeffe's work in 1923, he called it "Georgia O'Keeffe, American."[1] Stieglitz's billing of O'Keeffe as an "American" artist has been attributed partly to his rumored proclivity for Barnumesque hype and partly to a nativist reaction against the strong French influence of the previous four decades. Yet presenting O'Keeffe as a specifically American—as well as modernist—artist calls up complexities that knit her work, from its beginnings, into American art and culture.

This raises the rather bedeviled issue of whether one can speak (in the midst of a postmodern era wary of easy continuities) of an American tradition. "The painter as soon as he begins to paint almost unconsciously assumes himself the honored or unappreciated present representative of a glorious past tradition," O'Keeffe wrote.[2] Nonetheless, the word *tradition* is multivalent and its definition ultimately depends on making important cultural distinctions. Visual traditions, like tracks in the snow, can be traced variously, most frequently through subject, form, idea, process or procedure, and cultural context. In America (as I have proposed elsewhere)[3] tradition is not readily handed on from one artist to another. Rather, it would seem, American artists go back to the beginning, to rehearse and isolate similar problems, arriving at similar solutions in new contexts. Thus, instead of the genealogical chain of serial influences commonly read into European art, the visual tradition in America tends to inscribe multiple parallel lines along a broad cultural plane.

O'Keeffe locates herself in that parallel progression on not one but several planes. In subject: in the genres of American flower painting, landscape painting, and Western art. In form: on a plane that extends from the conceptual/pragmatic mix of John Singleton Copley, Martin Johnson Heade, and the luminists into Winslow Homer and ultimately her own Stieglitz circle, primarily Arthur Dove and Charles Demuth. In idea: from the nature wonder of the Hudson River and luminist landscapists into the concurrent transcendentalism of Ralph Waldo Emerson, Henry David Thoreau, and nineteenth-century spiritualism and on into the modernist involvement with theosophy. Her concern with nature and with the idea of nature as a spiritual repository echoes nineteenth-century thinking and practice. Her modernism adds a Freudian-inflected awareness of gender and sexual desire.

Even her complex gender-shifting had distinguished nineteenth-century antecedents: Emily Dickinson's attachment to Sue Gilbert, Margaret Fuller's proclamation that it was as easy to love a woman as a man. These women are, I feel, her natural ancestors—Fuller with her extraordinary intellectual independence and concern for what the nineteenth century sometimes capitalized as Mind, in this case, woman's Mind;[4] Dickinson with

her total devotion to making her art, poetry, speak for the elusive, mutable ocean of the Self. O'Keeffe's special affinity as an artist for nuances of white (she called a favorite painting venue "The White Place") calls to mind Emily's ubiquitous and symbolic white dress.

O'Keeffe usually preferred to wear black, but her art itself (even when richly colored) has the purity of white. Melville's exegesis on the whiteness of the whale seems relevant: "But not yet have we solved the incantation of this whiteness, and learned why it appeals with such power to the soul . . . is it that . . . it shadows forth the heartless voids and immensities of the universe . . . ?"[5] Was Stieglitz echoing Melville when, awed by O'Keeffe, he wrote, "Georgia is a Wonder—Truly an artist. If there ever was a Whiteness she is that— . . ."?[6] The whiteness to which he refers can be attached to the artist's persona, to the blinding whiteness of the skin he photographed so obsessively, and to the art.

If the American tradition may be described as a series of interruptions shunting in parallel fashion forward and backward, guided by unconsciously accepted notions of pragmatic and conceptual processes, O'Keeffe's art assumes a natural consonance with that tradition and inserts into it a strong measure of intuition. Her description of her methods emphasizes her trust in intuitive données: "That memory or dream thing that I do . . . for me comes nearer reality than my objective kind of work."[7] Often treated condescendingly as a "woman's trait" by male observers, intuition was also part of the European emphasis on the unconscious that ran through Dada and early Surrealism, to which O'Keeffe was exposed through Stieglitz in the early days of the 291 gallery. Her respect for intuition was reinforced, I suspect, by the exaltation of intuitive experience in nineteenth-century transcendentalism.

A self-reflexive, intuitive pragmatism, exercised in the most natural way, was, to my mind, a large part of what motivated her. "The men," as she called them, could talk all they wanted about Cézanne. But when O'Keeffe painted apples, they were her own apples, and as Henry James remarked, the apple of America "is a totally different apple."[8] The key words here are *her own*. O'Keeffe was the ultimate Emersonian self-reliant soul. She articulated that soul in forms that were so much a part of her locus, so culturally and artistically deictic, that she was, indeed, modern and American. A European hero of hers (and of the Abstract Expressionists later on) was Wassily Kandinsky, whose *On the Spiritual in Art* she read at least twice, absorbing it, I feel, as a personal Bible. From its theosophical roots she constructed, involuntarily perhaps, a bridge back into American nineteenth-century spiritualism. Like Kasimir Malevich, whose *White on White* may also be cited along with O'Keeffe's white subtleties, she might have found much to sympathize with in a theosophy that believed, along with Helena Petrovna Blavatsky and the Kabbalists, that "a stone becomes a plant; a plant, a beast; the beast, a man; a man a spirit, and the spirit a god."[9]

If, theosophically speaking, she had ever been a flower, it would not be surprising. When her good friend Demuth made his floral portrait of her, she became a spiky sansevieria, a snake plant, with little soft or delicate about it. Yet her intimacy with flowers, her sexual involvement and identification with them, speak to still another O'Keeffe. With her many ties to several traditions, O'Keeffe was a multiple person. She was prickly, thorny, dangerous, powerful. She was also fragile and vulnerable, womanly in her classic (and perhaps by now somewhat clichéd) identification with the generative earth. The curved, pulsing rhythms of her floral portraits attest to her affinities with the most basic organic principles. She was also moved by natural beauty in an almost nineteenth-century way. Despite her canonical paintings of New York skyscrapers, she made the same distinctions

between city and country living as had the nineteenth-century critics. "I was never a city person," she wrote, "always a country person."[10]

•

The American flower-painting tradition to which O'Keeffe made a major contribution can be traced back to the eighteenth-century plant gatherer and recorder Mark Catesby, whose magnificent magnolias are antecedent to Heade's waxen white beauties, the sinuous splendor of which look forward to O'Keeffe. Johan Huizinga has written eloquently of the dangers of taking a figure out of his or her historical period to become simply a forerunner, but neither Catesby nor Heade can be lessened by a comparison to O'Keeffe.[11] All three were specially attuned to the generative forces of seed, stem, and flower.

There was also in the nineteenth century what may be called a "popular tradition of flower culture"; it included the genteel preoccupations of the so-called lady-painters (Homer's mother was a very fine one) as well as the sentimental floral dictionaries so popular at the time. O'Keeffe's painting *Black Hollyhock with Blue Larkspur* (1929; plate 28) might have been interpreted by an 1844 floral dictionary as a combination of Fecundity (Hollyhock) and Levity (Larkspur).[12] The nineteenth century's concern with the botanical sciences also shows in the Hudson River painters' preoccupation with Isaac Sprague's botanical illustrations, often found on their library shelves in books by Asa Gray, Darwin's chief American supporter.

Within the more formal academic tradition, women artists in the latter part of the nineteenth century, such as Fidelia Bridges and Maria Oakey Dewing, helped remove flower painting from the sentimental "lady-painter" rubric. But O'Keeffe removed it so thoroughly to the realm of "serious" art that she finally met "the men" on their own terms. Some feminist critics have celebrated her becoming, as Stieglitz put it, "finally a woman on paper."[13] They have also underlined the sexual and regenerative properties in her work, which have been seen as properly within the realm of Woman as Earth Goddess.[14] Yet O'Keeffe herself did not want to be known as a woman artist but simply as an artist.[15]

Insofar as her art has entered the national—and international—stage, she has indeed escaped gender categories. Her floral concerns, within a tradition that includes such male artists as Heade and Demuth, do not make her vulnerable to the sexist distinctions that might have encumbered her female antecedents in the nineteenth century. She masterfully lifted the category of flower painting out of its connotation of a sentimental women's pastime and brought it within the precincts of modernism. Yet for all that, what is claimed for O'Keeffe's flowers in much criticism is true: they are imbued with an essential feminine power that signifies fecundity.

The concern with essence had always been part of an American artistic tradition. Though O'Keeffe had access through Stieglitz's circle to Henri Bergson's ideas of élan vital, that vitalism was already present earlier in Heade's flower paintings; his orchids bristle with the new Darwinian energies. Before Darwin and his orchids, however, there were the energies of transcendentalism.

Emerson proclaimed in *Nature* (1836) that "the sensual man conforms thoughts to things; the poet conforms things to his thoughts. The one esteems nature as rooted and fast; the other, as fluid, and impresses his being thereon."[16] Thomas Cole, about the same time, was complaining that the American public preferred "things not thoughts."[17] The dialogue between thought and thing was sometimes perceived as antagonistic (in Cole's sense of the material versus the ideal within American culture at large). More often, it was perceived as

Martin Johnson Heade.
Giant Magnolias.
c. 1885–95. Oil on canvas,
15¼ x 24″. The R.W. Norton
Art Gallery,
Shreveport, Louisiana

relational, as when Emerson wrote, "I cannot greatly honor minuteness in details, so long as there is no hint to explain the relation between things and thoughts; no ray upon the *metaphysics* of conchology, of botany, of the arts, to show the relation of the forms of flowers, shells, animals, architecture, to the mind, and build science upon ideas. In a cabinet of natural history, we become sensible of a certain occult recognition and sympathy in regard to the most unwieldy and eccentric form of beast, fish, and insect."[18]

O'Keeffe's relation to the thought/thing meditations of her nineteenth-century artistic and philosophical forebears was complex. One of her earliest reviewers, Henry Tyrrell, in 1916, acknowledged her involvement in the issue when he wrote that her drawings were "alleged to be of thoughts, not things."[19] Her very process, inherently conceptual (whether we are dealing with her earliest symbolic abstract drawings or her later, more recognizably representational images), can be traced back, as I have suggested, to the earliest American artistic traditions.

In American art, thought has always superseded the optically perceived thing, unless subverted (as Ernst Gombrich has made clear) by substantial academic—read European—training. Though one of O'Keeffe's early teachers, William Merritt Chase, had claimed he would rather go to Europe than to Heaven, O'Keeffe seems to have been little affected by his Impressionist feeling for paint. Rather, as someone who had never been "in" Europe, she took what she needed from Europe early on, appropriating the ideas circulating in 291 and *Camera Work* when they coincided with her artistic and philosophical needs. Those needs, while thoroughly "modern," as Stieglitz would have had it, also found parallels in many of the formal and philosophical currents of the preceding century in America.

O'Keeffe's art, like that of the early American limners, the nineteenth-century folk painters, and such artists as Copley, Fitz Hugh Lane, Heade, and to a lesser extent Homer, can be said to have an American "look." That look is distinguished by a singular tropism to

76

the planar, a process that subordinates the optical to the conceptual, masking the artist's persona through a rejection of the directly subjective expressiveness of paint. Paint, as *matière*—as part of the material world—"dissolves," to use Emerson's term, and becomes, along with things, "an object of the intellect."[20] There is also in this look something of what has been called the "plain style." It is seen as readily in American decorative arts and couture as in painting, and a case can be made for it in other aspects of American culture, including literature and religion.

In mid-nineteenth-century paintings, this "look" was the perfect vehicle for transcendental thought, for the idea of the "fact" as the "end or last issue of spirit."[21] Emerson's *Nature*, of course, offers itself as the canonical Bible here. But Thoreau was also a major force in establishing the parameters of transcendental thinking as it was worked out by the artists of his moment and after. His habit of picking up small flowers and putting them into his "botany-box" was not so different from O'Keeffe's tendency to bring home bits of things—a clamshell from Maine, a wooden shingle, a "large blackish red hollyhock and some bright dark blue larkspur that immediately went into a painting—and then another painting." "I have picked flowers where I found them—have picked up sea shells and rocks and pieces of wood where there were sea shells and rocks and pieces of wood that I liked. . . . When I found the beautiful white bones on the desert I picked them up and took them home too. . . . I have used these things to say what is to me the wideness and wonder of the world as I live in it."[22]

This comment bears the diagnostic mark of pragmatism, that commonsensical response to the empirical experience that joins with the conceptual to put a signature on so much American art. Thoreau, much more the pragmatic observer than Emerson, once noted a squirrel "twirling apparently a dried apple in his paws, with his tail curled close over his back as if to keep it warm, fitting its curve."[23] O'Keeffe too observed a squirrel: "There was one small raspberry bush by the platform that had one raspberry once in a while. If I sat very still a squirrel would come and pick the berry. Turning it over with his neat little paws, he carefully took off one section at a time, eyeing me brightly as he ate the piece with its small seed. It was a very careful performance."[24]

For both Thoreau and O'Keeffe, pragmatic observation made thought tangible. O'Keeffe's reference to using "these things to say what is to me the wideness and wonder of the world as I live in it"[25] abandons nineteenth-century rhetoric, while nonetheless suggesting Thoreau's "every new flower that opens, no doubt, expresses a new mood of the human mind"[26] and Emerson's "occult relation between man and the vegetable."[27] Emerson's reference to the occult, his idea of "every natural fact" as a "symbol of some spiritual fact,"[28] is another reminder of the correspondences between transcendentalism and nineteenth-century spiritualism.

•

O'Keeffe's transcendental and spiritualist concerns would have been further fortified not only by the Stieglitz circle's admiration for Emerson and Thoreau as early exponents of ideas they valued and shared[29] but also by her reading of Kandinsky and by the spiritualist and theosophist ideas of her most important early mentor, Arthur Wesley Dow.[30] From Dow she could have absorbed a respect for Japanese planarism that reinforced in her art the planarism already present in earlier American painting. But she might have gained even more philosophically. Vincent van Gogh has eloquently reminded us that the Japanese artist spends his time studying "a single blade of grass." "Come now," he wrote, "isn't it almost a

true religion which these simple Japanese teach us, who live in nature as though they themselves were flowers?"[31] O'Keeffe studies the flower as the Japanese studied the blade of grass. Van Gogh envied the Japanese "the extreme clearness which everything has in their work. It is never tedious, and never seems to be done too hurriedly."[32]

I suspect he would have admired O'Keeffe's "extreme clearness" as well. It is, as he said of the Japanese, "as simple as breathing."[33] If there are correspondences between O'Keeffe's work and that of Asian artists—the Sung flower painters as well as the Japanese—connections can also be made to earlier parallels between Heade's flowers and Asian art as well as to the transcendental interest in Asian philosophy, primarily Persian and Indian.

As with Asian art and philosophy, much in O'Keeffe's work is essentially meditative. Like Thoreau, who so often looked Eastward in contemplation, finding in the Vedas "no grander conception of creation anywhere,"[34] O'Keeffe could readily have noticed that "the universe lies outspread in floods of white light to it. . . . There is no name for this life unless it be the very vitality of *vita.* Silent is the preacher about this, and silent must ever be, for he who knows it will not preach."[35] The silence of O'Keeffe's work seems especially evident in the "floods of white light" that embody her white flowers: *Abstraction, White Rose II* (1927; plate 35), *Belladonna—Hāna* (1939; plate 51), *An Orchid* (1941; Museum of Modern Art, New York). They are works that vibrate with that "very vitality of *vita.*"

That *vita* was evident to O'Keeffe not only in the flowers but in the rocks and hills of the Southwestern landscape. Like the transcendentalists before her, she was looking for "the feeling of infinity on the horizon line or just over the next hill" (*Red Hills with White Flower,* 1937; plate 65).[36] Thus, in engaging the expansive actualities of the vastly hollow Western space, her work connects as much to the earlier Western painters—to an Albert Bierstadt or a Thomas Moran—as to the more mental spatial infinities of the Concord philosophers.

The nineteenth-century landscape artists were on a quest to find Creation. Less rhetorically, O'Keeffe seems to have been searching for the same thing. Her comment "The unexplainable thing in nature that makes me feel the world is big far beyond my understanding—to understand maybe by trying to put it into form"[37] recalls Albert Pinkham Ryder's observation about trying to find something out there beyond the place on which he had a footing. But Ryder maintained a mental space that kept his infinities small in scale. O'Keeffe, on the other hand, took upon herself the grand scale of modernism. Even before the gargantuanism of Abstract Expressionism, she recognized the polemical importance of enlarging and magnifying her work, painting the small flower big so "they will be surprised into taking time to look at it."[38]

Yet the problematic of scale, or of size as scale, takes on ironic dimensions when we place the flower paintings next to the Western expanses. The flowers, writ large, gain extraordinary monumentality at the same time that the biological rhythms they embody gain power and vitality. To capture the immense infinity of Western space, however, was a problem that often defied the great Western artists. Bierstadt and Moran tried—at times simplistically—to equate size and scale, hoping that the panoramic extensions of their meticulous canvases would convey the infinities they sought. But Western space has always proved elusive. O'Keeffe sidestepped the problem in a way by making her Western landscapes only equal in size to her large flowers, and dealing more abstractly with Western space through a process that distilled the feeling of the "wide empty country" she had heard stories of while growing up in Wisconsin and experienced directly early in her career while teaching in Amarillo, Texas.

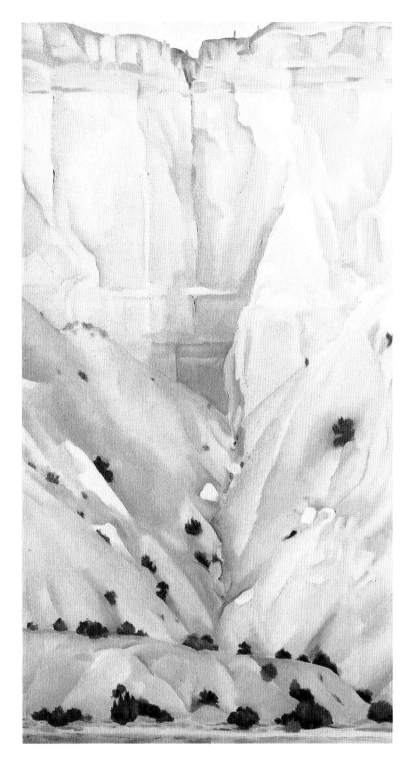

From the Plains I (1919; private collection), painted in New York after she first left the West, grasps the vast infinity of a Western sky as effectively in its curving rhythms of blue and white as had Bierstadt's skies earlier. *Cliffs Beyond Abiquiu,* painted years later (1943; The Cleveland Museum of Art), suggests enormity of scale through the vertical rise of the pink rock above the low horizon of earth and brush. There is no attempt at space here but rather that same close looking that presses the flowers against the picture plane. It seems clear that rocks, hills, and bones encompassed infinitudes for O'Keeffe at least as much as Western space itself. They represented those eons of time that for her Western predecessors had offered geological evidence of the Creator's hand.

79

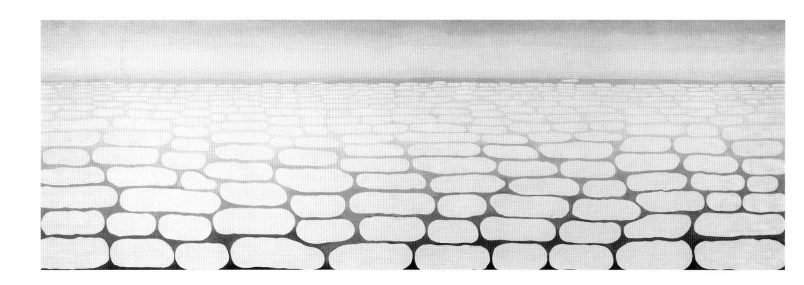

O'Keeffe's involvement with nature, in fact, remarkably mimicked nineteenth-century artistic concerns: the flower as a type of Creation in small, the rocks and hills of the West testifying to God's handiwork in layers of time and stone. Even her paintings of skies and clouds had a long history in the meteorologically preoccupied nineteenth century—from the cloud drawings that testify to obsession in the notebooks of the Hudson River artists, through the oil sketches of Frederic Church and Bierstadt, and into the powerful celestial symphonies of their larger, more ambitious works or the more modest ladders to heaven suggested by Heade's dwindling cumuli. The transcendentalist thinkers had, of course, delivered themselves of some memorable phrases on the subject. Emerson spoke of the sky as "the daily bread of the eyes."[39] Thoreau waxed poetic about "the fantastic feathery scrawls of gauze-like vapor" on the "elysian ground."[40]

Both O'Keeffe and Stieglitz converted this preoccupation with sky into a modernist idiom. O'Keeffe's earliest abstract watercolors may have inspired Stieglitz's extraordinary Song of the Skies series, which attempted, as had the nineteenth-century painters, to fix the transient moment, now utilizing a photographic instrument literally designed for that task. Yet in O'Keeffe's later Cloud series, the handling of these fleeting celestial signatures was still more unique. Where the nineteenth-century painters had looked up at the clouds, O'Keeffe looked down, from an airplane. Where Stieglitz remained confined to the relatively small size of his photographs, depending on their serial combination to convey a variety of sky effects, O'Keeffe, like Bierstadt before her, ultimately chose for *Sky Above Clouds IV* (1965; The Art Institute of Chicago) a panoramic expanse of canvas. Unlike any other artist within the American tradition, however, she filled it with ur-clouds. In distilling the mutable into the immutable, she reinforced a long-standing American concern with an underlying absolute that had always been tempered by the specific and came down on the side of the Platonic. Her cloud shapes, a singularly modernist abstraction of type, use modernist repetition to step back to a horizon that Emerson had claimed necessary for "the health of the eye."[41]

•

It is perhaps with Emerson, the sage of the self-reliant, that O'Keeffe finds her strongest affinity. It was Emerson who called one of her most valuable traits, intuition, a "primary wisdom."[42] It was Emerson who counseled his readers in his essay "Self-Reliance," ". . . believe your own thought. . . . Speak your latent conviction, and it shall be the universal sense."[43] O'Keeffe always wanted to speak her own thought: "I decided I was a very

Georgia O'Keeffe. *Sky Above Clouds IV.* 1965. Oil on canvas, 8 x 24'. The Art Institute of Chicago, Restricted gift of the Paul and Gabriella Rosenbaum Foundation, Gift of Georgia O'Keeffe, 1983.821

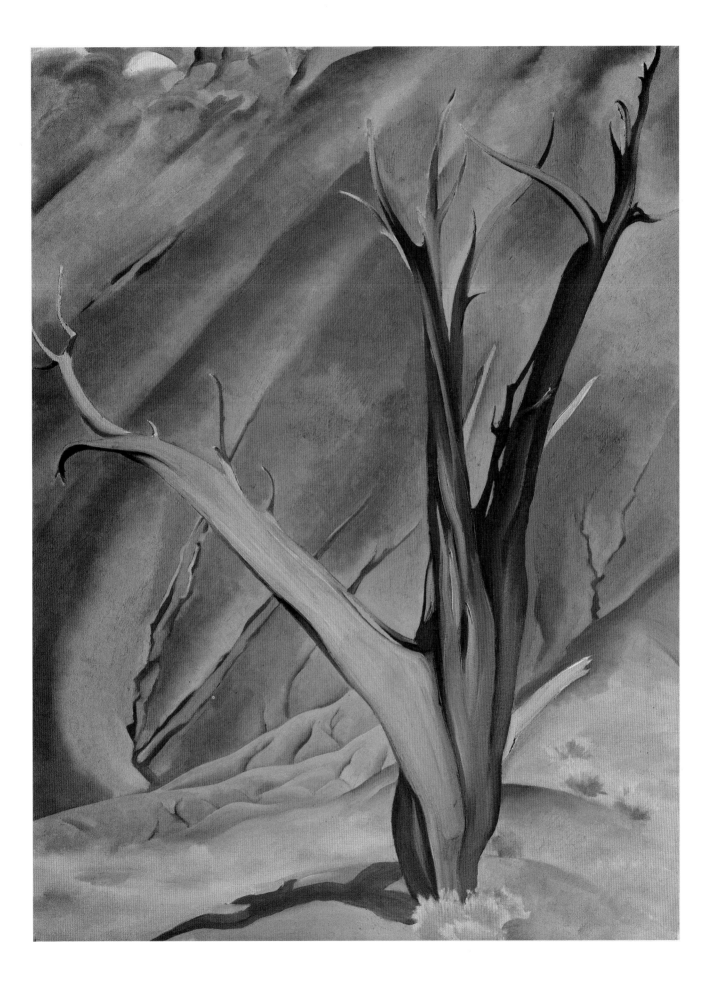

48. *Gerald's Tree I.* 1937. Oil on canvas, 40 x 30⅛″.
Gift of The Burnett Foundation

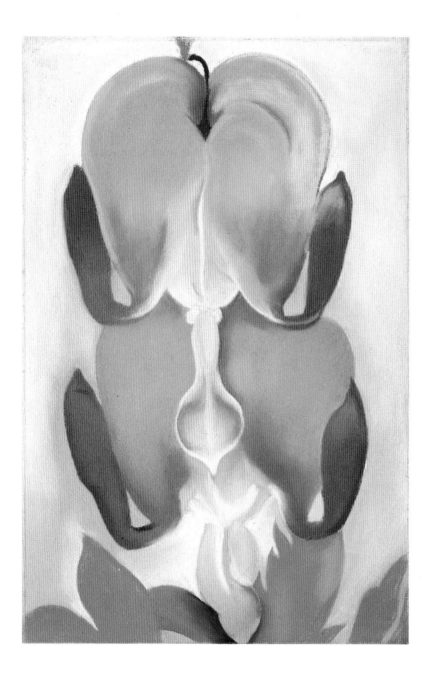

49. *Bleeding Heart.* 1932. Pastel on fiberboard, 15⅛ x 10″.
Gift of Anne Windfohr Marion and Anne Windfohr Phillips

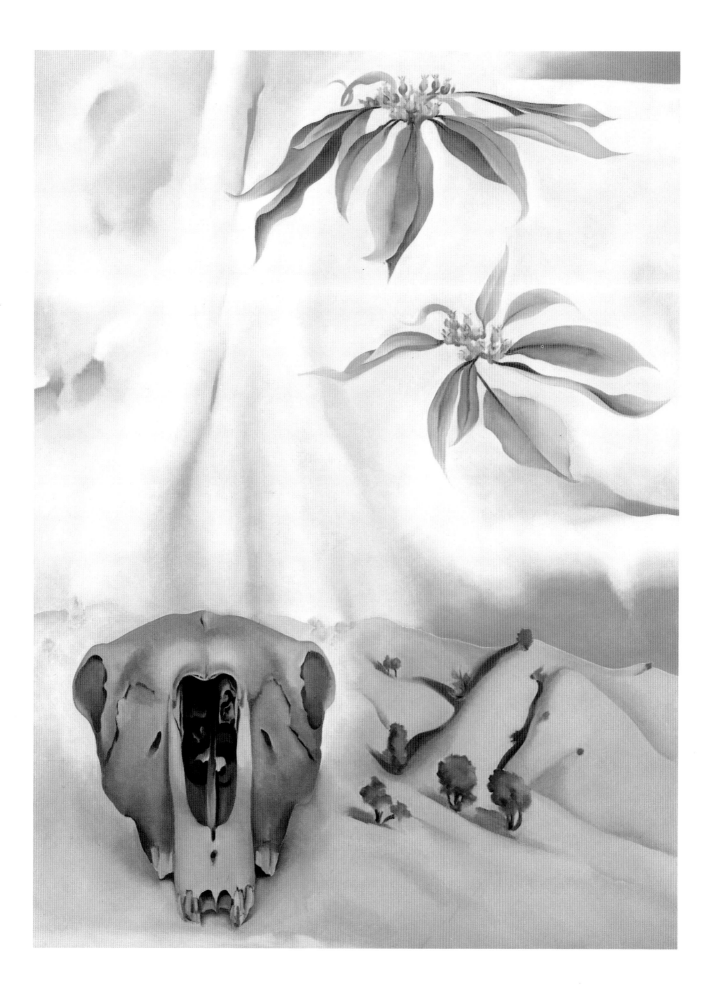

50. *Mule's Skull with Pink Poinsettias.* 1936. Oil on canvas, 40⅛ x 30″.
Gift of The Burnett Foundation

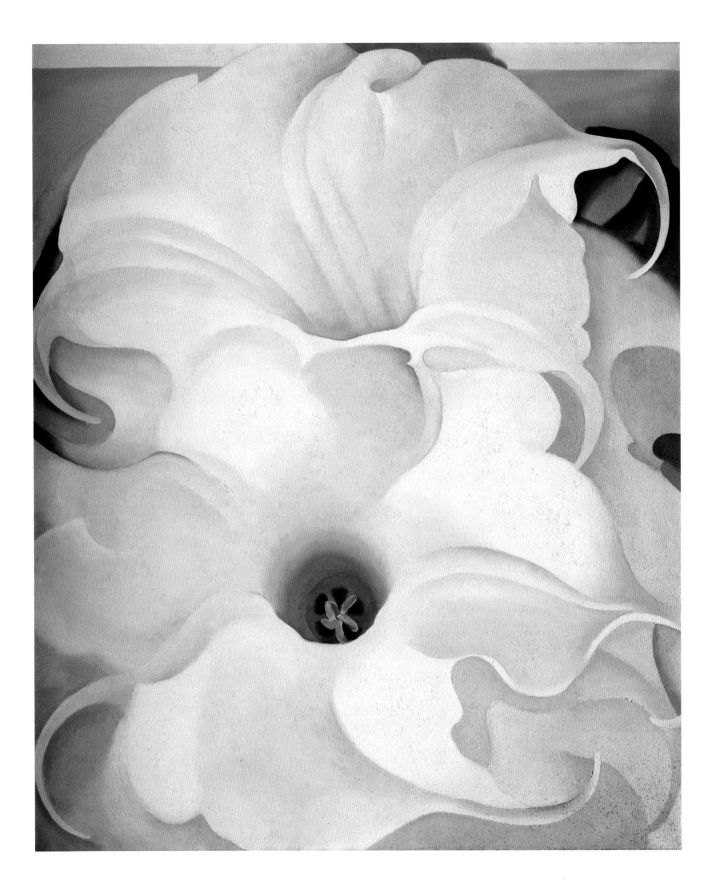

51. *Belladonna—Hāna (Two Jimson Weeds)*. 1939. Oil on canvas, 36¼ x 30″.
Extended loan, private collection

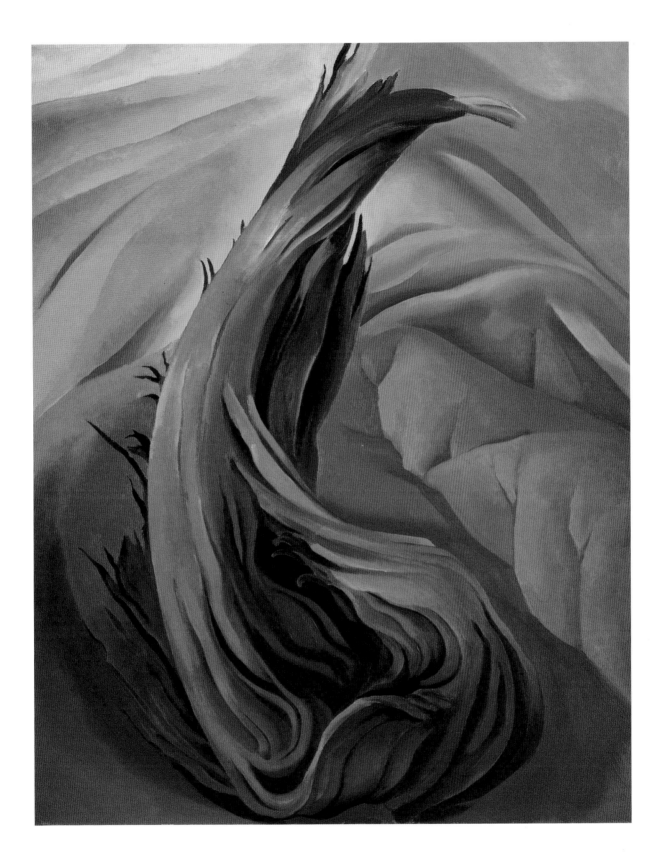

52. *Stump in Red Hills.* 1940. Oil on canvas, 30 x 24″.
Gift of the Stephane Janssen Trust

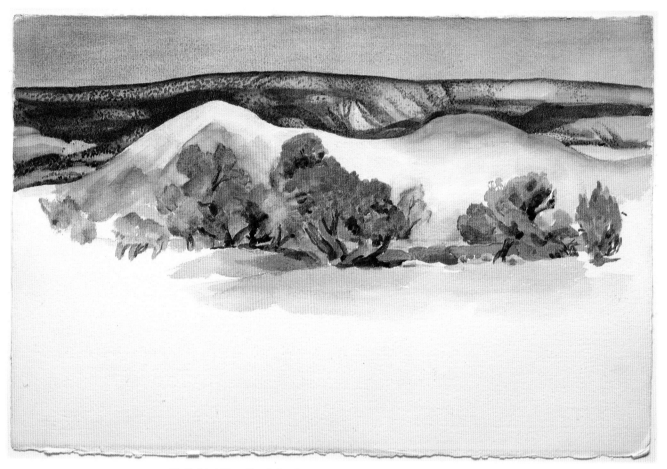

53. *Untitled Ghost Ranch Landscape.* c. 1940. Watercolor on paper, 15 x 22¾″.
Gift of The Burnett Foundation

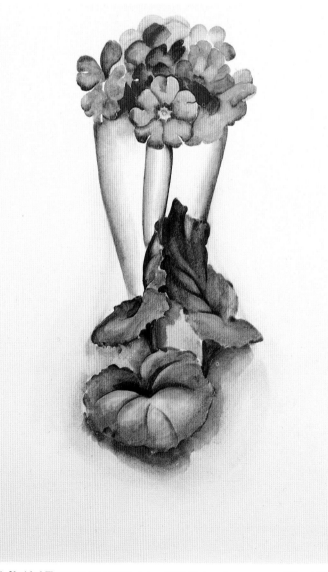

54. *Untitled Flower in Vase (Primula).* c. 1930. Watercolor on paper, 15¾ x 11¼″.
Gift of The Burnett Foundation

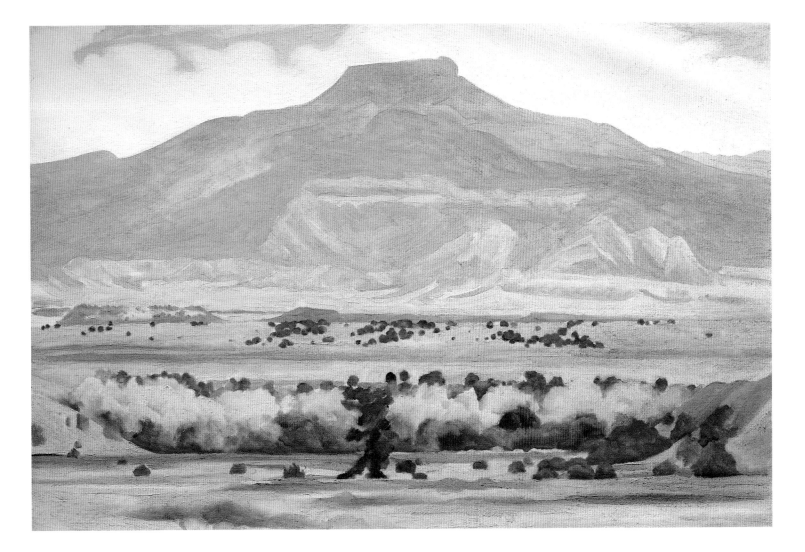

55. *Pedernal, Blue and Yellow.* 1941. Oil on canvas, 20⅛ x 30¼″.
Gift of The Burnett Foundation and The Georgia O'Keeffe Foundation

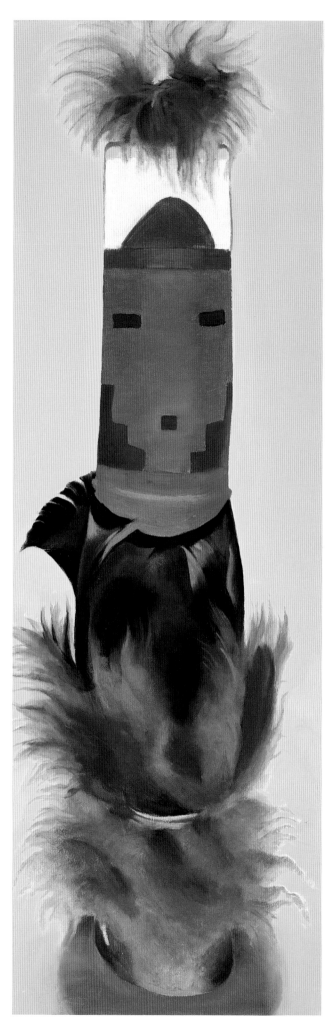

56. Kachina. 1945. Oil on canvas, 24⅛ x 8″.
Gift of The Burnett Foundation

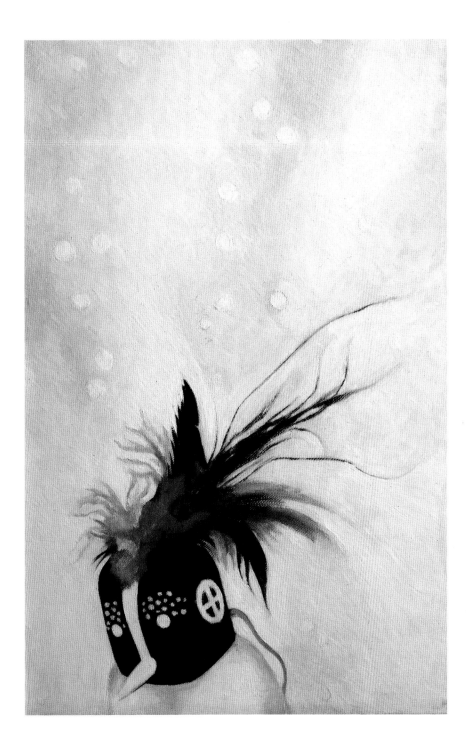

57. *Kokopelli with Snow.* 1942. Oil on board, 15 x 10″.
Gift of The Burnett Foundation and The Georgia O'Keeffe Foundation

58. *Cottonwood Trees in Spring.* 1943. Oil on canvas, 30 x 36″.
Gift of The Burnett Foundation

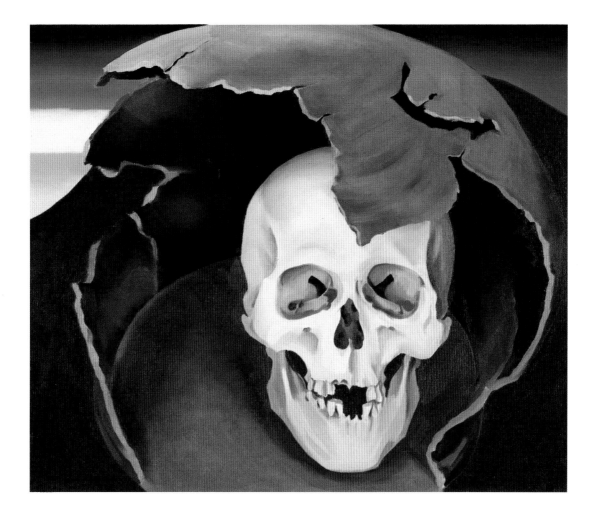

59. *Head with Broken Pot.* 1943. Oil on canvas, 16 x 19″.
Gift of the Stephane Janssen Trust

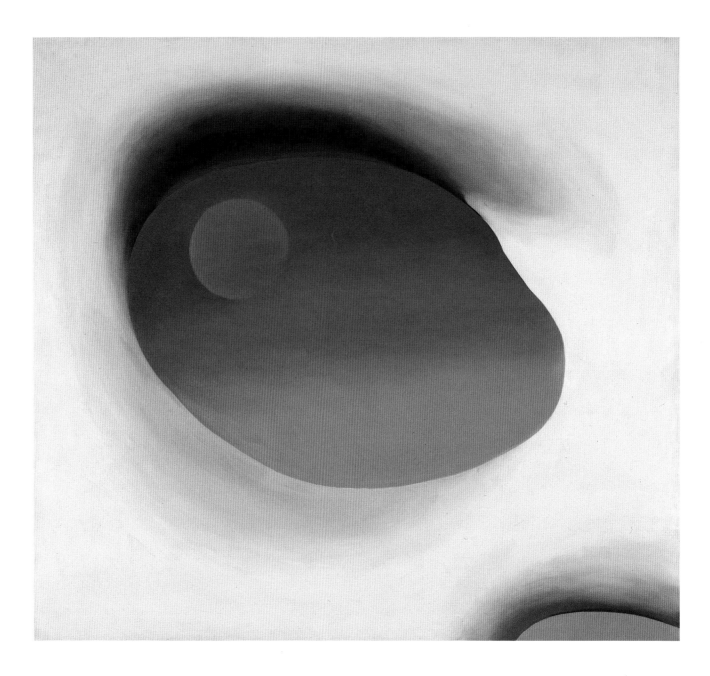

60. *Pelvis IV.* 1944. Oil on board, 36 x 40".
Gift of The Burnett Foundation

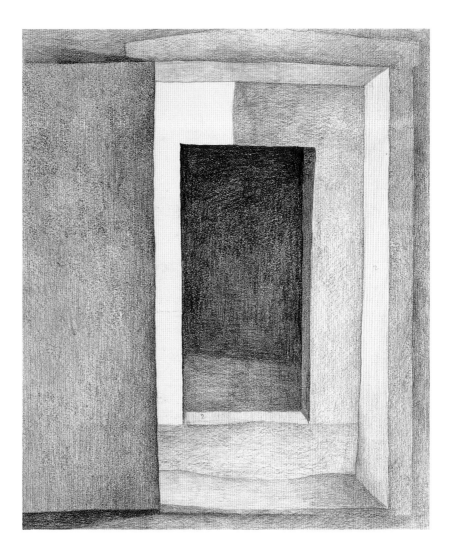

61. *Patio Door.* 1946. Pencil on paper, 17 x 14″.
Gift of The Burnett Foundation

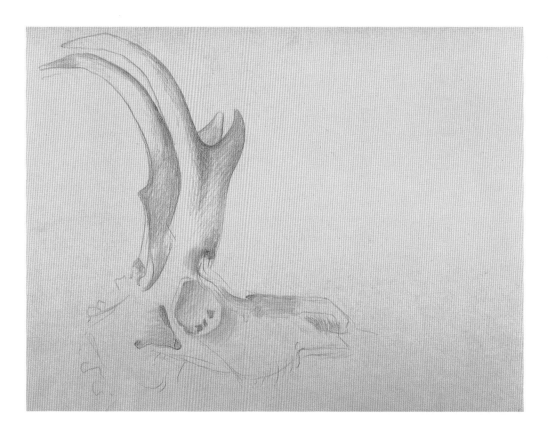

62. *Antelope Horns.* c. 1954. Pencil on paper, 17⅞ x 23⅞".
Gift of The Burnett Foundation

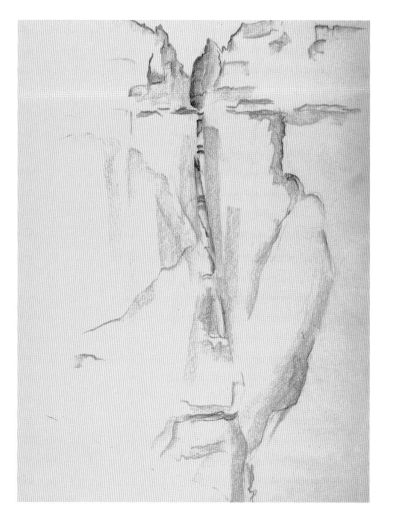

63. *Dry Waterfall, Ghost Ranch.* c. 1940. Pencil on paper, 23⅞ x 17⅞″.
Gift of The Burnett Foundation

64. *Ghost Ranch Cliff.* c. 1940. Pencil on paper, 23⅞ x 17⅞″.
Gift of The Burnett Foundation

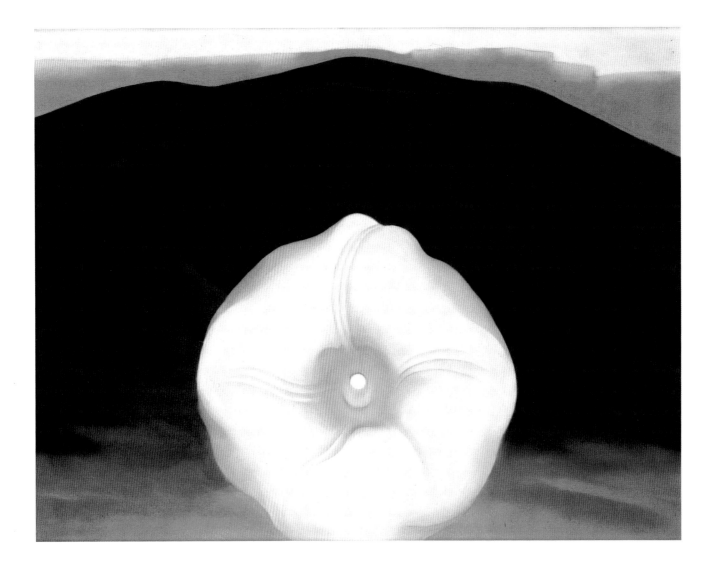

65. *Red Hills with White Flower.* 1937. Pastel on paper-covered board, 19⅛ x 25⅝″.
Gift of The Burnett Foundation

stupid fool not to at least paint as I wanted to and say what I wanted to when I painted as that seemed to be the only thing I could do that didn't concern anybody but myself—that was nobody's business but my own."[44] In his classic study *The Imperial Self,* Quentin Anderson noted that Emerson "moved the task of self-validation within. . . . Our prime business is no longer imagined as either generation or action, but, ultimately, an exhibition of the power of the self to image the world it has incorporated."[45]

One of O'Keeffe's main strengths was her power of self-validation. "I get out my work," she wrote, "and have a show for myself before I have it publicly. I make up my own mind about it—how good or bad or indifferent it is. After that the critics can write what they please. . . . I am quite free."[46] She worked out of what Emerson would have called "the aboriginal Self, on which a universal reliance may be grounded," out of a "sense of being which in calm hours rises . . . in the soul . . . not diverse from things, from space, from light, from time, from man but one with them."[47] Like Emerson's ideal self-reliant soul, she first shares "the life by which things exist" and afterward sees them "as appearances in nature" but does not forget "that we have shared their cause."[48] By her natural occupancy of several of those parallel sequences noted earlier, she takes her place within the intellectual and visual traditions that contribute to our continuing redefinition of American culture.

1. New York, Anderson Galleries, 1943.
2. Quoted in Sarah Whitaker Peters, *Becoming O'Keeffe: The Early Years* (New York: Abbeville Press, 1991), p. 140.
3. See Barbara Novak, *Nature and Culture: American Landscape and Painting, 1825–75,* rev. ed. (New York: Oxford Univ. Press, 1995), p. 23.
4. As early as 1923, Henry McBride had called O'Keeffe "a modern Margaret Fuller." See Charles C. Eldredge, *Georgia O'Keeffe, American and Modern* (New Haven and London: Yale Univ. Press in association with InterCultura and The Georgia O'Keeffe Foundation, 1993), p. 177.
5. Herman Melville, *Moby Dick* (New York: Norton, 1977), p. 169.
6. Quoted in Eldredge, *American and Modern,* p. 165.
7. Quoted in Peters, *Becoming O'Keeffe,* p. 45. In a provocative article, "O'Keeffe and the Masculine Gaze" (*Art in America* 78, no. 1 [January 1990]), Anna Chave takes strong exception (p. 116) to the idea advanced by many critics, mostly male, that O'Keeffe was a "purely instinctual" or "intuitive" creature. As Chave rightly observes, she was "no plant, no amoeba, and no dimwit; she was a self-possessed, literate person." Chave's stance here seems to be that "intuitive" or "instinctive" is a condescending male term, applied mainly to female artists. Perhaps this is indeed the way it has been used. But for an artist (whether male or female) to rely on faculties of intuition and the unconscious does not seem to me to compromise intelligence, but simply to use an aspect of the intelligence that is harder to pin down. Much of O'Keeffe's art gains strength from her application of her intuitive faculties and from her deep desire, as she put it, "to make the unknown—known." Chave herself quotes (pp. 116–18) from the same letter to Sherwood Anderson, in which O'Keeffe continues, "By unknown—I mean the thing that means so much to the person that he wants to put it down—clarify something he feels but does not clearly understand. . . . Sometimes it is all working in the dark—but a working that must be done."

When I speak here of O'Keeffe's reliance on the intuitive or unconscious, I am thinking of such a process. See also Eldredge, *American and Modern,* p. 176, which notes that during an interview with O'Keeffe, "Describing her working method, she referred to her 'so-called brain' and suggested that her approach was unconscious rather than rational."
8. Quoted in Novak, *Nature and Culture,* p. 226. See also Eldredge, *American and Modern,* pp. 180ff., for an interesting consideration of O'Keeffe's actual use of the apple motif.
9. Quoted in H. P. Blavatsky, *The Secret Doctrine* (1888; reprint, Los Angeles: Theosophy Company, 1974), p. 246.
10. Quoted in Eldredge, *American and Modern,* p. 195.
11. Theodore E. Stebbins, *The Life and Works of Martin Johnson Heade* (New Haven: Yale Univ. Press, 1975), p. 196 n. 25, observes: "Miss O'Keeffe had never heard of Heade until I brought him to her attention in 1972" (O'Keeffe to Stebbins, letter, January 19, 1973).
12. See Frances S. Osgood, ed., *The Poetry of Flowers and Flowers of Poetry* (New York: J. C. Riker, 1844), pp. 260–61.

13. Quoted in Benita Eisler, *O'Keeffe and Stieglitz: An American Romance* (New York: Penguin Books, 1991), p. 7.

14. Chave, "Masculine Gaze," p. 123, objects to those critics of O'Keeffe who see her as the "priestess of Eternal Woman," resulting in her "oppression through exaltation . . . a negation of women's carnal reality." Yet many feminist critics have also found O'Keeffe inspiring "because she pictured essential and existential femininity in a sensorial and transcendent female principle." See Arlene Raven, Cassandra L. Langer, and Joanna Frueh, eds., *Feminist Art Criticism, An Anthology* (New York: HarperCollins, Icon Edition, 1991), p. 228.

15. See Eldredge, *American and Modern,* p. 210, quoting O'Keeffe, "I am not a woman painter," and stating (p. 211) that she wanted to be remembered "as a painter—just as a painter."

16. Ralph Waldo Emerson, *Ralph Waldo Emerson, Essays and Lectures* (New York: Library of America, 1983), p. 34.

17. Quoted in Barbara Novak, *American Painting of the Nineteenth Century: Realism, Idealism, and the American Experience* (New York: Praeger [1969]), p. 70.

18. Emerson, *Essays and Lectures,* p. 43.

19. Henry Tyrrell, in *Christian Science Monitor,* June 2, 1916, quoted in Eldredge, *American and Modern,* p. 163.

20. Emerson, *Essays and Lectures,* p. 18.

21. Ibid., p. 25.

22. Georgia O'Keeffe, *Georgia O'Keeffe* (New York: Penguin Books, 1977), opp. pls. 56, 71.

23. Henry David Thoreau, December 15, 1855, in *The Journal of Henry D. Thoreau,* eds. Bradford Torrey and Frances H. Allen (New York: Dover, 1962), vol. 2, p. 51.

24. O'Keeffe, *O'Keeffe* (1977), opp. pl. 33.

25. Ibid., opp. pl. 71.

26. Thoreau, May 23, 1853, *Journal,* vol. 1, p. 574.

27. Emerson, *Essays and Lectures,* p. 11.

28. Ibid., p. 20.

29. There has been sufficient scholarly evidence that O'Keeffe, Stieglitz, and their circle were familiar with, and indeed admired, the philosophical ideas of Emerson and Thoreau. See especially Barbara Rose, "O'Keeffe's Trail," *New York Review of Books,* March 31, 1977, pp. 29–33; Eldredge, *American and Modern,* p. 193; Peters, *Becoming O'Keeffe,* p. 356, which notes however (n. 98) that Thoreau was not on Stieglitz's lifetime-favorite reading list. O'Keeffe's library in her home at Abiquiu (owned by The Georgia O'Keeffe Foundation) incorporates books from Stieglitz's library as well as her own. Among them are Thoreau's *Walden, A Week on the Concord and Merrimack Rivers,* and *The Transmigration of the Seven Brahmans,* all inscribed to Stieglitz from Edward Dahlberg in the 1930s. The library also houses Van Wyck Brooks's *The Life of Emerson* (1932). The question of the influence of these ideas arises with O'Keeffe, as it does with the Hudson River painters and luminist artists, whose works incorporate similar attitudes. My own feeling is that O'Keeffe's ideas (and those of the nineteenth-century painters) naturally paralleled many of the sentiments of Emerson and Thoreau, and would have done so even if she had not read them. Knowledge of these sources would only have fortified ideas and feelings already central to her.

30. Barbara Rose ("Trail," p. 30) has insightfully emphasized the influence on Dow and possibly on O'Keeffe of Ernest Fenollosa's ideas, which as Rose puts it "preached a curious mixture of notions derived from Emerson and Thoreau together with Buddhist quietism and detachment." Rose (p. 31) tells us that "O'Keeffe herself began reading Emerson and Thoreau when she was young." Also in the O'Keeffe library at Abiquiu is Lawrence Chisholm's *Fenollosa, the Far East and American Culture* (1963), inscribed to O'Keeffe from the author "with profound respect and thanks," as well as a number of important books on Chinese and Japanese art. A 1941 publication of Meister Eckhart's writings seems significant in view of the parallels between transcendental thought and Eckhart's philosophy.

31. Vincent van Gogh, *The Complete Letters of Vincent Van Gogh* (Boston: Bulfinch Press, 1991), vol. 3, p. 55 (no. 542).

32. Ibid.

33. Ibid.

34. Thoreau, August 28, 1841, *Journal,* vol. 1, p. 87.

35. Thoreau, August 1, 1841, *Journal,* vol. 1, p. 84.

36. O'Keeffe, *O'Keeffe* (1977), opp. pl. 100.

37. Ibid.

38. Ibid., opp. pl. 23.

39. Ralph Waldo Emerson, in *Emerson: A Modern Anthology,* eds. Alfred Kazin and Daniel Aaron (Boston: Houghton Mifflin, 1958), p. 39 (from his journals).

40. Thoreau, January 7, 1852, *Journal,* vol. 1, p. 319. See also Peters, *Becoming O'Keeffe* (pp. 244–45), quoting O'Keeffe's letter to Sherwood Anderson in 1924: "He [Stieglitz] has done with the sky something similar to what I had done with color before—as he says—proving my case—He has done consciously something I did most unconsciously—and it is amazing to see how he has done it out of the sky with the camera."

41. Emerson, *Essays and Lectures,* p. 15.

42. Ibid., p. 269.

43. Ibid., p. 259.

44. O'Keeffe, *O'Keeffe* (1977), opp. pls. 12, 13.

45. Quentin Anderson, *The Imperial Self* (New York: Vintage Books, 1972), p. 14.

46. O'Keeffe, *O'Keeffe* (1977), opp. pl. 31.

47. Emerson, *Essays and Lectures,* p. 268.

48. Ibid., p. 269.

O'Keeffe's Originality

BARBARA ROSE

G EORGIA O'KEEFFE is unique in art history, but not because she claimed autonomy and parity at a time when American women did not have the right to vote. The radicality of her lifestyle has obscured the originality of her work; curiosity about her personal relationships hides the importance of her innovations to future generations of artists. This is especially ironic since O'Keeffe aspired to a style that was timeless, universal, and, above all, impersonal. For this reason, like Piet Mondrian and Kasimir Malevich, she did not sign her paintings.[1] By now it is time to put away her fame as Alfred Stieglitz's Garboesque muse and model and investigate why she was the most singularly original American artist before World War II.

Early in her career, O'Keeffe developed a powerful, concise, reductive style that in many ways anticipated future efforts by American artists to break free of European traditions.[2] Central to that style is her articulation of a unique conception of pictorial space that married the infinity of Asian scroll painting with that of Wassily Kandinsky's metaphysical plenum. Her discovery of the fluid space of Asian art coincided with her first contact with Kandinsky's concept of painting as a visionary space filled with unanchored forms floating as freely as thoughts flow through the unconscious. She was introduced to Kandinsky's theories by her teacher Arthur Wesley Dow, who also taught her the Japanese design principles known as notan. This system, which had a decisive influence on O'Keeffe's attitude toward composition, was based on a yin-yang opposition of light and dark, dividing the pictorial field on the surface. It offered an alternative to the Western system of composition, which rhymes analogous forms located in a space whose depth is established by the recession of planes behind the surface.

Although O'Keeffe was impressed by Pablo Picasso's Analytical Cubist works, which she had seen at the Armory Show and at 291,[3] she deliberately and defiantly turned her back on Cubism. For her, Cubism was a relic of a European Renaissance that was not native to American culture. She, like Stieglitz, believed in the urgency of creating a new art for a new world. Her quest for authenticity led her to look elsewhere than European art for precedent. Eventually she synthesized elements taken, on the one hand, from Kandinsky and, on the other, from Asian art. Her familiarity with photography added another model for visualizing space and form outside the Western pictorial tradition. Drawing on these divergent sources, she devised a new pictorial space that took her far afield from Paul Cézanne's telescoping vision, with its shallow space, bas-relief, and blunted perspective.

•

From Kandinsky, O'Keeffe learned that art could be as abstract as music and that the inner sensation or emotion counted for more than the outer object or image. Asian art taught her that the field was a whole to be divided rather than filled with busy activity. This approach suited her contemplative temperament and corresponded to her idea that the empty could

also signify fullness. Her knowledge of how the camera lens visualizes differently from the human eye gave her a basis for a style that was by definition reductive and compressed. In the mechanically registered space of photography, nearness and distance are abruptly sandwiched together, without the graduated transitions that the human eye perceives as middle ground. Such compression of distance—which is not to be confused with the pancake-flat space of Japanese prints and of decorative art—enhanced the power and impact of her forms. It also contributed to the illusion of an otherworldly space, where the near could seem far away and the distant near.

As a pioneer abstractionist, O'Keeffe was well informed of Kandinsky's idea that art could express emotion abstractly; Stieglitz had published Kandinsky's *Uber das Geistige in der Kunst* (On the spiritual in art) in English in *Camera Work* in 1912, just after its German publication.[4] Until quite recently, the inspiration for Kandinsky's conversion to abstraction had not been studied. New scholarship, however, firmly establishes the roots of abstract art in the antiscientific doctrines of occult mysticism that developed in response to the fin de siècle religious crisis and that had a profound effect on all the major artists of O'Keeffe's generation. Sixten Ringbom's essay "Transcending the Visible: The Generation of the Abstract Pioneers," for instance, outlines Kandinsky's relationship to theosophy and especially to the occult teachings of the German mystic Rudolf Steiner.[5]

A New Age thinker *avant la lettre*, Kandinsky popularized the idea that abstract art was a means of getting in tune with the "harmonic reverberation" of the universe—a phrase that echoes the concept of the "music of the spheres," which had long been part of the artistic search for divine perfection. This contact, he held, would make possible the "perfect reaction to higher stimuli; thereby the exclusion of distracting, accidental stimuli and highest concentration and absorption."[6] Like Kandinsky and other artists attuned to theosophical ideas, O'Keeffe believed that listening to music induced a synesthesia that could translate aural forms into visual equivalents. Through her friendship with John Toomer and his wife, Marjory Latimer, a disciple of G. I. Gurdjieff, she maintained a connection with the occult and mystical undercurrent of American thought.

Another of the continuous threads in O'Keeffe's life was her commitment to Asian philosophy and aesthetics. She appreciated the economy, the elegance, and the mysterious sense of infinite space—at once both page and sky—suggested but not depicted in Asian art. These delicate works, particularly scroll paintings of landscapes, appealed to her sense of restraint and refinement. She learned from them to dispose of the horizon line, the common anchor that distinguishes Western from Eastern art. Her library contained not only a large number of fine editions of illustrated books on Chinese and Japanese art but also classic theoretical works on the subject, such as Mai-Mai Sze's *The Tao of Painting*.[7] O'Keeffe may well have been aware of Japanese art even before she began studying with Dow through the lectures and writings of the American scholar Ernest Fenollosa, who brought the doctrine of Zen and the aesthetics of the Far East to the Midwest before they became popular on the East and West Coasts. Among those influenced by Fenollosa were O'Keeffe's Midwestern contemporaries the architect Frank Lloyd Wright and the poet Ezra Pound, whose modern styles, like hers, owe much to ancient Asian models and traditions.

In 1890 Fenollosa returned to the United States from Japan, where he had created a collection of Japanese painting that was purchased by the Boston Museum of Fine Arts. After serving as that museum's first Curator of Oriental Art, he left to resume teaching in Japan in 1897, and Dow became Boston's Keeper of Japanese Paintings and Prints.

Fenollosa's collection of twelfth- and thirteenth-century masterpieces of Japanese scroll painting was installed in 1909 in a new wing of the museum, where it is likely O'Keeffe saw it.[8] This collection, which she revisited many times, was probably her first direct contact with Asian art, and it remained important to her throughout her life.

In 1904 Dow left his curatorial post in Boston to head the art school at Teachers College, Columbia University, in New York, where the young Georgia O'Keeffe, who planned to earn a living teaching art, enrolled as a student in 1914. From 1916 to 1918 she taught art to children at West Texas State Normal College in Canyon, Texas. There she produced a recently discovered suite of watercolors that have the same freshness and directness found in children's art; clearly, O'Keeffe was searching in many directions to find an alternative to the European Renaissance on which to base her art. The conventions of children's art, with which O'Keeffe had firsthand experience, were as distinctly different from mainstream Western painting as those of Asian art. Both became for her a source of freshness that offered the immediate vitality that academic art had lost.

O'Keeffe's interest in Zen Buddhism lasted long after she left Dow. Her friendship with Asian art curator Henry Clifford and her later contact with Zen scholars Thomas Merton and Alan Watts testify to her continued fascination with Japanese civilization.[9] Indeed the surprise of concentrated poetry in her images recalls the condensed Japanese poetic form of haiku, which says much with little.

•

O'Keeffe's experience with photography was part of her daily life. She worked on Stieglitz's negatives, painstakingly spotting them so that they would be perfect in their unblemished opposition of black and white.[10] Here it is significant that although, later in life, O'Keeffe was close to Eliot Porter, the master of landscape color photography, her preference was the black-and-white, or "straight," photography that Stieglitz championed. Black-and-white photography is in essence reductive: it is ipso facto anti-illusionist because we know nature as colored. O'Keeffe's relationship to photography was, however, significantly different from that of the Precisionists, with whom she is often grouped. She did not paint from photographs, and she isolated forms and spread them out across the surface rather than overlapping them. Like Charles Demuth, Charles Sheeler, and the other Cubist Realists, she did borrow the way the lens frames an image as a means of organizing the visual field simultaneously as a given whole. However, she used the principle of enlargement to dramatic effect, as they did not. Her forms bulk up; they are not flat, like those of the Precisionists, because she uses modeling to describe volume, and she does not flatten shadow into negative shape. Concave and convex are alternated to give a sense of swelling, breathing form. Most images influenced by photography have the same lighting overall, because only a single moment in time is recorded in a photograph; yet O'Keeffe's forms have volumes whose modeling is neither rational nor consistent.

Initially, as we have observed, O'Keeffe was saved from the superficiality of the dominant fin de siècle decorative styles by Kandinsky's concept of fluid and mutable space. Her experience with photography gave her another way to create a compressed space that was nevertheless ambiguous in its representation of forms. The camera records textures but it does not distinguish among them as the brush does. Similarly, O'Keeffe paints the crease in a tablecloth, in skin, in a mountain, identically, without alteration of the stroke; reduction of the size of images in the background does not complete an illusion of three-dimensional objects in space. Tablecloth, adobe, skin, bone, mountain, are equivalents. But they do not

depict illusionistic space. Nor are they simply pattern. She paints a state of mind, an emotion, a sensation—not an object. Compared with photography, her images are incomplete. They offer selective visual information, and this poetic elision makes them even more powerful.

American vision is so colored by the way the camera sees that the scientific optics of Impressionism and Post-Impressionism had relatively little influence on American art. O'Keeffe's contemporaries may have been unmistakably affected by photography, but she was married to it. Her relationship to Stieglitz's art was far more complex than her relationship to the artist, who was her husband, mentor, discoverer, promoter, and dealer. It is a misconception to believe she shared his aesthetics completely; he was interested in modern Western art, while her focus and inspiration, from the outset, were rooted in Asian art and aesthetics. The emphasis on the mythic substance of O'Keeffe's relationship with Stieglitz has obscured how the 291 exhibitions and *Camera Work* publications shaped her understanding of modernity. For example, her early watercolor style was decisively influenced by Auguste Rodin's watercolors of Isadora Duncan, which Stieglitz showed at 291 in 1908 and 1910. The image of the rebellious American dancer who courageously defied ballet conventions to define a modern art form was fascinating to many. Isadora represented modern American woman liberated from corsets, her body free to move. More important to O'Keeffe, however, was Rodin's fluid, transparent watercolor-wash technique. For a while she imitated Rodin's style quite directly in a series of watercolors of nudes that are probably self-portraits in a mirror. Outside of some early watercolors and a few isolated drawings, however, O'Keeffe did not paint people, either moving or still—although a case can be made that all her works are self-portraits.

The series of small oils of 1915 that mark her debut as an abstract painter cost O'Keeffe a great deal of suffering and may, in fact, have been prompted by memories of an altered consciousness experienced as a child when she suffered a nearly fatal illness. Contemplation of these works raises the question of whether O'Keeffe actually practiced any of the meditative exercises prescribed by the various mystical disciplines; we do not know, but it is certainly possible. Rudolf Steiner, for example, maintained that meditation could develop "the faculty of forming images even where no sensible objects are present."[11] In this series, however, O'Keeffe departs from Kandinsky's planarity: she is inspired not by decorative art or folk patterns, nor by the dream of weightless floating, but by the rich, mutable, multivalent space of classical Chinese landscapes, where light and dark fade away into vapors and mists rather than assuming any fixed or permanent form.

By 1916, the year Stieglitz first showed her work at 291, O'Keeffe was well on her way to a synthesis of painting and drawing. As the century progressed, the goal of advanced art increasingly became to end the fundamental division that the Western tradition had established between the two—a division overcome in Asian art by the ancient technique of drawing with a brush. O'Keeffe looked throughout her life not to Western models but to the great Asian masters of the brush. The relationship of her conception of space to the continuous rolling, undulating space of scroll painting is particularly clear in her drawings, which fade out into the indefinable distance like the feathery trees and mountains in a misty Chinese landscape.

•

O'Keeffe's rejection of Cubism was a deliberate and conscious rejection of European prototypes. She was opposed both to its theoretical pretensions and to its fragmentation of forms. Her search was for an autonomous, fresh, specifically American art that did not rely on European models as precedent—a goal that came to be shared by future generations of

artists and writers. The evolution of O'Keeffe's style must be seen as part of the same national search for identity that inspires the works of Sherwood Anderson and William Carlos Williams, Frank Lloyd Wright and Jackson Pollock, e. e. cummings and Donald Judd. Like Stieglitz, who was born in Hoboken but educated in Berlin, O'Keeffe felt the urgency of defining an art that was specifically and unmistakably made in the U.S.A. as part of a quest for an authentic personal identity. In pursuit of this goal, she discarded much that was central to the Western art tradition, including any vestiges of perspective and the characteristic Renaissance separation of *disegno* and *colore.* O'Keeffe accepted as a given America's lack of a Renaissance and had no regrets or nostalgia for the glorious ruins of antiquity when she could look at a pristine, untouched nature as it was before man intruded to despoil its grandeur with "progress." She was a pioneer in seeking precedents in the indigenous artisan tradition of the well made and finely crafted, as exemplified in the Shaker identification of the aesthetic with the ethical.[12]

The critic and curator E. C. Goossen was the first to understand O'Keeffe's connection to later developments in American art. In 1968 he gave her work a place of honor in his Museum of Modern Art exhibition "The Art of the Real," a landmark show that defined the aesthetic criteria for American art after Abstract Expressionism. Touching on one of the main currents in American art, he characterized the impetus behind the mature styles of Jackson Pollock, Mark Rothko, Clyfford Still, and Barnett Newman as "the desire to find one's real self on the canvas through personal imagery and format." "This desire," he continued, "was expressed in an overriding ambition to make something so original that its reality could not be challenged."[13] Goossen was among the handful of critics to see beyond the gender issue that obstructs an understanding of the importance of O'Keeffe as an innovator. (The others were Henry McBride and James Johnson Sweeney, whose eye for quality was infallible.) By placing her art at the center of his exhibition, Goossen courageously confronted the notorious misogynist Clement Greenberg head-on. Greenberg's writings appeared to identify quality with innovation. Yet, if the degree of innovation in O'Keeffe's work were recognized, Greenberg had a lot to lose: it would soon be obvious that his "postpainterly abstraction," which is based on staining paint into raw canvas, actually amounts to little more than blowing up O'Keeffe's abstract watercolors. (An obvious comparison with a painting by Jules Olitski of the mid-1960s reveals how widely O'Keeffe's watercolors had been reproduced by that point.) Greenberg's dismissal of O'Keeffe as "the Grandma Moses of abstract painting" safely put her work outside the area of serious criticism.

Goossen found the basic elements of postpainterly and minimal art prophetically present in O'Keeffe's work of the 1920s. He correctly located the crucial change in postwar American art as a move from the desire to represent or depict, which requires a dualistic separation of drawing from color, to a desire to "*make* something, something which had never existed in the world before."[14] This shift from delineated, depicted image to presented object is in many ways anticipated by O'Keeffe's paintings. Goossen established O'Keeffe as a precedent for the literalist aesthetic of 1960s art by juxtaposing her *Lake George Window* (1929; Museum of Modern Art, New York) with Ellsworth Kelly's *Window (Museum of Modern Art, Paris)* (1949; Musée Nationale d'Art Moderne, Paris).

One sees how radical O'Keeffe's attitude was toward composition by comparing her works with contemporary abstractions by Arthur Dove, the artist closest to her in both sensibility and style. Their training was similar, but O'Keeffe was drawn to an emptiness and reductiveness that foresaw the minimal styles of the 1960s. She also supplied great detail in

103

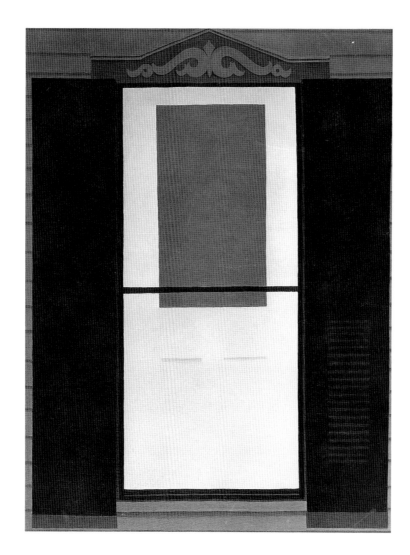

Georgia O'Keeffe. *Lake George Window*. 1929. Oil on canvas, 40 x 30". The Museum of Modern Art, New York. Acquired through the Richard D. Brixey Bequest

edges, whereas Dove smoothed out his edges to become regular contours and sharply silhouetted shapes. Dow's training focused O'Keeffe on the fundamental problem of "how to fill a space beautifully." Barnett Newman's solution—dividing the pictorial field rather than filling it with additive shapes that echo one another—is prefigured by O'Keeffe's famous 1916 watercolor *Blue Lines, No. 10* (The Metropolitan Museum of Art, New York). This work was completed shortly after Stieglitz is quoted as having called O'Keeffe's charcoal drawings "finally a woman on paper." Stieglitz was so impressed that the works were by a woman that he seems not to have perceived their importance as radical formal statements with far-reaching repercussions. (The ubiquity of this quote in the O'Keeffe literature makes one wonder how Barnett Newman's vertical "zips" would be viewed had they been characterized as "finally a man on paper.")

O'Keeffe anticipated much of what characterizes post-Cubist American painting: radically compressed, telescoped space; holistic or single-image compositions with immediate graphic impact and intense, high-key, saturated color; suppression of detail; and a reductive literalism that questions depiction as an outworn convention of representation. Her fine brushstrokes are visible only on close inspection; she does not resort to loaded-brush impasto or applied highlights. Light is essential to O'Keeffe's paintings, but like Rothko, Newman, and Ad Reinhardt, she seeks radiance from within. Her surfaces are modest and reticent, uniform and uninflected by the bravura effects of academic painting. Her drama is played out in an inner world of sensation, not on the surface. Her surfaces themselves are both resistant and yielding, welcoming and hermetic.

To analyze the nature of O'Keeffe's contribution, it is useful to take as a point of departure the great French art historian Henri Focillon's concept of an immanent and ahistorical system of forms, not determined by the limitations of biography or psychology or anatomy but available as a language to artists at any time from prehistory to the present.[15] "History," Focillon observed, "is, in general, a conflict among what is precocious, actual or merely delayed."[16] And indeed O'Keeffe's abstractions belonged to all three categories. Focillon's thinking on this subject parallels André Malraux's investigation of the simultaneous existence of images in a "museum without walls." In this connection, it is significant that O'Keeffe had an outstanding library of color reproductions in her home in Abiquiu that she consulted throughout her life. Her library, like Pollock's, also included illustrated books from divergent cultures and times. For O'Keeffe, as for Pollock, the art of the Native American was no less valid than that of the Renaissance.

Of the classes of universal forms, two stand out as fundamental polarities: the geometric and the organic. O'Keeffe was one of the few artists to make equal use of both. Her straight-edged geometric works are based in memories of architecture. Certainly the softened geometry of the adobe constructions with which she lived much of her life influenced the way she viewed abstraction. The hand-smoothed surfaces of adobe, too, are reflected in her paintings. Her walls and doors and windows have a warmth rather than the remote coldness we associate with the mechanical and industrial forms that inspired Cubism. Her first abstractions, painted in 1915, are not geometric but organic; they derive from plant or landscape forms rather than from the geometric shapes we associate with architectural

ornament or the minor arts. Was her preference for the swelling, breathing, and organic the case because she felt closer to living nature than to crystalline forms, which by definition are cold because they are dead?

•

O'Keeffe was in favor of exercising all the parts of the body, including the brain.[17] She kept pace with current developments in art even after she settled to live full-time in New Mexico after Stieglitz's death in 1946. She also continued to evolve imagery from her own past work. In many respects the late paintings elaborate her traditional themes: the grandeur and vast-ness of the American landscape, the simple geometry of the patio, the enigma of a single isolated object like a stone, a flower, or a bone examined at close hand.

O'Keeffe did not normally paint large pictures. The essence of her art, its monu-mentality, is created through scale, not size. The portable mural that inspired the oversize pictures of the New York School did not concern her. (Of the Mexicans, the only one who inter-ested her was Frida Kahlo, with whom she kept up a lively correspondence.) In O'Keeffe's work, isolated objects that in life are small appear magnified and immense because of her highly developed capacity to create scale. Her mastery of scale is a function of her contem-plative art, which involves transcendence and timelessness and whose function is not to decorate or entertain but to induce contemplation in the way that the placement of stones in Zen gardens does. Indeed, the practice in Zen meditation of mental scale change is sug-gested by her enlarged rocks and flowers.

Stieglitz, whose work was related to an earlier tradition of documentary and picto-rial photography, did not blow up images. But Edward Steichen's flowers, which she knew well, were enlarged to fill the whole pictorial field; they suggested to her the possibility of magnifying details in close-ups, the specialty of Stieglitz's protégé, Paul Strand. Small objects like flowers, shells, and stones, once they fill the pictorial field, take on monumen-tal proportions. Yet the actual texture of objects, so dear to Northern painting and to Photo-Realism, is not O'Keeffe's concern; her flowers, rocks, bones, snowflakes, and clouds all have the same texture. Her images suspend time and transience: the bones and rocks speak of prehistory, before man began to measure time; the flowers are both fragile and perma-nent, without season or decay. Her small pictures are as monumental as her large ones; a rock can look like a mountain. Her flowers are larger than life, emblems of vitalist Bergsonian energies. "I feel," she wrote to Sherwood Anderson about 1923, "that a real liv-ing form is the natural result of the individual's effort to create the living thing out of the adventure of his spirit into the unknown—where it has experienced something—felt some-thing—it has not understood—and from that experience comes the desire to make the unknown—known."[18]

•

White Patio with Red Door (1960; The Regis Collection, Minneapolis) is a poetic reformula-tion of the concrete reality of the Abiquiu courtyard door. The rectangular door opens now not to a domestic interior but to a distant, limitless vista that suggests infinity. O'Keeffe's ear-lier earthbound views of skyscrapers, barns, and houses are exchanged for a glimpse into a mysterious world beyond the one we know so well. O'Keeffe was so rooted to her experi-ence of the present that at the time the late Patios were painted (she was in her seventies), she could not help but see ahead of her the great beyond. In paintings of the 1960s such as *Red Past View* and the series of cloud paintings culminating in the 1965 mural, we note the same absence of a horizon line as well as the use of a paler white and a more translucent

palette, which gives the impression that light is suffused from within rather than focused on forms from a source outside the painting. There are no shadows. The close-valued, pale tints create an incandescent luminosity, a radiance from within that we associate with mystical experience. The pastel tints that O'Keeffe often used suggest a fragility that softens the forcefulness of her simple, bold designs; edges too are softened through her avoidance of sharp angles or hard, linear contours. The word *streamlining* is brought to mind, when one searches for a term to describe the nature of her simplifications, rather than Cézanne's *cylinder*, *sphere*, and *cone*.

The absence of a horizon line confronts us with an unbounded field. Without the conventional visual cues for bodily orientation, we do not experience that we are looking at something from above, from a distance, or through a window. We are forced to project ourselves physically rather than intellectually, as was demanded by the rationalized Renaissance perspective views, into the fictive illusion of infinite space. In her rejection of scientific perspective, O'Keeffe, as always in her own singular way, joins an important current in the evolution of modern painting. In earlier works she had painted birds in flight, picturing their motion as they sweep the sky. In the cloud paintings she represents what birds see when they are flying. The result is that the sensation and the motion of flying are subjectively experienced by the viewer. The greater immediacy gained by locating the sensation of movement and spatial immersion within the viewer's own body has much in common with certain advances made by Claude Monet in his late water-lily paintings. In these paintings the absence of a horizon line requires us to perceive the view as if we were floating among the lily pads, as opposed to looking at them from a distance. Pollock was decisively influenced by the late *Nymphéas* installed at the Museum of Modern Art, and it is likely O'Keeffe was as well in her later paintings.[19]

When Pollock spoke of being "in" his paintings, he referred to this sensation of a physical projection of the body into the space of the painting. This removal of the distance that had separated viewer from object ever since the art of the Renaissance makes for a more intense and intimate experience of the work. In other paintings by O'Keeffe, roads or rivers are seen from an aerial view, a perspective unique to twentieth-century art. The first artist to become conscious of the new perceptions induced by flying was Malevich, who published photos of aerial views in his text on Suprematism, inadvertently revealing how his own compositions were abstracted from such views. Malevich's aerial abstractions, however, remain views of what a bird might see looking down at the earth. O'Keeffe's paintings portray what we might see if we were actually floating among the clouds ourselves, feeling as though we were literally "in" the picture, as weightless and bodiless as Emerson's "transparent eyeball."

Possibly the most original of O'Keeffe's outer-space paintings, with space itself as the subject, is the immense *Sky Above Clouds IV* (The Art Institute of Chicago; see page 80), an 8-by-24-foot mural executed in 1965. A double image is suggested: there is a horizon line depicted, but its unexpected placement above the clouds suggests that the blue sky is also a blue sea flowing away toward a distant horizon. The rhythmic movement of the oblong cloud forms fading from view also brings to mind the rocking motion of the sea and further supports the double metaphor. O'Keeffe uses rapid scale diminution, not perspective, to imply that the air or water zones lie at an angle to our vision. The clouds, however, are lined up frontally, parallel to the picture plane, reasserting O'Keeffe's ambition to paint a mural.[20] The reduction in the size of the cloud forms from foreground to background is not haphaz-

ard. It is also a way of expressing distance in Asian art, which does not use scientific perspective. In this final giant cloud mural, we can no longer think of ourselves as occupying a point in front of the painting, from which we view the receding clouds. We would perceive the silver-thin clouds this way only if we had walked out of an airplane in flight. This kind of immediacy heightens the dramatic impact of many of O'Keeffe's late paintings. In *White Patio with Red Door*, for example, the movement may be experienced as the rapid speed of cars on the highway (its markings recalled by the staccato row of rectangular patches) as they pass by Abiquiu on their way from Santa Fe into the parched badlands.

•

Writing of O'Keeffe, whom he clearly admired, Marsden Hartley maintained that she approached "the border-line between finity and infinity" and mentioned her quest "to inscribe the arc of concrete sensation and experience."[21] Hartley, who was a mystic, viewed O'Keeffe as a kindred soul. He located her correctly within the context of a mysticism firmly grounded in the direct experience of the here and now, a mysticism that insists on the sanctity and importance of the commonest flower or stone. One thinks of certain analogies with Meister Eckhart and Saint Teresa of Avila, as well as of the Zen masters who valued the humble and insisted on the holiness of the commonplace. Because of their mystical content, O'Keeffe's still lifes have much in common with the works of the Spanish old masters Juan Sánchez Cotán, Francisco de Zurbarán, and Luis Meléndez. Like their work, her paintings have the impact of a blinding vision, corresponding to a spiritual revelation or epiphany.

It is in many ways more correct to speak of a spiritual rather than a stylistic evolution in O'Keeffe's work. She found the elements of her style early in the century and essentially refined that style as opposed to "developing," in the sense of the frantic modern Western quest for the perpetually advancing avant-garde. That may be because her quest was never material but always spiritual, another reason her works seem to speak so directly to our time. We may trace the evolution of her imagery from the violence and conflagration of the first abstractions, to the catastrophic images of floods and deluge in the works of the early 1930s, through the struggle with mortality of the memento mori themes of the late 1930s and the 1940s, to the peaceful, infinitely spacious late works.

The Patio and Cloud series are typical of O'Keeffe's tendency to rework themes that she found particularly resonant. In their resolutely stable fixedness, these images are like others she painted: the predominance of a horizontal axis establishes a mood of tranquil serenity. O'Keeffe's keen sense of the present demanded that she invent a style to record the changes in perception that she experienced over her lifetime—from looking down on scroll paintings to flying high above the clouds. For O'Keeffe, each of these changes compromised the easel format as a parallel to the wall. Noting this profound alteration, Leo Steinberg alluded to it in his description of a "flat-bed" picture plane.[22] Jean Dubuffet, for example, lifts up the sidewalk to reorient it on the wall in a way that once again emphasizes the painting as object.

To be free of the earthly horizon line as well as the mechanical grid underlying all Cubist and Cubist-derived styles, O'Keeffe took as her example not easel painting but scroll brush painting. Pollock, followed by Franz Kline and Robert Motherwell, later referenced the same sources, enlarging brush drawings into paintings to achieve a thorough synthesis of drawing and painting that eliminated the depiction that is the basis of representational art. This is an important link between O'Keeffe and the later New York School, shared by no other earlier artists; it is a major reason why her work looks so different from that of other early modernists and why her abstractions appear so prescient.

O'Keeffe's concept of harmony was based on music rather than on compositional precedents in the visual arts. Baroque composition gives a precedent for forms that spill out expansively beyond the frame, but its forms are multiple, not enlarged isolated images. O'Keeffe is the first artist to consciously and consistently think of the field as an autonomous and self-defining space to be divided rather than filled with echoing forms. Because she continues to modulate tones, she does not go as far as Newman, but she anticipates many of the developments of postwar American painting to an uncanny degree. The first to make this observation was Edith Halpert, who became O'Keeffe's dealer after the death of Stieglitz. In 1952 she organized an exhibition that included O'Keeffe's small watercolors of 1916–17, seeing in these works the artist's role as a precursor of Abstract Expressionism. At the time, the perceptive painter and critic Fairfield Porter noted that O'Keeffe's work anticipated the static, emblematic art of the Color Field painters or Chromatic Abstractionists like Newman and Rothko rather than the gestural style of Willem de Kooning and Pollock. Porter recognized in O'Keeffe's abstractions "the scale of emptiness and Romanticism that is seen in different ways in the work of such native Westerners as Still and Reinhardt. And her division of space in *In the Patio* has in it some of the design of Rothko."[23]

White Patio with Red Door has no confining boundaries. It is evidently a fragment of a larger field—an endless blank whiteness infinitely extendable beyond the framing edge. Into this ambiguous ground—ambiguous in that it suggests both the flatness of a wall and an incalculable area within a dazzling white space—O'Keeffe inserts the familiar rectangle of the patio door. The use of aerial perspective contradicts flatness; the graduated tonal fading out of red to pink from bottom to top as shades of white are added suggests that behind the door there is a view into an infinite space. While noting that O'Keeffe "did come first," Porter argued that "our present familiarity with these painters should help us to see O'Keeffe's work freshly again, with its sense of the immensity of space."[24] Given the well-known misogyny of the New York School, the idea that a woman artist was the ultimate source of some of its most important innovations was not especially popular at the time.

O'Keeffe's emblematic imagery was so familiar to American artists that it is difficult to imagine that her art was not in some way a precedent for dividing the canvas into zones of color rather than depicting shapes against a background. There are, of course, great differences of size and surface that set a limit for analogies between O'Keeffe and the giants of the New York School. She was both abstract and expressionist before the New York School, but she was never a nonobjective painter. Her ties to nature were more specific: even the austere *Blue Lines, No. 10* is reminiscent of reeds or stalks. Nor was she interested in asserting the self as a theme, although it may certainly be argued that ultimately her body was the content of her landscapes.

O'Keeffe painted visions of what she felt and what she saw and experienced directly. Her abstract paintings have an emotional power that is rare in abstract art, but she refused to be theoretical. As she explained to Sherwood Anderson, "Making the unknown—known—in terms of one's medium is all absorbing—if you stop to think of form—as form you are lost—The artist's form must be inevitable—You mustn't even think you won't succeed."[25]

O'Keeffe aspired to an anonymous style of paint handling consonant with her transcendentalist belief that great art expresses not an individual consciousness but the grand impersonality associated with those spiritual states in which ego is denied or merged with an oversoul. Her interest in Ralph Waldo Emerson's concept of self-reliance was shared by

Newman, who turned that moral principle into a compositional concept: a Newman image relates to its own framing edge and is thus autonomous from architecture as well as from the interdependence of internal relationships. Newman, Rothko, Still, and the other New York School painters, however, relied exclusively on hue contrast, rejecting value contrast as a relic of academic art—a rejection that could include the tonal modulations employed by O'Keeffe in her undulating, curving, and blossoming organic forms. Yet O'Keeffe makes sure we cannot read her forms as literally sculptural or three-dimensional by expanding them to wrap around the frame so that one cannot imagine being able to reach behind it. Her source here is not Cézanne's shallow space and truncated perspective, the point of departure for modernist painting, but the telescoping of space that photography imposed on American art.

·

O'Keeffe's modernity was singular and in essence contradictory. She made no distinctions between her abstract and representational works. She did not eliminate modeling and value contrasts, as Fauvism had, nor did she fragment shapes, as Cubism did. Even her purist abstractions—the In the Patio series, for example—are still anchored in experienced reality rather than in any kind of dogmatic, a priori drive to reduce form to a logical system. Her relationship to abstraction excludes the nonobjective and its allusions to a utopian system of order. She understood that nature was as unruly and unrepetitious—sometimes soft and inviting, at other times hard and resistant—as she was herself. Indeed, it could be said that she came to know the world through knowing herself. The unmistakable analogies between her landscapes and the human body account for the profound impact of her work on the unconscious of the spectator, as much as her flattened, enlarged images account for the powerful visual presence. Her consistent use of a hieratic frontality, the mode of presentation of the icon, raises the possibility that the essential content of her work is a Lawrencian paean to the body as a religious shrine that is sacred, as in antiquity, rather than profane, as the Puritans would have it. Hers is a romantic vision of the physical in which, as William Blake believed, the body makes the mind. Her images are isolated, as sturdy and alone as she was in her chosen solitude, which was so absolute it is reminiscent of Emily Dickinson's great poem: "The Soul selects her own Society—/Then—shuts the Door—/To her divine Majority—/Present no more—."[26]

Georgia O'Keeffe was such a complex and contradictory person that it will take a while to fully digest her contribution as an artist. She was an antiauthoritarian revolutionary who would not accept any form of paternalism, including that of Cézanne, whom Matisse identified as the father of modern art. Cézanne destabilized vision; photography supplies the human eye with less to see than the eye itself records; it registers shadows as solids and telescopes foreground and background, eliminating the middle ground. Cézanne modeled volumes in shallow space; photography flattens them through the compression of space. It is obvious that when O'Keeffe paints the volumes of forms, she sees nature through her experience of photography—and of Asian scroll painting—not of Cézanne. She makes us look *at* the window and the door, not *through* them, as in a Dutch genre painting, to some fictive world beyond our own reality. The unique way O'Keeffe found to provide the liberating sensation of pictorial space without compromising the wholeness and the "self-reliance" of the painting as a tangible, real object in the world was an American revolution: it did no less than change the way we see.

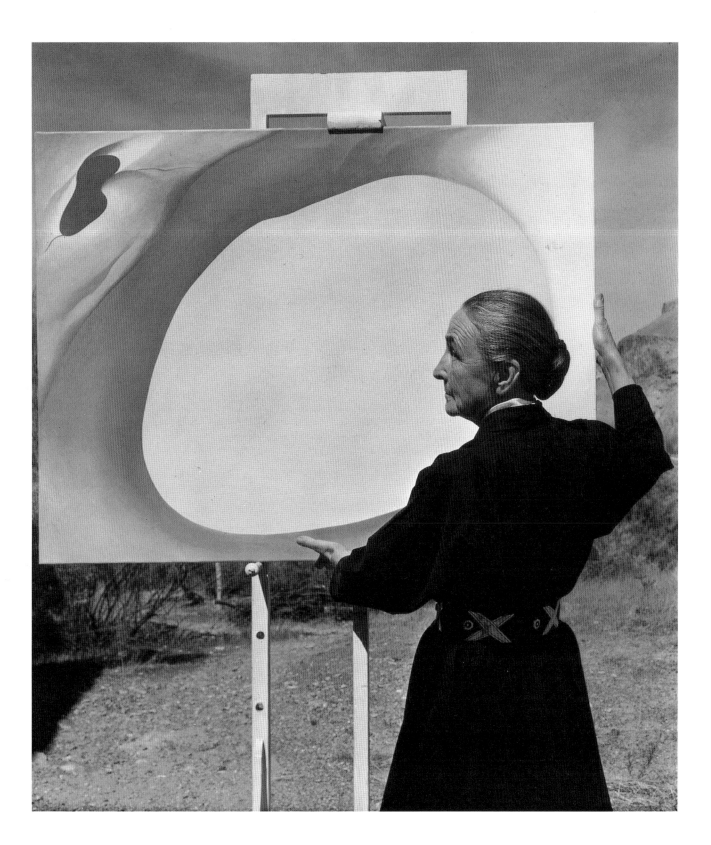

Tony Vaccaro. *Georgia O'Keeffe, Abiquiu, N.M.* April 8, 1960

1. "It would make a dirty mark," she told the author. Comments from O'Keeffe are taken from extensive notes made by the author during trips to Abiquiu between 1967 and 1985.

2. Others, like her contemporaries John Marin, Charles Demuth, and Marsden Hartley, may have been more technically sophisticated, but none was as daring as O'Keeffe in terms of formal invention that deliberately ignored Cubism. Still others, like Edward Hopper, Stuart Davis, and Patrick Henry Bruce, were closer to the sophisticated techniques and compositions of the School of Paris, but O'Keeffe's attitude toward the American scene was especially prescient of later developments in American art. The self-consciousness of these artists toward the issue of creating a new art for a new country is revealed by their statements regarding the problem of an American identity.

3. As part of her role as curator of Stieglitz's collection, she chose a few favorite pieces for high-quality facsimile reproduction. She expressed special admiration when showing the author a reproduction of the 1910 Picasso drawing of a figure that she gave to the Metropolitan Museum of Art as part of the Stieglitz bequest.

4. Hartley, who was in Berlin at the time, sent Stieglitz a copy of the text. Since Stieglitz's first language was German, he was able to translate and publish it immediately.

5. Sixten Ringbom, "Transcending the Visible: The Generation of the Abstract Pioneers," in *The Spiritual in Art: Abstract Painting 1890–1985* (New York: Abbeville Press in association with Los Angeles County Museum of Art, 1986), pp. 131–53.

6. Quoted in ibid., p. 132. One might describe transcendentalism as a marriage between the pantheism of German Romanticism and the Buddhist conception of the oversoul.

7. When O'Keeffe's library is catalogued, it will reveal how deeply indebted she was to Asian aesthetics.

8. When at last O'Keeffe visited Japan, in 1960, she painted an image of Mount Fuji that recalls Hiroshige's famous woodcut, although significantly it leaves out the heavy lines that distinguish woodcuts (plate 83). In her library, she had a copy of the Fenollosa monograph that introduced the great Japanese printmaker to America, *Hiroshige, the Artist of Mist, Snow and Rain* (1901).

9. All visited her in Abiquiu eventually. The stone Buddha that sits in a niche in the Abiquiu house was a gift from Clifford.

10. O'Keeffe to the author.

11. Quoted in Ringbom, "Transcending the Visible," p. 132.

12. The coincidence between the simplicity and austerity of Shaker design and that of Japanese art has been increasingly noted.

13. E. C. Goossen, *The Art of the Real* (New York: Museum of Modern Art, 1968), p. 7.

14. Ibid.

15. Henri Focillon, *The Life of Forms in Art* (1934; New York: Zone, 1996).

16. Ibid., p. 140.

17. O'Keeffe practiced eye exercises to strengthen her vision. She told the author she believed glasses made the eyes lazy.

18. O'Keeffe to Anderson, c. September 1923; reprinted in Jack Cowart, Juan Hamilton, and Sarah Greenough, *Georgia O'Keeffe: Art and Letters* (Washington, D.C.: National Gallery of Art, 1987), p. 174 (no. 29).

19. O'Keeffe, who visited New York museums throughout her life, certainly saw the *Nymphéas* after they were installed as an environment at the museum in 1946.

20. She had attempted mural painting and believed that she had failed. Her maquette for a mural at Radio City Music Hall in New York (now owned by the National Museum of American Art, Washington, D.C.) was exhibited at a mural painting show at the Museum of Modern Art. She had insisted on painting the mural in oil, alone, and abandoned the project in frustration and exhaustion.

21. Marsden Hartley, "Georgia O'Keeffe—A Second Outline in Portraiture," in *On Art*, ed. Gail R. Scott (New York: Horizon Press, 1982), p. 105.

22. Leo Steinberg, *Other Criteria: Confrontations with Twentieth-Century Art* (New York: Oxford Univ. Press, 1972), p. 82.

23. Fairfield Porter, *Art in Its Own Terms: Selected Criticism 1935–1975*, ed. Rackstraw Downes (New York: Taplinger Publishing, 1979), p. 180.

24. Ibid.

25. O'Keeffe to Anderson, c. September 1923; reprinted in Cowart, Hamilton, and Greenough, *Art and Letters*, p. 174 (no. 29).

26. *The Collected Poems of Emily Dickinson*, ed. Thomas H. Johnson (Boston: Little, Brown, n.d.), p. 143.

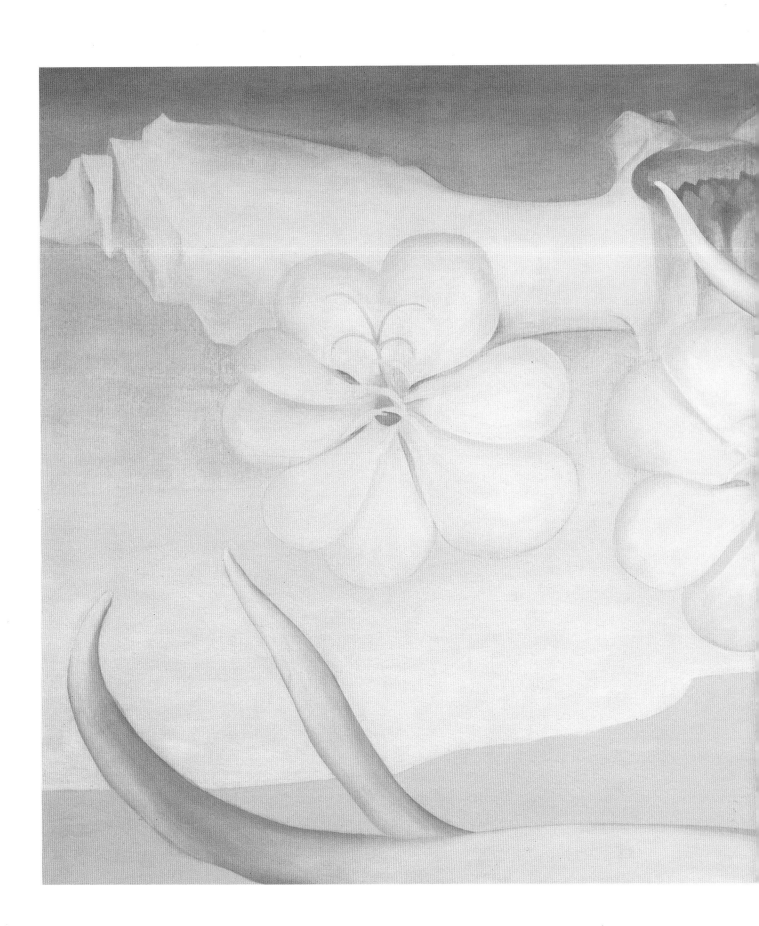

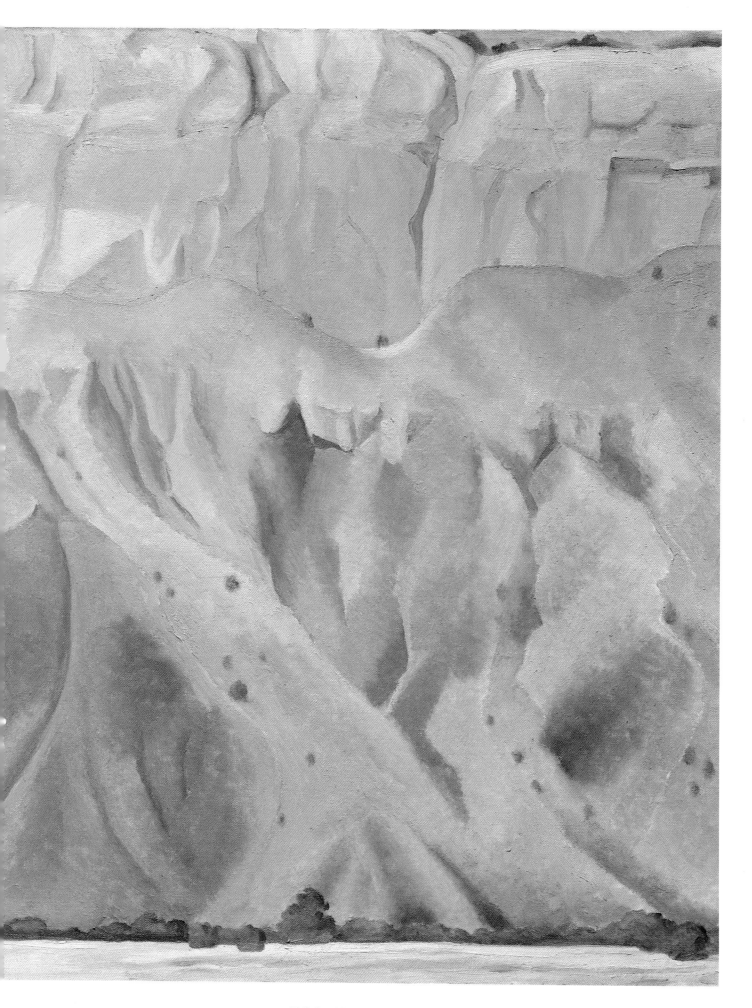

67. *Red and Yellow Cliffs*. 1940. Oil on canvas, 24 x 36".
Gift of The Burnett Foundation

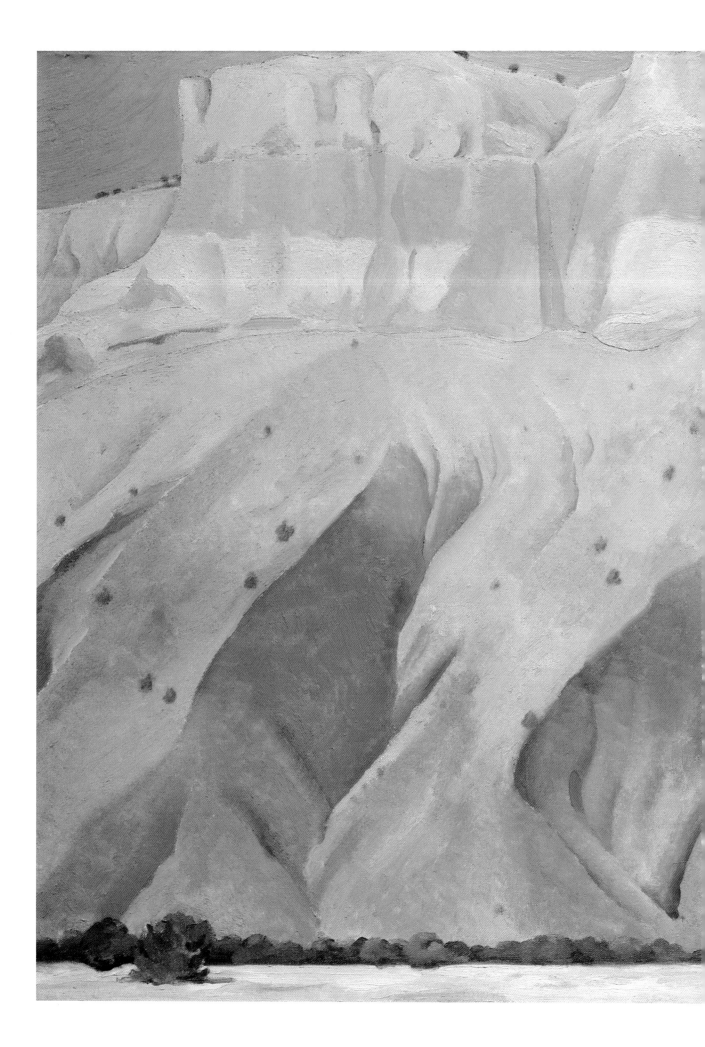

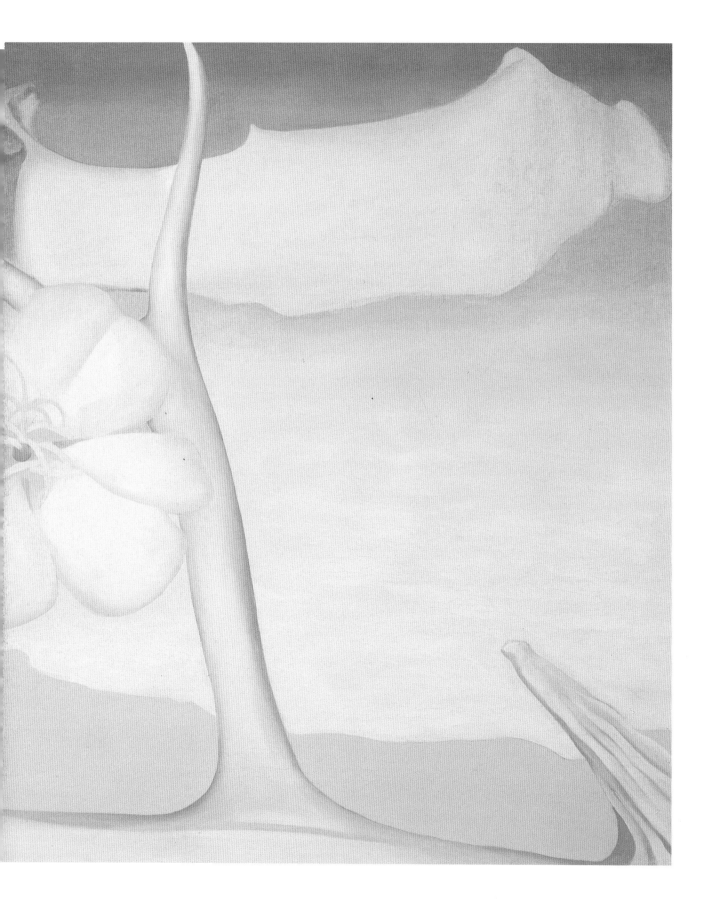

66. *Spring.* 1948. Oil on canvas, 48¼ x 84¼″.
Gift of The Burnett Foundation

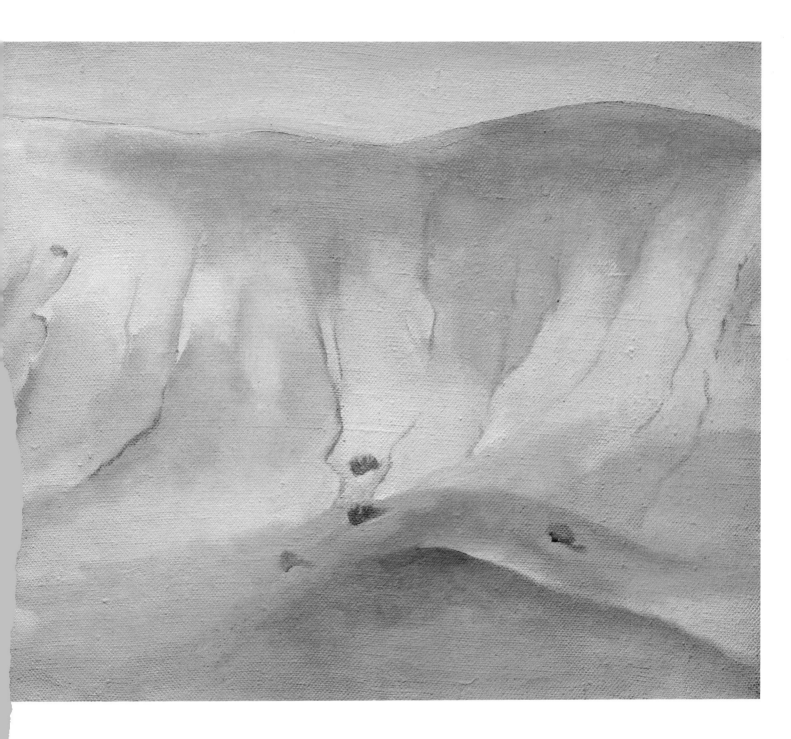

69. *Lavender Hill with Green.* 1952. Oil on canvas, 12 x 27⅛″.
Gift of The Burnett Foundation and The Georgia O'Keeffe Foundation

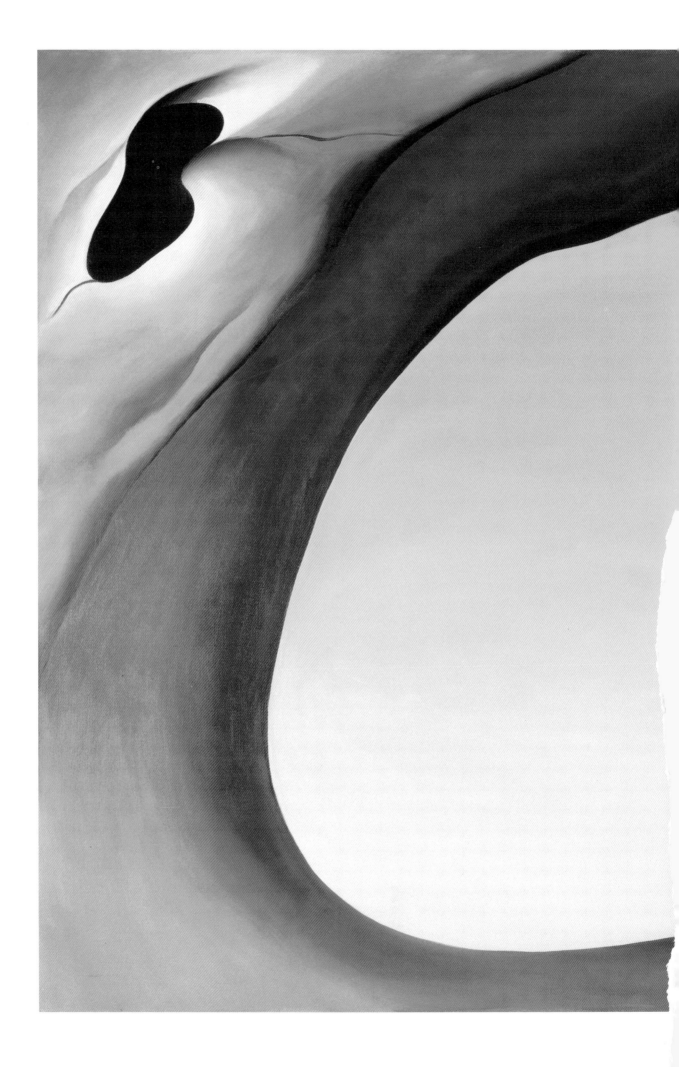

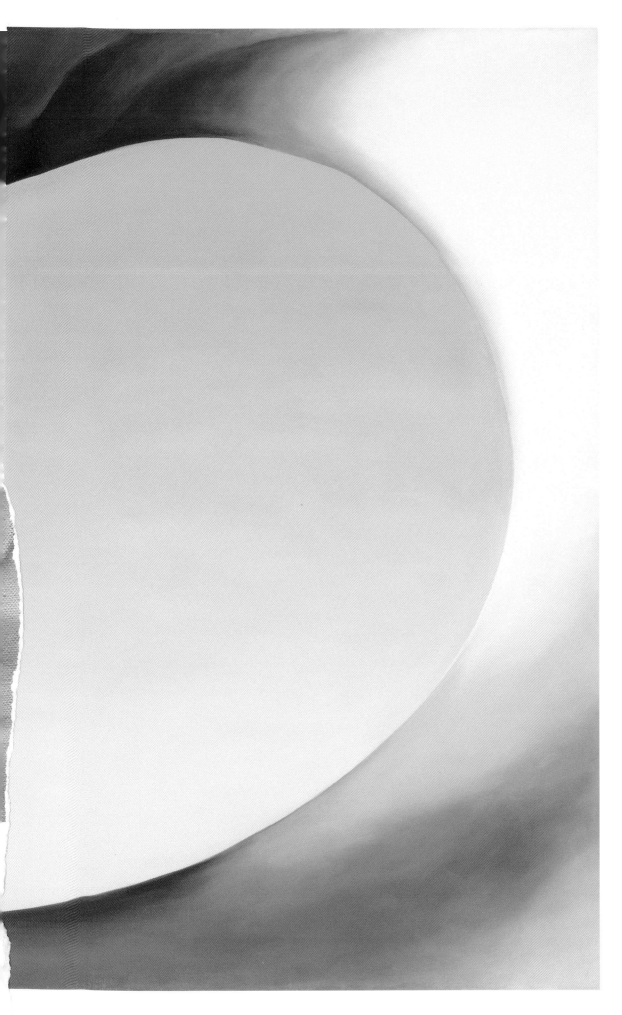

68. *Pelvis Series, Red with Yellow*. 1945. Oil on canvas, 36⅛ x 48¼".
Extended loan, private collection

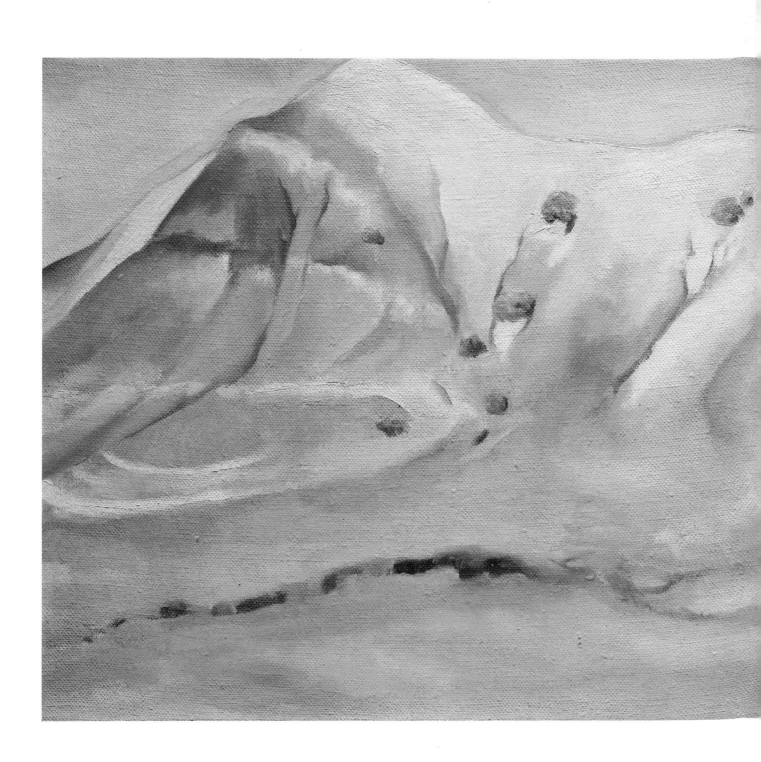

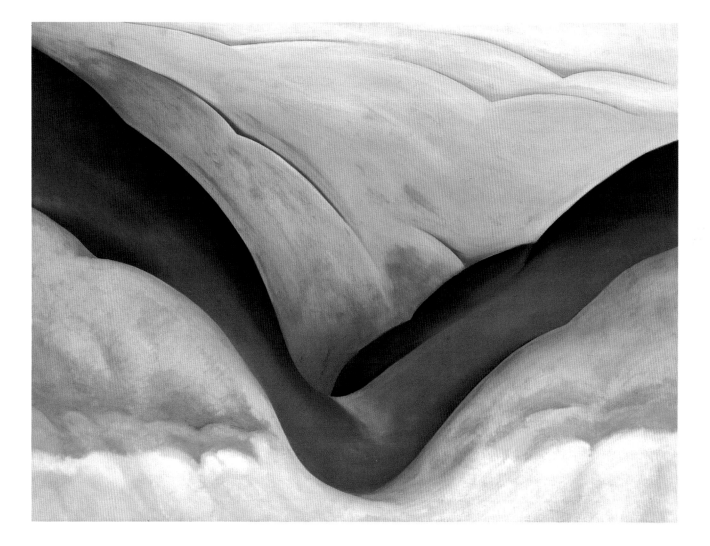

70. *Black Place, Grey and Pink.* 1949. Oil on canvas, 36 x 48″.
Gift of The Burnett Foundation

71. *Abiquiu Mesa I.* c. 1950. Pencil on paper, 5⅜ x 17½".
Gift of The Burnett Foundation and The Georgia O'Keeffe Foundation

72. *Abiquiu Mesa II.* c. 1950. Pencil on paper, 5⅜ x 17½".
Gift of The Burnett Foundation and The Georgia O'Keeffe Foundation

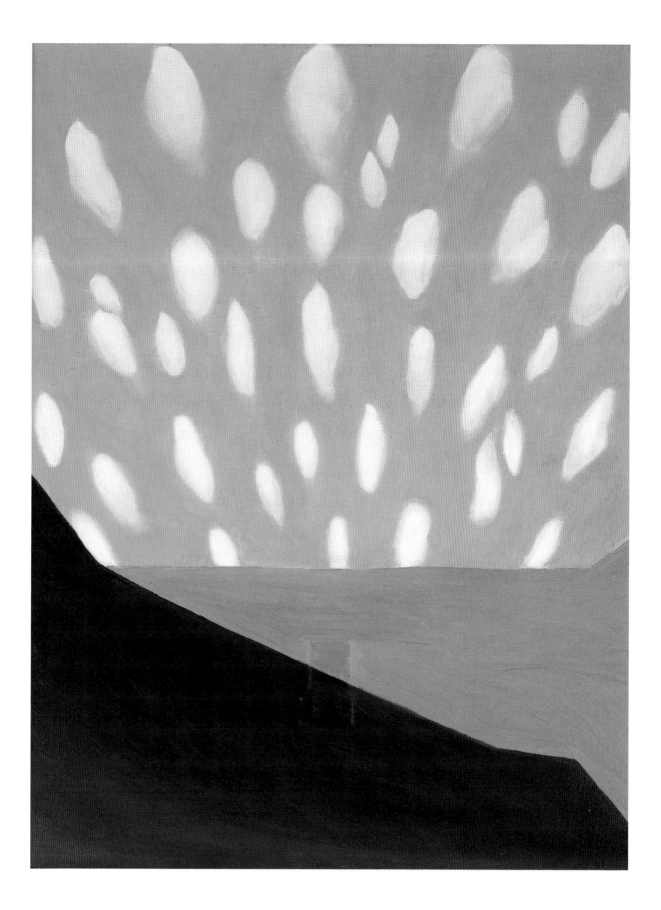

73. *In the Patio VIII*. 1950. Oil on canvas, 26 x 20″.
Gift of The Burnett Foundation and The Georgia O'Keeffe Foundation

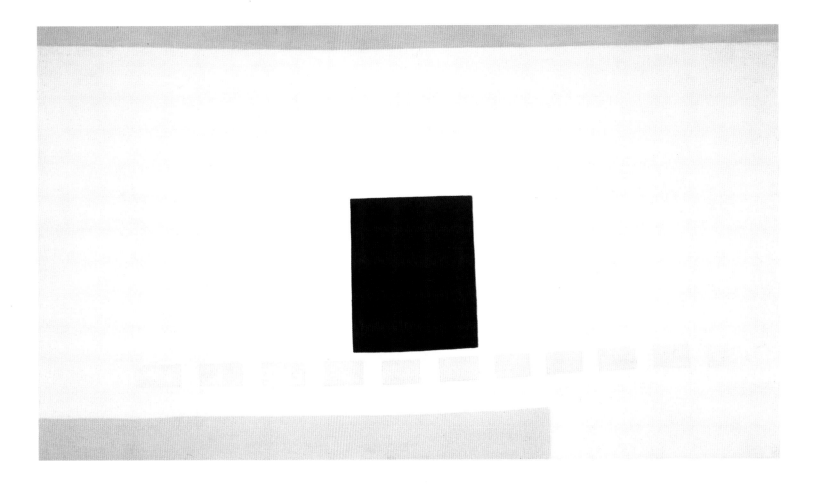

74. *My Last Door*. 1954. Oil on canvas, 48 x 84".
Gift of The Burnett Foundation

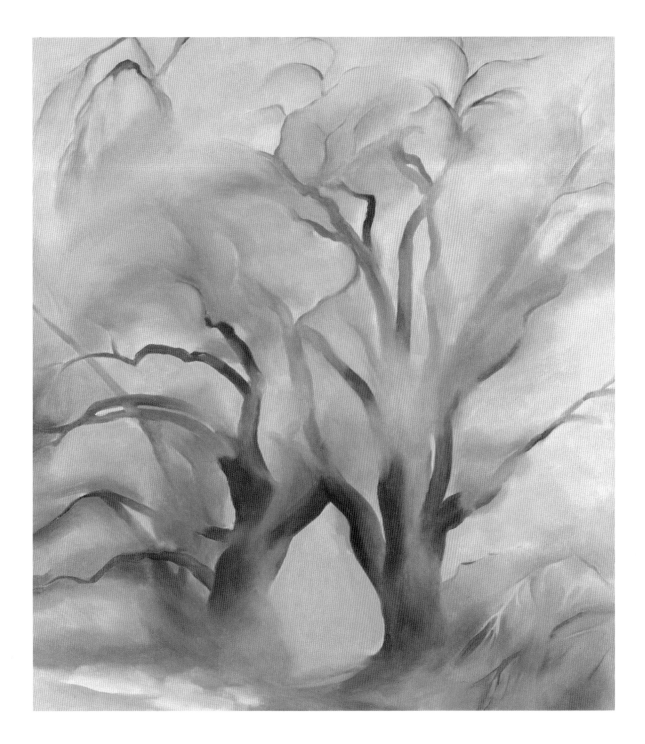

75. *Winter Cottonwoods East V.* 1954. Oil on canvas, 40 x 36".
Gift of The Burnett Foundation

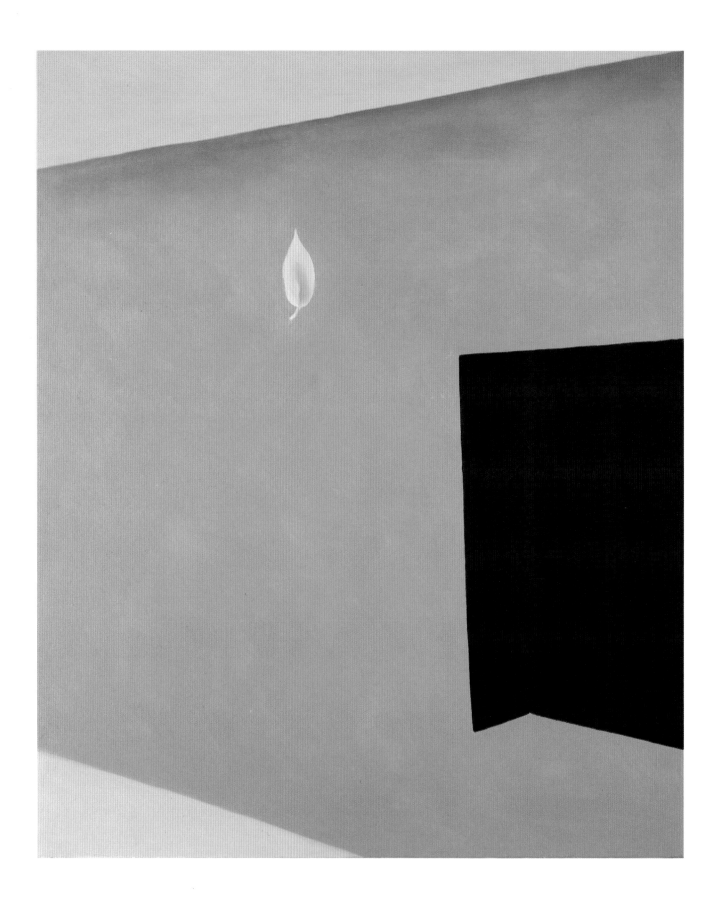

76. *Patio Door with Green Leaf.* 1956. Oil on canvas, 36 x 30″.
Gift of The Burnett Foundation and The Georgia O'Keeffe Foundation

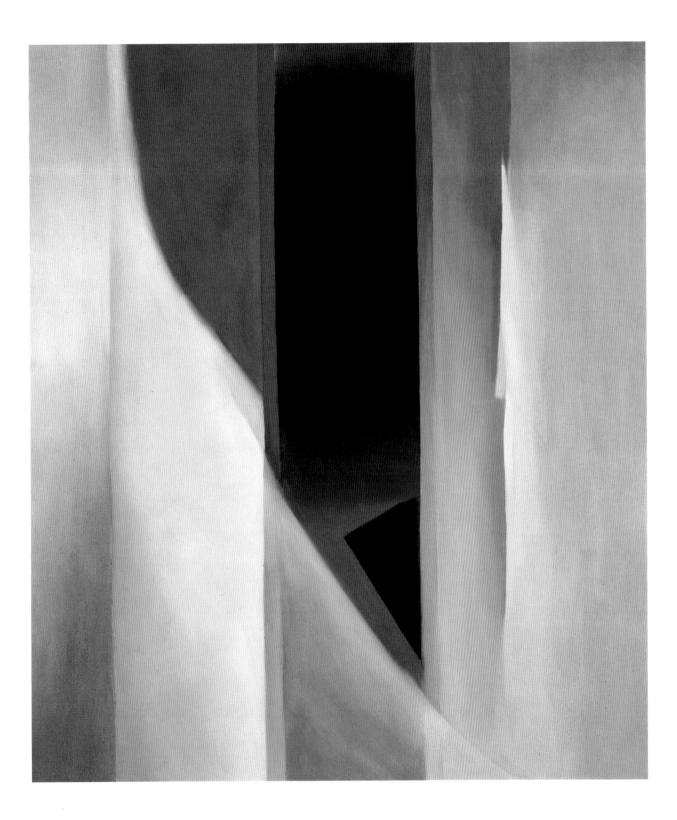

77. *Blue II*. 1958. Oil on canvas, 30 x 26".
Gift of The Burnett Foundation and The Georgia O'Keeffe Foundation

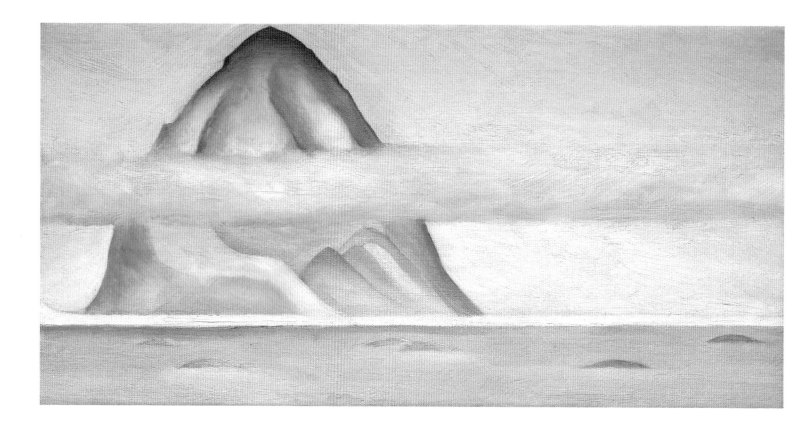

78. *Like Misti, A Memory.* 1957. Oil on canvas, 10⅛ x 20⅛″.
Gift of The Burnett Foundation and The Georgia O'Keeffe Foundation

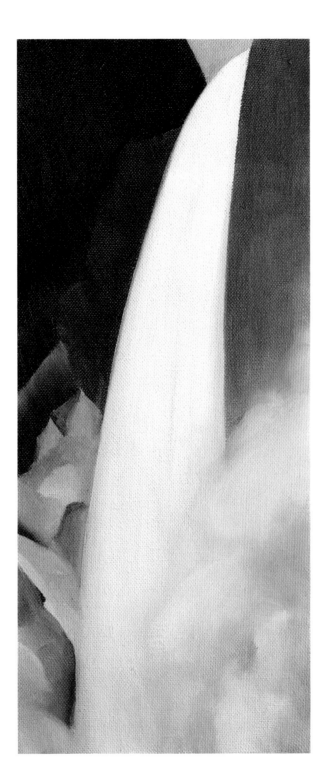

79. *Green and White Waterfall*. c. 1957. Oil on canvas, 16 x 7".
Gift of The Burnett Foundation and The Georgia O'Keeffe Foundation

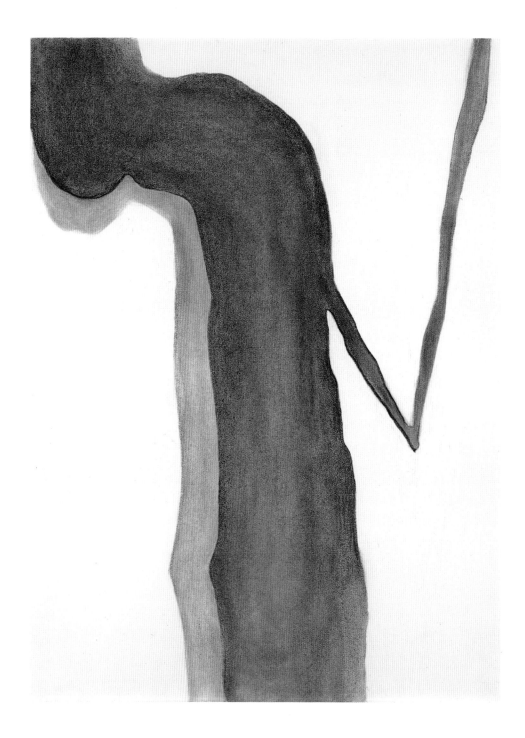

80. *Drawing V.* 1959. Charcoal on paper, 24½ x 18¾".
Gift of The Burnett Foundation and The Georgia O'Keeffe Foundation

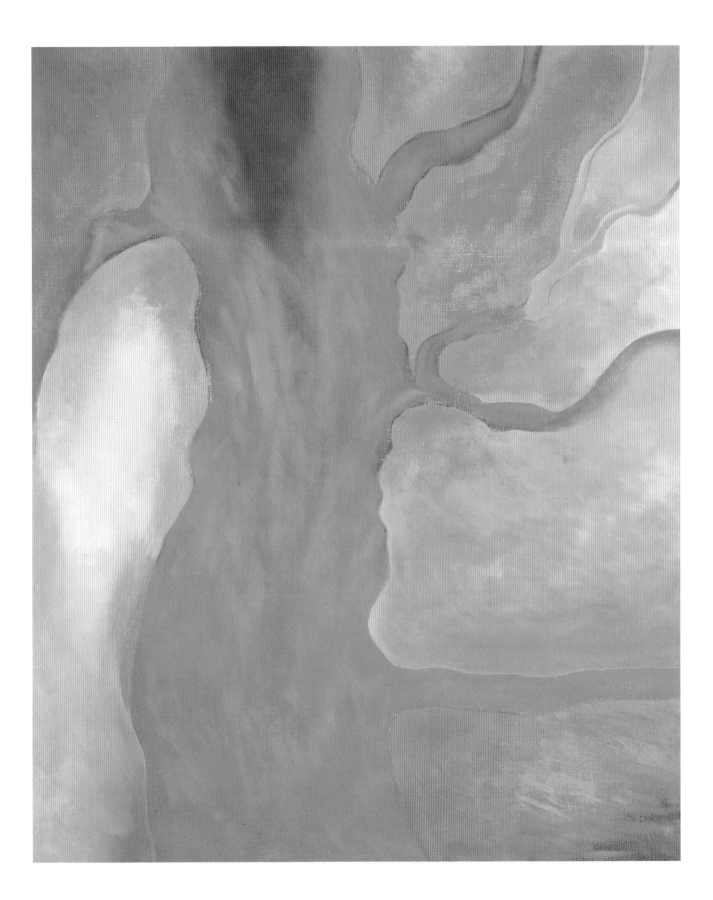

81. *Tan, Orange, Yellow, Lavender.* c. 1959. Oil on canvas, 36 x 30".
Gift of The Burnett Foundation and The Georgia O'Keeffe Foundation

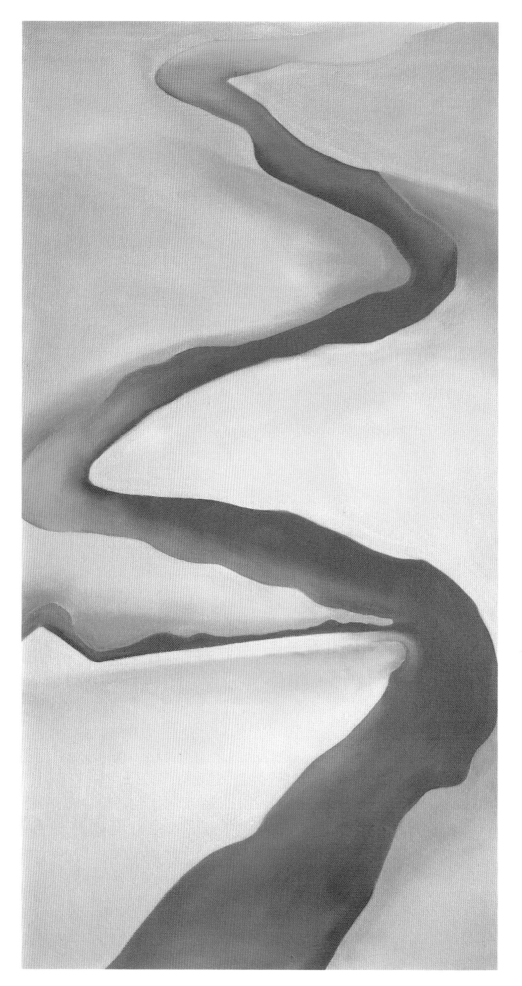

82. *Pink and Green.* 1960. Oil on canvas, 30 x 16″.
Gift of The Burnett Foundation

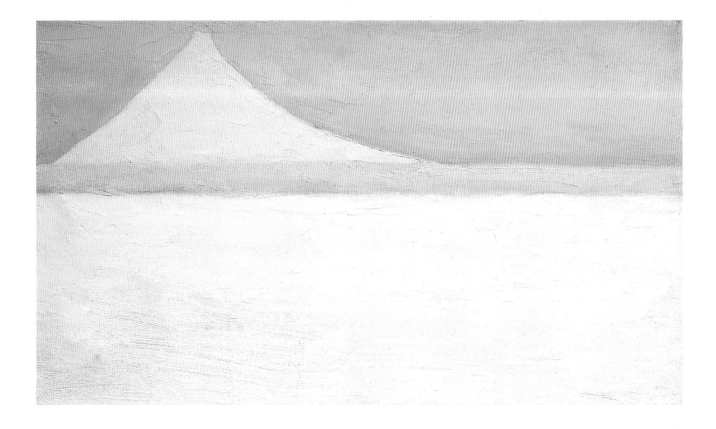

83. *Mt. Fuji.* 1961. Oil on canvas, 10 x 17⅛″.
Gift of Mr. and Mrs. Gerald Peters

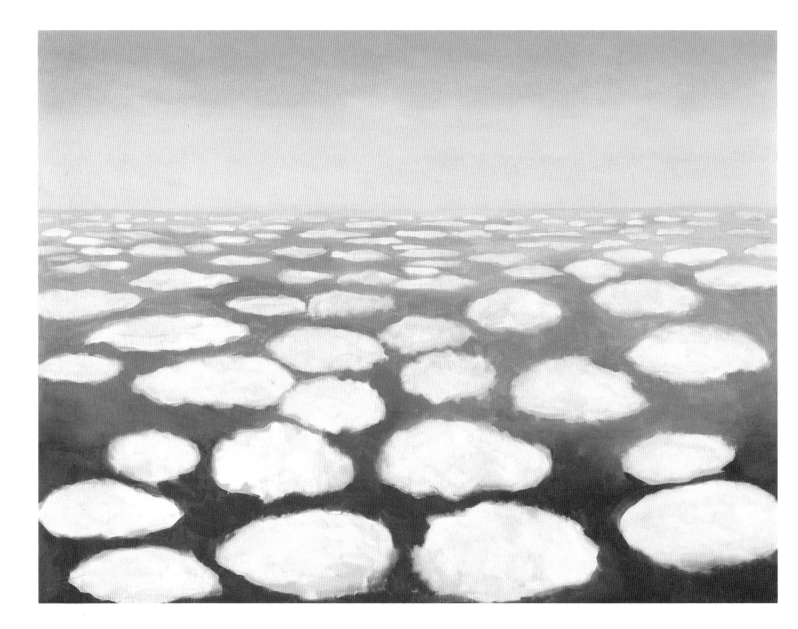

84. *Sky Above Clouds I*. 1963. Oil on canvas, 36⅛ x 48¼".
Gift of The Burnett Foundation and The Georgia O'Keeffe Foundation

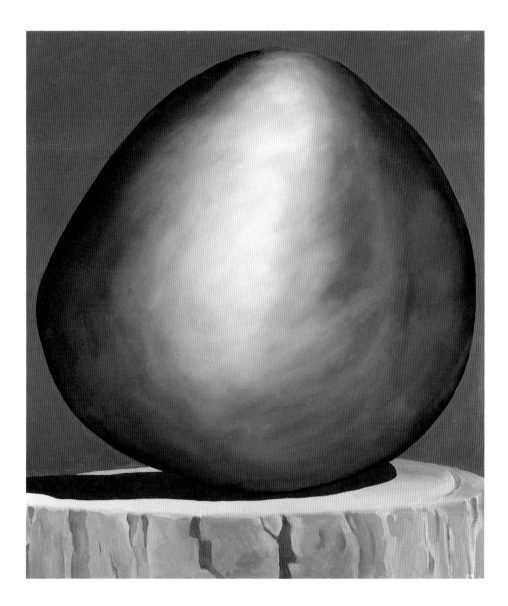

85. *Black Rock with Red.* 1971. Oil on canvas, 30⅛ x 26″.
Gift of The Burnett Foundation and The Georgia O'Keeffe Foundation

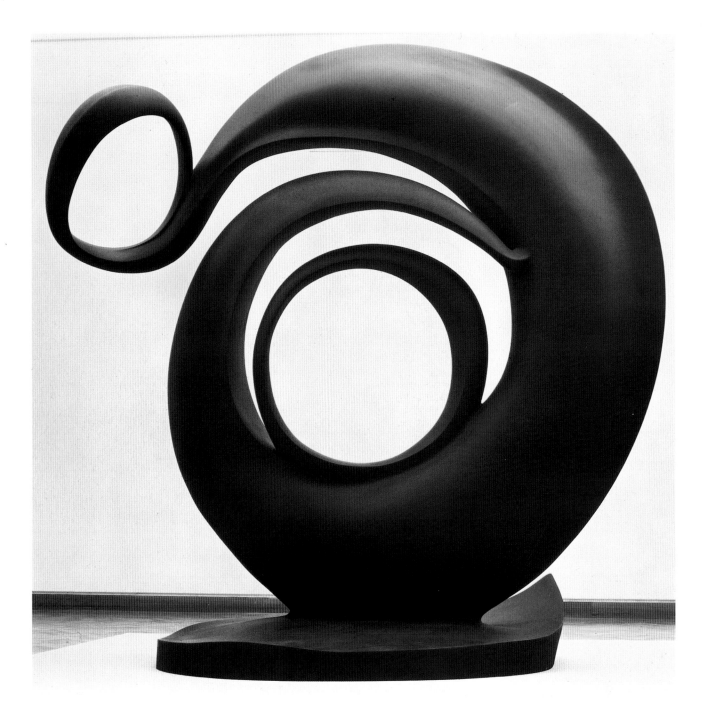

86. *Abstraction*. 1945, 1979–80. Cast aluminum, 128 x 108 x 59″.
Gift of The Burnett Foundation and The Georgia O'Keeffe Foundation

Chronology

CHARLES C. ELDREDGE

Hall Distinguished Professor of American Art, The University of Kansas

O'Keeffe in Texas. 1912.
Courtesy Catherine V.
Krueger

Enlarged and updated by Dr. Eldredge from the chronology in his Georgia O'Keeffe *(Abrams in association with the National Museum of American Art, Smithsonian Institution, 1991).*

1887 Born November 15 in Sun Prairie, Wisconsin, to Francis Calyxtus O'Keeffe and Ida (Totto) O'Keeffe, the second child and first girl in a family that grew to two sons and five daughters.

1887–1903 Lives on family's 640-acre dairy farm in Sun Prairie; educated at local grammar school, later at Sacred Heart Academy, Madison (where she received first art instruction), and Madison High School. Family moves to Williamsburg, Virginia, in 1902, after which she lives with an aunt in Madison.

1903 Spring: Joins family in Williamsburg. Autumn: Enrolls at Chatham Episcopal Institute, Chatham, Virginia, graduating in 1905.

1905–6 Studies at School of the Art Institute of Chicago, where John Vanderpoel's classes are particularly inspirational.

1907–8 Studies at Art Students League, New York, with William Merritt Chase, in whose class she earns scholarship for still life; also with F. Luis Mora and Kenyon Cox. Visits exhibitions of modern art (Rodin, Matisse) at Alfred Stieglitz's Little Galleries of the Photo-Secession (known as 291 for its Fifth Avenue address).

1908 Summer: Attends Art Students League's summer school at Lake George, New York.

1908–10 Abandons painting to pursue career as commercial artist in Chicago, drawing lace and embroidery for advertisements; leaves commercial work after eyesight suffers owing to measles. Returns to family, who have relocated to Charlottesville, Virginia.

1911 Spring: Substitutes for Elizabeth May Willis, her favorite early mentor, at Chatham Hall—her first teaching experience.

1912 Summer: Visits art classes at University of Virginia taught by Alon Bement, a disciple of Arthur Wesley Dow; interest in painting revived.

1912–14 Employed as art supervisor and teacher in

public school in Amarillo, Texas, her introduction to the American West.

1913–16 Summers: Teaches art at University of Virginia with Bement.

1914–15 Studies with Dow at Columbia University's Teachers College, New York. Visits exhibitions of Braque and Picasso, Marsden Hartley, and John Marin at 291.

1915–16 Teaches art at Columbia College, Columbia, South Carolina; begins series of abstract charcoal drawings, some of which she shares with New York classmate Anita Pollitzer as a form of private, nonverbal communication.

1916 January 1: Pollitzer shows abstract drawings to Stieglitz, who retains works. Spring: Returns for more classes with Dow. May–July: Drawings exhibited (with paintings by Charles Duncan and Rene Lafferty) at 291—without artist's knowledge; meets with Stieglitz to demand exhibition's dismantling, but he prevails. September: Returns to Texas to head art department at West Texas State Normal College in Canyon; works there until February 1918.

1917 April 3: Stieglitz presents her first solo exhibition (through May 14), which is 291's finale. May 25–June 1: Visits New York, meeting Paul Strand and others of Stieglitz circle; Stieglitz rehangs show and photographs her for the first time. Summer: Travels to Colorado; en route, detours through New Mexico, her first visit to the state.

1918 Spring: Recuperates from influenza in South Texas. June: Returns to New York at Stieglitz's urging. July: Stieglitz moves into her temporary quarters and begins photographing her regularly. August: Resigns from West Texas State Normal College to pursue painting in New York. Late summer: Accompanies Stieglitz to his family's Lake George home, returning there annually through the 1920s.

1918–29 Renewed interest in oil painting, creating abstract designs, still lifes, and landscapes.

1921 February: Stieglitz's photographs of O'Keeffe publicly exhibited for first time at Anderson Galleries, New York. Hartley publishes early appreciation of her work, an essay tinged with sexual interpretations.

1922 Designs typographic logo for *MSS.*, a little magazine published by several of Stieglitz's associates, and contributes autobiographical statement to special issue of the publication devoted to photography and its meaning.

1923 Stieglitz presents exhibition of 100 O'Keeffe works at Anderson Galleries, her first solo show in six years; followed by presentation of 116 new Stieglitz photographs, including many O'Keeffe portraits.

1924 March: Simultaneous exhibition of fifty-one O'Keeffe paintings with sixty-one Stieglitz photographs at Anderson Galleries. Begins large floral paintings as well as Big Trees series and still lifes of enlarged leaves. September: Stieglitz divorced from first wife. December 11: Marries Stieglitz before justice of the peace in Cliffside Park, New Jersey, with Marin as witness.

1925 Paints first urban subject, *New York with Moon.* March: Stieglitz's "Seven Americans" exhibition at Anderson Galleries includes O'Keeffe along with Marin, Hartley, Arthur Dove, Charles Demuth, Strand, and Stieglitz, generating considerable acclaim. November: Moves to new Shelton Hotel. December: Stieglitz opens the Intimate Gallery.

1926–29 Annual exhibitions of new work at the Intimate Gallery.

1927 June–September: Small retrospective at Brooklyn Museum (no catalogue).

1928 May: Reported sale of six calla lily paintings for record price ($25,000) earns wide attention (later revealed as publicity hoax). Spring: Travels to Wisconsin to visit family and childhood home.

1929 April–August: Visits New Mexico with Rebecca Strand, as guest of Mabel Dodge Luhan, initiating cycle of summers in Southwest. June: The Intimate Gallery closes. December: Included in "Paintings by Nineteen Living Americans," second exhibition at new Museum of Modern Art. Stieglitz opens An American Place gallery.

Georgia O'Keeffe near "The Pink House," Taos, New Mexico. 1929. Courtesy Museum of New Mexico, Santa Fe

1930 February–March: Exhibition at An American Place includes first New Mexican subjects; presents work there nearly annually through 1950.

1930–31 First paintings of skeletal subjects.

1932 April: Receives commission to paint mural for Radio City Music Hall. Summer spent at Lake George instead of New Mexico; travels to Canada and paints barns and crosses of Gaspé country. November: Technical problems cause cessation of work on the Radio City mural; abandons painting for more than a year.

1933 February–March: Hospitalized in New York; subsequently recuperates in Bermuda and, from May onward, at Lake George.

1934 June–September: Returns to New Mexico for first time in three years; first visit to Ghost Ranch, six-

Todd Webb.
*Ladder and Wall,
O'Keeffe's Abiquiu
House.* 1956.
Courtesy Evans
Gallery, Portland,
Maine

teen miles north of Abiquiu, to which she returns frequently thereafter.

1936 October: Moves with Stieglitz to penthouse apartment on East Fifty-fourth Street.

1937 July–December: At Ghost Ranch, staying in adobe house that she later buys; hostess to Ansel Adams and other friends, with whom she travels in the West. Winter: Failing health forces Stieglitz to give up photography.

1938 April: Stieglitz suffers heart attack, followed by pneumonia; delays departure for New Mexico until August. May: Receives honorary Doctor of Fine Arts degree from College of William and Mary, the first of many such honors.

1939 February–April: Paints in Hawaii as guest of Dole Pineapple Company; later, in New York, reluc-

tantly completes painting of a pineapple for her sponsor. April: Honored as one of twelve outstanding women of past fifty years by New York World's Fair Tomorrow Committee; painting *Sunset, Long Island* selected to represent New York in the fair's exhibition. Summers at Lake George instead of New Mexico.

1940 October: Buys house at Ghost Ranch during a six-month visit.

1941 October–November: Group show with Stieglitz, Marin, Dove, and Picasso at An American Place.

1943 January–February: First full-scale retrospective at Art Institute of Chicago, with catalogue by curator Daniel Catton Rich. Begins series of paintings based on animal-pelvis bones.

1944 Spring: Assists in preparations for exhibition of Stieglitz's collection of modern American and European art and photography at Philadelphia Museum of Art.

1945 May–October: In New Mexico. December: Buys abandoned adobe structures on three acres in Abiquiu, which over the next three years she remodels as a winter home.

1946 May–August: Retrospective at Museum of Modern Art, organized by James Johnson Sweeney, is first show there to honor a woman (no catalogue). June–July: In Abiquiu. July 10: Returns to stricken Stieglitz in New York; he dies July 13. Autumn: Returns to Abiquiu.

1947–49 Works in New York, settling Stieglitz's estate, preparing exhibition of his collection at Museum of Modern Art (1947; subsequently, Art Institute of Chicago, 1948), and distributing his artworks to public institutions. Summers in New Mexico, but few paintings result.

1949 Spring: Moves to New Mexico permanently, dividing time between Abiquiu (winters and springs) and Ghost Ranch (summers and autumns). Elected to National Institute of Arts and Letters.

1950 October–November: Exhibition at An American Place marks gallery's closing. Edith Gregor Halpert, director of the Downtown Gallery, becomes new dealer (until 1963).

1951 February: First trip to Mexico, beginning international travels.

1952 February–March: First show at Downtown Gallery features pastels from 1915–45, suggesting paucity of recent work in oil.

1953 February: Retrospective at Dallas Museum of Art. Spring: First trip to Europe (France and Spain); returns to Spain for three months the following year.

1956 Spring: Visits Peru for three months, inspiring group of coastal and Andean subjects.

1959 Travels around the world for three months, including seven weeks in India. Paintings based on overhead views of river patterns inspired by experience of flight.

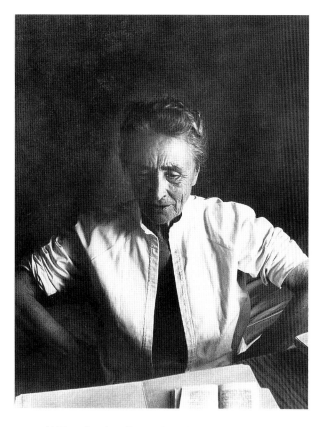

1960 October–December: Retrospective exhibition at Worcester Art Museum, with Rich as curator and catalogue author. Autumn: Six-week trip to Japan, Taiwan, Philippines, Hong Kong, Southeast Asia, and Pacific Islands; tropical landscapes and views of islands through clouds result.

1961 Summer: First of several trips down the Colorado River, which inspire Canyon Country series.

1962 Elected to American Academy of Arts and Letters, the nation's most prestigious assembly of creative artists, filling the seat left vacant by the death of e. e. cummings.

1963 Travels to Greece, Egypt, and the Near East.

1965 Paints her largest canvas, *Sky Above Clouds IV* (8 by 24 feet), the culmination of a series of "cloudscapes" viewed from overhead.

1966 March–May: Retrospective organized by Amon Carter Museum of Western Art, Fort Worth, with catalogue prepared by Mitchell A. Wilder. September–October: Art Museum at University of New Mexico presents first solo exhibition of her work in her adopted state.

1970 May: Receives National Institute of Arts and Letters' Gold Medal for Painting. October–November: Major retrospective organized by Lloyd Goodrich and Doris Bry for the Whitney Museum of American Art heralds triumphant return to New York; subsequently, exhibition travels to Chicago and San Francisco, winning new acclaim nationally.

1971 Loss of central vision leaves only peripheral sight.

1972 Last unassisted oil painting.

1973 Autumn: Meets Juan Hamilton, a young ceramic artist working at Ghost Ranch, who becomes her assistant and constant companion, and ultimately

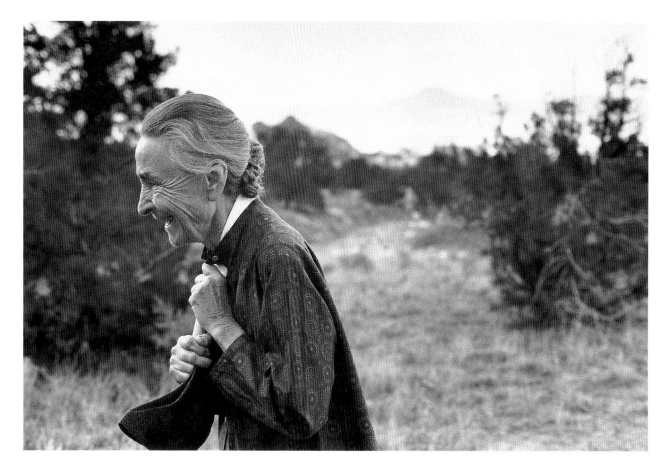

her representative; he assists in new work with clay, making hand-built pots.

1974 January: Visits Morocco with designer-architect Alexander Girard and wife, plus Hamilton; over the next decade travels with her assistant often, visiting Central America, the Caribbean, Hawaii, and cities in continental United States. Publishes *Some Memories of Drawings*, a portfolio of reproductions with comments by artist.

1975 Resumes painting in watercolors and, with assistance, in oils.

1976 Publishes *Georgia O'Keeffe*, a best-selling book of fine reproductions with distinctive text by artist.

1977 January: Receives Medal of Freedom, the nation's highest civilian honor, from President Gerald Ford. Perry Miller Adato produces film portrait of the artist that is aired nationally on public television. Ninetieth-birthday celebration at National Gallery of Art, Washington, D.C., generates increased public interest.

1978 Prepares catalogue introduction for exhibition "Georgia O'Keeffe: A Portrait by Alfred Stieglitz," which opens at Metropolitan Museum of Art, New York, in November.

1980 Laurie Lisle publishes *Portrait of an Artist: A Biography of Georgia O'Keeffe*, the first full-length study of her life.

1984 Moves to Santa Fe, where she lives with Juan Hamilton and his family.

1985 April: Awarded National Medal of Arts by President Ronald Reagan.

1986 March 6: Death at Saint Vincent's Hospital, Santa Fe.

1987 November: Centennial celebrated by major retrospective at National Gallery of Art, with Jack Cowart, Juan Hamilton, and Sarah Greenough as co-curators; subsequently toured to Art Institute of Chicago, Dallas Museum of Art, Metropolitan Museum of Art, and Los Angeles County Museum of Art.

1989 Following distribution of designated paintings by bequest, The Georgia O'Keeffe Foundation established, to perpetuate the memory of the artist and her work.

1991 October: The Georgia O'Keeffe Foundation and National Gallery of Art announce joint sponsorship of catalogue raisonné of the artist's work, with Barbara Buhler Lynes as author; publication scheduled for 1999.

1993 April: Major retrospective opens at Hayward Gallery, London (catalogue by curator, Charles C. Eldredge), the first such international exposure for an American modernist of her generation; exhibition subsequently travels to Mexico City and Yokohama.

1997 July: Opening of The Georgia O'Keeffe Museum in Santa Fe. October: The Georgia O'Keeffe Foundation announces the promised gift of the Georgia O'Keeffe home and studio in Abiquiu to the National Trust for Historic Preservation.

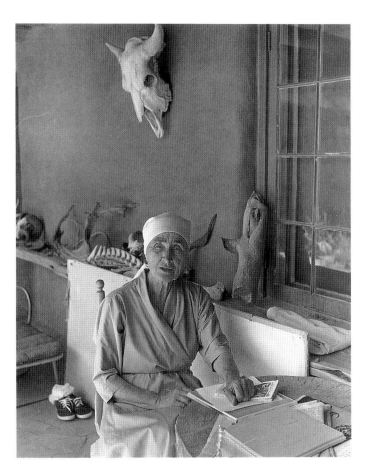

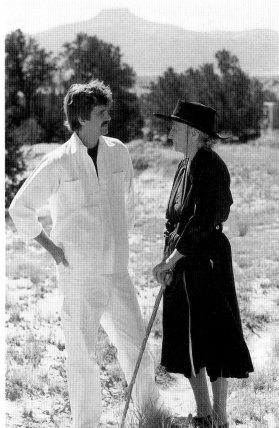

Selected Bibliography

Adato, Perry Miller, producer and director. *Georgia O'Keeffe*. Videotape, 59 min. Produced by WNET/THIRTEEN for Women in Art, 1977. Portrait of an Artist, no. 1; distributed by Films, Inc./Home Vision, New York.

Callaway, Nicholas, ed. *Georgia O'Keeffe: One Hundred Flowers*. New York: Knopf in association with Callaway Editions, 1993.

Castro, Jan Garden. *The Art and Life of Georgia O'Keeffe*. New York: Crown Publishers, 1985.

Cowart, Jack; Juan Hamilton; and Sarah Greenough. *Georgia O'Keeffe: Art and Letters*. Washington, D.C.: National Gallery of Art, 1987.

Eisler, Benita. *O'Keeffe and Stieglitz: An American Romance*. New York: Penguin Books, 1991.

Eldredge, Charles C. *Canyon Suite: Early Watercolors by Georgia O'Keeffe*. Santa Fe and Kansas City: Gerald Peters Gallery and Kemper Museum, 1994.

———. *Georgia O'Keeffe*. New York: Abrams in association with the National Museum of American Art, Smithsonian Institution, 1991.

———. *Georgia O'Keeffe, American and Modern*. New Haven and London: Yale Univ. Press in association with InterCultura and The Georgia O'Keeffe Foundation, 1993.

Goodrich, Lloyd, and Doris Bry. *Georgia O'Keeffe*. New York: Whitney Museum of American Art [Praeger], 1970.

Hartley, Marsden. "Georgia O'Keeffe," from "Some Women Artists in Modern Painting." In *Adventures in the Arts: Informal Chapters on Painters, Vaudeville, and Poets*. 1921. Reprint, New York: Hacker Art Books, 1972.

Lisle, Laurie. *Portrait of an Artist: A Biography of Georgia O'Keeffe*. New York: Seaview Books, 1980.

Lynes, Barbara Buhler. *O'Keeffe, Stieglitz and the Critics, 1916–1929*. Chicago and London: Univ. of Chicago Press, 1989.

Merrill, Christopher, and Ellen Bradbury, eds. *From the Faraway Nearby: Georgia O'Keeffe as Icon*. Reading, Mass.: Addison-Wesley Publishing, 1990.

Messinger, Lisa M. *Georgia O'Keeffe*. New York: Thames and Hudson and the Metropolitan Museum of Art, 1988.

O'Keeffe, Georgia. *Georgia O'Keeffe*. New York: Viking Press, 1976; Penguin Books, 1977.

———. *Some Memories of Drawings*. Edited by Doris Bry. Albuquerque: Univ. of New Mexico Press, 1974.

Peters, Sarah Whitaker. *Becoming O'Keeffe: The Early Years*. New York: Abbeville Press, 1991.

Robinson, Roxana. *Georgia O'Keeffe: A Life*. New York: Harper and Row, 1989.

Rose, Barbara. "O'Keeffe's Trail." *New York Review of Books*, March 31, 1977.

Saville, Jennifer. *Georgia O'Keeffe: Paintings of Hawai'i*. Honolulu: Honolulu Academy of Arts, 1990.

above left:
Todd Webb. *Pedernal from the Ghost Ranch House.* 1959. Center for Creative Photography, University of Arizona, Tucson/Courtesy Evans Gallery, Portland, Maine

above right:
Dan Budnik. *Georgia O'Keeffe—Ghost Ranch Patio Portal, New Mexico—March 1975.* 1975

Index

Italics indicate pages with black-and-white illustrations; "pl." indicates colorplates.

Abiquiu, New Mexico, 13, 15, 36, 38, 43–44, 105, 106, 108, *139*
Abiquiu Mesa I, pl. 71
Abiquiu Mesa II, pl. 72
Abstract Expressionism, 74, 78, 109
Abstraction (c. 1916), pl. 16; (1945), pl. 86
Abstraction, White Rose II, 37, 78; pl. 35
Abstraction with Curve and Circle, 34; pl. 2
Adams, Ansel, *48*
Aerial paintings, 44–45, 80, 107–8, 109
Alcalde, New Mexico, 38, 40
Amarillo, Texas, 78
Analytical Cubism, 99
Anderson, Quentin, 97
Anderson, Sherwood, 36, 103, 106, 109
Antelope Horns, pl. 62
Apple Family II, 36; pl. 27
Architectural subjects, O'Keeffe's paintings of, 37–38. *See also* Patio doors; Skyscrapers
Art Institute of Chicago, School of, 33
"Art of the Real, The" (exhibition), 103
Art Students League, New York, 33
Asian art, O'Keeffe and, 77–78, 99, 100–101, 102, 108, 110
Autumn Trees, The Maple, 36; pl. 26

Bell, Cross, Ranchos Church, New Mexico, pl. 42
Belladonna—Hāna (Two Jimson Weeds), 40, 78; pl. 51
Bement, Alon, 34
Bergson, Henri, 75
Bierstadt, Albert, 78, 79, 80
Black Bird series, 44
Black Hollyhock with Blue Larkspur, 38, 75; pl. 28
"Black Place, The," 40–41
Black Place, Grey and Pink, 41; pl. 70
Black Place II, *41*
Black Rock paintings, 45
Black Rock with Red, 45; pl. 85
Blake, William, 110
Blavatsky, Helena Petrovna, 74
Bleeding Heart, pl. 49
Blue, Black, and Grey, 44
Blue-Headed Indian Doll, pl. 45
Blue Line, 35; pl. 17
Blue Lines, No. 10, 104, *105*, 109
Blue II (1917), pl. 3; (1958), pl. 77
Bones, O'Keeffe's paintings of, 15, 16, 40, 41–43, 77, 106
Boston Museum of Fine Arts, 100–101
Brancusi, Constantin, 16
Bridges, Fidelia, 75
Broken Shell, Pink, pl. 47
Buddhist Retreat by Stream and Mountains (Chü-jan), *102*, 103
Budnik, Dan, *142*

Calla Lily, White with Black, pl. 36
Calla Lily in Tall Glass II, 37; pl. 23
Camera Work, 76, 100, 102
Canadian White Barn series, 43
Canna, Red and Orange, pl. 22
Canna Leaves, 37; pl. 33
Canyon, Texas, 34, 101
Catesby, Mark, 75
Cather, Willa, 15–16
Cézanne, Paul, 74, 99, 107, 110
Chase, William Merritt, 76

Chü-jan, *102*, 103
Children's art, O'Keeffe and, 101
Chromatic Abstractionists, 109
Church, Frederic, 80
Clamshells, O'Keeffe's paintings of, 35, 77
Clifford, Henry, 101
Cliffs Beyond Abiquiu, Dry Waterfall, *79*
Clouds, O'Keeffe's paintings of, 44–45, 80, 106, 107–8
Cole, Thomas, 75
Color, O'Keeffe's use of, 16, 34, 35, 42, 74, 106–7, 109
Color Field painters, 109
Columbia College, South Carolina, 34
Columbia University, Teachers College of, New York, 33–34, 101
Concord (Newman), *105*
Copley, John Singleton, 73, 76
Corn II, 37; pl. 32
Cottonwood Trees in Spring, 36; pl. 58
Cow's Skull: Red, White and Blue, 41
Cow's Skull with Calico Roses, 41, *42*
Cross, pl. 40
Cubism, 99, 102, 103, 108, 110
cummings, e. e., 103

Dada, 74
Dark Iris III, pl. 37
Darwin, Charles, 75
Death Comes for the Archbishop (Cather), 15–16
De Kooning, Willem, 14, 109
Demuth, Charles, 35, 73, 74, 75, 101
Desert, O'Keeffe's paintings of, 15, 16. *See also* Bones, O'Keeffe's paintings of
Dewing, Maria Oakey, 75
Dickinson, Emily, 73–74, 110
Dove, Arthur, 13, 35, 73, 103–4
Dow, Arthur Wesley, 34, 77, 100, 101–2
Drawing V, 44; pl. 80
Dry Waterfall, Ghost Ranch, pl. 63
Dubuffet, Jean, 108
Duncan, Isadora, 102

East River, New York, No. 2, 14
Eckhart, Meister, 108
Emerson, Ralph Waldo, 73, 74, 75, 76, 77, 78, 80, 97, 107, 109
Evening, 34; pl. 9
Evening Star series, 34
Evening Star VII, 34; pl. 11
Excavation (De Kooning), 14
Exhibitions of O'Keeffe's works, 34, 35, 38, *46–47*, *48*, 73, 103, 109

Fauvism, 110
Fenollosa, Ernest, 100–101
Figures Under Rooftop, pl. 14
Flowers, O'Keeffe's paintings of, 13, 16, 35–37, 38, 40, 42, 73, 74–75, 77, 78, 80
Focillon, Henri, 105
From the Plains I, *79*
Fuller, Margaret, 73

Gender-shifting, O'Keeffe and, 73–74
Geometric works, of O'Keeffe, 105
"Georgia O'Keeffe" (exhibition), *46–47*
"Georgia O'Keeffe, American" (exhibition), 73
Georgia O'Keeffe Museum, The, Santa Fe, 33, 38
Gerald's Tree I, 36; pl. 48
Ghost Ranch, New Mexico, 38, 40, 43, *140*, *141*, *142*

Ghost Ranch Cliff, pl. 64
Giant Magnolias (Heade), *76*
Gilbert, Sue, 73
Gombrich, Ernst, 76
Goossen, E. C., 103
Gray, Asa, 75
Green and White Waterfall, pl. 79
Greenberg, Clement, 103
Green Lines and Pink, pl. 18
Grey Line, 35
Gurdjieff, G. I., 100

Halpert, Edith, 109
Hamilton, Juan, 45, *141*
Hartley, Marsden, 13, 35, 108
Hawaii, 38, 40
Heade, Martin Johnson, 73, 75, *76*, 78, 80
Head with Broken Pot, pl. 59
Homer, Winslow, 73, 76
Horse's Skull on Blue, 41
Horse's Skull with White Rose, 41; pl. 44
Hudson River painters, 75, 80
Huizinga, Johan, 75

Imperial Self, The (Anderson), 97
In the Patio, 109
In the Patio I, 43
In the Patio VIII, 44; pl. 73
In the Patio series, 110
Intuition, O'Keeffe and, 74, 80–81

Jack-in-the-pulpit, O'Keeffe's paintings of, 35
James, Henry, 74
Jimson Weed, 38, 40; pl. 46
Judd, Donald, 103

Kabbalists, 74
Kachina, pl. 56
Kahlo, Frida, 106
Kandinsky, Wassily, 14, 74, 77, 99, 100, 101, 102
Karsh, Yousuf, *8*, *9*
Kelly, Ellsworth, 103
Kline, Franz, 108
Kokopelli with Snow, pl. 57

Lady-painters, flower paintings of, 75
Lake George, New York, 35–38, 41
Lake George Window, 103, *104*
Landscapes, O'Keeffe's paintings of, 34, 35–36, 40, 42, 73, 78, 100, 106, 109, 110
Lane, Fitz Hugh, 76
Latimer, Marjory, 100
Lavender Hill with Green, pl. 69
Lawrence Tree, The, 36
Like Misti, A Memory, pl. 78
Little House with Flagpole, 37–38, 43; pl. 31
Loengard, John, *140*
Luhan, Mabel Dodge, 38

McBride, Henry, 14, 103
Maine, 38, 77
Malevich, Kasimir, 74, 99, 107
Malraux, André, 105
Maple and Cedar, Lake George, pl. 21
Marin, John, 13, 35
Matisse, Henri, 110
Meléndez, Luis, 108
Melville, Herman, 74
Merton, Thomas, 101
Modernism, O'Keeffe and, 14, 73, 75, 78, 80, 102, 110
Mondrian, Piet, 16, 99

Monet, Claude, 107
Moran, Thomas, 78
Motherwell, Robert, 108
Mt. Fuji, pl. 83
Mule's Skull with Pink Poinsettias, 42; pl. 50
Museum of Modern Art, New York, exhibitions, *46–47*, 103
Music, O'Keeffe and, 35, 100, 109
Music, Pink and Blue I, 35
My Last Door, 44; pl. 74
Mysticism, O'Keeffe and, 15, 100, 108

Nature (Emerson), 75, 76, 77
Newman, Barnett, 103, 104, *105*, 109, 110
New Mexican Landscape, *15*, 16
New Mexico, 13, 14, 15–16, 36, 38, 40–44, 105, 106, 108, *138*, *139*, *140*, *141*, *142*
New York, Night, 14
New York City, 14, *15*, 35, 38, *39*, 74–75; pl. 34
New York School, 106, 108, 109, 110
Nude figure, O'Keeffe's paintings of, 34, 102
Nude Series (Seated Red), 34; pl. 5
Nude Series VII, 34; pl. 4
Nude Series VIII, 34; pl. 7
Nude Series XII, 34; pl. 8
Nymphéas (Monet), 107

O'Keeffe, Georgia, 33; as art teacher, 34, 78, 101; depictions of, *1*, *2*, *4*, *6*, *8*, *9*, *12*–13, 15, 16, 35, *36*, 41, *48*, 74, *111*, *137*, *138*, *140*, *141*, *142*; early life of, 14, 33–34, 78; education and training of, 33–34, 101; and female roles, 12–13, 75, 104; first abstract paintings of (1915), 34, 76, 102, 105–6, 108; husband, *see* Stieglitz, Alfred; influences on, 14, 34, 35, 37, 44–45, 73–80, 97, 99–102, 107, 109; originality of, 16, 74, 80, 97, 99–110
Olitski, Jules, 103
On the Spiritual in Art (Kandinsky), 74, 100
Orchid, An, 78
Out Back of Marie's II, 40; pl. 43
Out Back of Marie's IV, 40; pl. 29

Patio Door, pl. 61
Patio doors, O'Keeffe's paintings of, 43–44, 106, 108, 109
Patio Door with Green Leaf, 44; pl. 76
Pedernal, Blue and Yellow, pl. 55
Pelvis IV, 42; pl. 60
Pelvis series, 42–43
Pelvis Series, Red with Yellow, 42; pl. 68
Pelvis with Moon, *43*
Petunia II, pl. 25
Photography, O'Keeffe and, 99, 100, 101–2, 110
Picasso, Pablo, 12, 99
Pink and Blue Mountain, 34; pl. 10

Pink and Green, 44; pl. 82
Pollock, Jackson, 12, 103, 105, 107, 108, 109
Porter, Eliot, 101
Porter, Fairfield, 109
Portrait W III, 34; pl. 6
Pound, Ezra, 100
Pragmatism, 77
Precisionists, 101
Purple Hills II, Ghost Ranch, New Mexico, pl. 30

Radiator Building—Night, New York, 14, 38, *39*
Ranchos Church, pl. 41
Red and Yellow Cliffs, 40; pl. 67
Red Hills with White Flower, 40, 78; pl. 65
Red Past View, 100
Reinhardt, Ad, 104
Ringbom, Sixten, 100
Rivers, O'Keeffe's paintings of, 44, 107
Rodin, Auguste, 102
Rothko, Mark, 103, 104, 109, 110
Ryder, Albert Pinkham, 78

Sánchez Cotán, Juan, 108
Scale, O'Keeffe and, 16, 37, 40, 78–79, 106
"Self-Reliance" (Emerson), 80, 97
Series I, 12, pl. 20
Sexuality, of O'Keeffe's paintings, 13, 16, 35, 74, 75
Shaker art, 103
Sheeler, Charles, 101
Shell II, pl. 39
Shelton with Sunspots, The, 14, *15*
Sky, O'Keeffe's paintings of, 80. *See also* Clouds, O'Keeffe's paintings of
Sky Above Clouds I, 44–45; pl. 84
Sky Above Clouds IV, 80, 107–8
Sky Above Clouds series, 44–45
Skyscrapers, O'Keeffe's paintings of, 14, 38, 74–75, 106
Song of the Skies series (Stieglitz), 80
Special XVII, pl. 19
Special XXII, pl. 1
Spiritualism, O'Keeffe and, 73, 74, 77–78
Sprague, Isaac, 75
Spring, 42; pl. 66
Steichen, Edward, 37, 106
Steinberg, Leo, 108
Steiner, Rudolf, 100, 102
Stieglitz, Alfred, 14, 35, 37, 38, 44, 75, 76, 77, 99, 103, 106, 109; *Camera Work*, 76, 100, 102; in Lake George, 35–36, 37; O'Keeffe and photography of, 101–2; O'Keeffe depicted by, *1*, *2*, *4*, *6*, *12*–13, 16, 35, *36*, 41; on O'Keeffe's paintings, 13, 35, 73, 74, 75, 104; Song of the Sky series, 80; 291 gallery, 34, 35, 76, 99, 102
Still, Clyfford, 103, 110

Strand, Paul, 16, 35, 37, 106
Street, New York I, 14, 38; pl. 34
Stump in Red Hills, 36; pl. 52
Sun Prairie, Wisconsin, 14, 33, 78
Surrealism, 74
Sweeney, James Johnson, 103

Tan, Orange, Yellow, Lavender, 44; pl. 81
Tao of Painting, The (Mai-Mai Sze), 100
Taos, New Mexico, 38, *138*
Teresa of Avila, Saint, 108
Texas, 14, 34
Thoreau, Henry David, 73, 77, 78, 80
Three Women, pl. 15
Toomer, John, 100
Transcendentalism: in American tradition, 73, 78, 80, 109–10; O'Keeffe and, 15–16, 76–77, 78, 109–10
Trees, O'Keeffe's paintings of, 36
291 gallery, 34, 35, 74, 76, 99, 102
Tyrrell, Henry, 76

University of Virginia, Charlottesville, 33
Untitled Flower in Vase (Primula), pl. 54
Untitled Ghost Ranch Landscape, pl. 53

Vaccaro, Tony, *111*
Van Gogh, Vincent, 77–78
Varon, Malcolm, *141*

Warhol, Andy, 12
Watercolors, O'Keeffe's use of, 34, 101, 102, 103, 104, 109
Watts, Alan, 101
Webb, Todd, *139*, *140*, *141*, *142*
West, the, American, 14–15, 34, 73, 78–79, 80. *See also* New Mexico
West Texas State Normal College, Canyon, 101
White, O'Keeffe and, 34, 74, 78, 106, 109
White Calla Lily with Red Background, pl. 24
White on White (Malevich), 74
White Patio with Red Door, 106, 108, 109
"White Place, The," 74
Williams, William Carlos, 103
Window (Museum of Modern Art, Paris) (Kelly), 103
Window, Red and Blue Sill, pl. 13
Winter Cottonwoods, East V, pl. 75
Wisconsin, 14, 78
Wisconsin Barn, pl. 38
Woman with Apron, pl. 12
Wright, Frank Lloyd, 100, 103

Zen Buddhism, O'Keeffe and, 101, 106, 108
Zurbarán, Francisco de, 108

Photograph Credits

The authors and publishers wish to thank the museums, galleries, private collections, and individuals who permitted the reproduction of works of art in their collections. Photographs have been supplied by the owners or custodians of the works, except for the following, whose courtesy is gratefully acknowledged (the numbers given refer to pages):

©1997 The Art Institute of Chicago. All Rights Reserved: 15 (left), 42, 80; © 1997 Dan Budnik: 142 (right); © 1997 The Cleveland Museum of Art: 79, 102; © Yousuf Karsh: 8; © Catherine V. Krueger: 137; Life Magazine, © Time Inc.: 140 (below); © 1997 The Metropolitan Museum of Art, New York: 41, 105 (left); © 1997 The Museum of Modern Art, New York: 46–47, 104; Museum of New Mexico, Santa Fe (negative no. 9763): 138; © 1997 Board of Trustees of the National Gallery of Art, Washington, D.C.: 1, 2, 6, 12, 36; © Tony Vaccaro: 111; © 1987 Malcolm Varon, New York City: 141 (right); © Todd Webb: 139, 140 (left), 141 (left), 142 (left).

Artists' copyrights: © 1997 Ansel Adams Publishing Rights Trust. All Rights Reserved: 48 (top); © 1997 Barnett Newman Foundation/Artists Rights Society (ARS), New York: 105 (right).